Presented to

West University Library

By

**Friends of the West University
· Library**

D1225638

Author: Victoria Charles
Translation: Marlena Metcalf

Layout:
Baseline Co Ltd
127-129A Nguyen Hue
Fiditourist 3rd Floor
District 1, Ho Chi Minh City
Vietnam

© 2007, Parkstone Press International, New York, USA
© 2007, Confidential Concepts, Worldwide, USA

ISBN : 978-1-85995-676-2

Printed in China

Renaissance Art

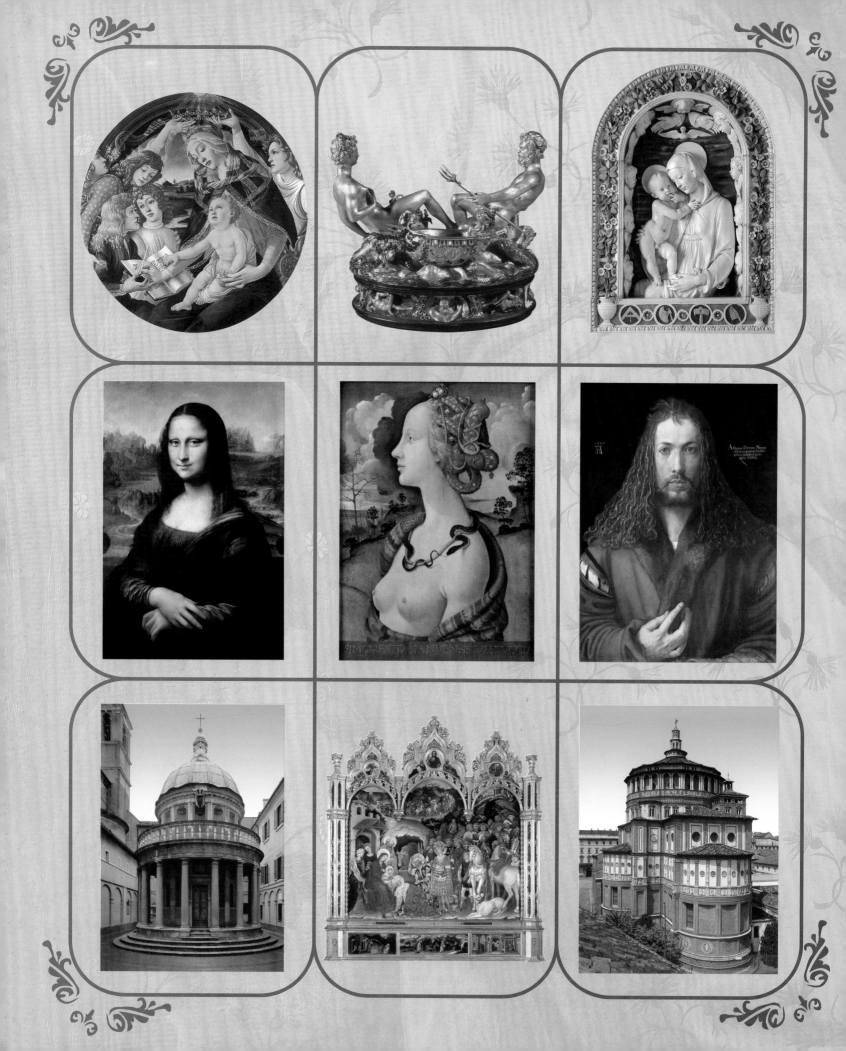

~ Contents ~

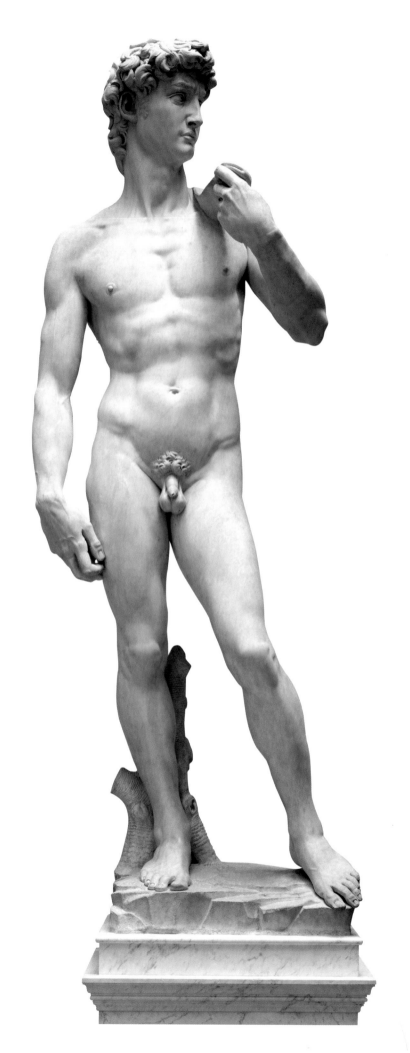

Introduction

In the middle of the fourteenth century a cultural transformation took place, a transformation that was initiated in Italy and was called *Rinascimento* there, and was subsequently known as *Renaissance* in France. It separated the Middle Ages from the Modern Age and was accompanied by Humanism and the Reformation. This development was a return to the classical arts of Greek and Roman Antiquity. It led to intensive studies of the long forgotten poets, to an enthusiasm for sculpture and for the numerous remains of architecture, even if they only existed as ruins.

Equally important for this development was the development of technology and sciences, which began in today's Scandinavia, as well as the Netherlands and later in Germany.

In Italy, it was initially architecture which fell back on classical ideals and, a little later, it was sculpture which sought a closer bond with nature. When the architect and sculptor, Filippo Brunelleschi (1377 to 1466), went to Rome to excavate, study and measure the remains of antique buildings, he was accompanied by the goldsmith and sculptor Donatello (around 1386 to 1466). The sculptures found during that time and during later excavations fired the enthusiasm of the sculptors, which, at the end of the fifteenth century was powerful enough to lead Michelangelo to bury one of his pieces of work in the ground, so that shortly afterwards it could be dug up as being "genuinely antique".

The Italian Renaissance lasted for approximately two hundred years. The early Renaissance is classed as belonging to the years between 1420 and 1500 (the *Quattrocento*), the heyday of the Renaissance ended about 1520, and the late Renaissance, which turned into Mannerism, came to a close in around 1600 (the *Cinquecento*). Baroque art (roughly translated as "quirky, eccentric") developed as an imperceptible transition from the late Renaissance as a further development in Italy and in some other countries and was occasionally seen as a deviant and decadent, but now and again as a higher form of development, dominating until the end of the seventeenth century. After the Renaissance crossed the Alps into Germany, France and the Netherlands, it took a similar course and is classified the same way as in Italy.

Michelangelo Buonarroti,
David, 1501-1504.
Marble, h: 410 cm.
Galleria dell'Accademia, Florence.

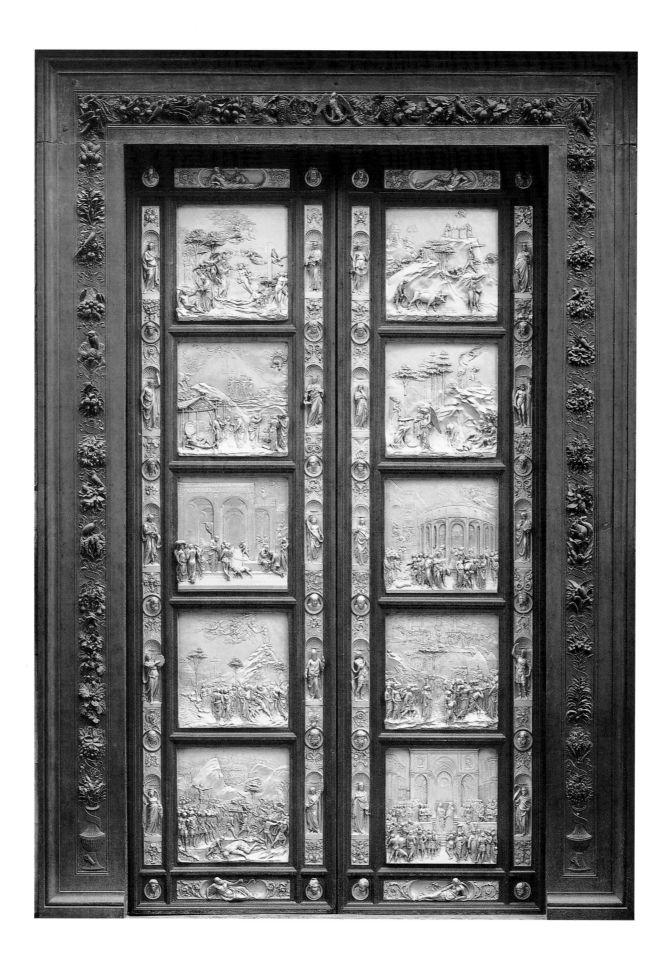

I. Art in Italy

The Italian Early Renaissance

The earliest traces of the Renaissance are found in Florence. In the fourteenth century, the town already had 120,000 inhabitants and was the leading power in middle Italy. The most famous artists of this time lived here – at least at times – Giotto (probably 1266 to 1336), Donatello (1386 to 1466), Masaccio (1401 to 1429), Michelangelo (1475 to 1564), Lorenzo Ghiberti (1378 to 1455).

Brunelleschi secured a tender in 1420 to reconstruct the Florentine Cathedral, which was to receive a dome as a proud landmark. The foundation of his design was the dome of the Pantheon, originating in the Roman Empire. He deviated from the model by designing an elliptical dome resting on an octagonal foundation (the tambour). In his other buildings, he followed the forms of columns, beams and chapters of the Greek-Roman master builders. However, owing to the lack of new ideas, only the crowning dome motif was adopted in the central construction, in the form of the Greek cross or in the basilica in the form of the Latin cross. Instead, the embellishments taken from the Roman ruins were further developed according to classical patterns. The master builders of the Renaissance fully understood the richness and delicateness, as well as the power of size in Roman buildings, and complemented it with a light splendour. Brunelleschi, in particular, demonstrated this in the chapel erected in the monastery yard of Santa Croce for the Pazzi Family, with its portico born by Corinthian columns, in the inside of the Medici Church San Lorenzo and the sacristy belonging to it. These buildings have never been surpassed by any later, similar building in so far as the harmony of their individual parts is in proportion to the entire building.

Leon Battista Alberti (1404 to 1472), who like Brunelleschi was not only a master builder, but at the same time also a significant art historian with his writings *About Painting* (1435) and *About Architecture* (1451), was probably the first to articulate this quest for harmony. He compared architecture to music. For him, harmony was the ideal of beauty, because for him beauty meant "…nothing other than the harmony of the individual limbs and parts, so that nothing can be added or taken away without damaging it". This principle of the science of beauty has remained unchanged since then.

Alberti developed a second type of Florentine palace for the Palazzo Rucellai, for which the facade was structured by flat pilasters arranged between the windows throughout all storeys.

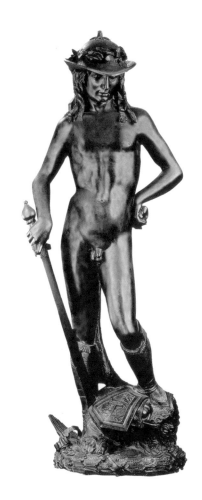

Lorenzo Ghiberti,
Door of Eden, 1425-1452.
Gilded bronze, 506 x 287 cm.
Baptistery, Florence.

Donatello,
David, c. 1440-1443.
Bronze, h: 153 cm.
Museo Nazionale del Bargello, Florence.

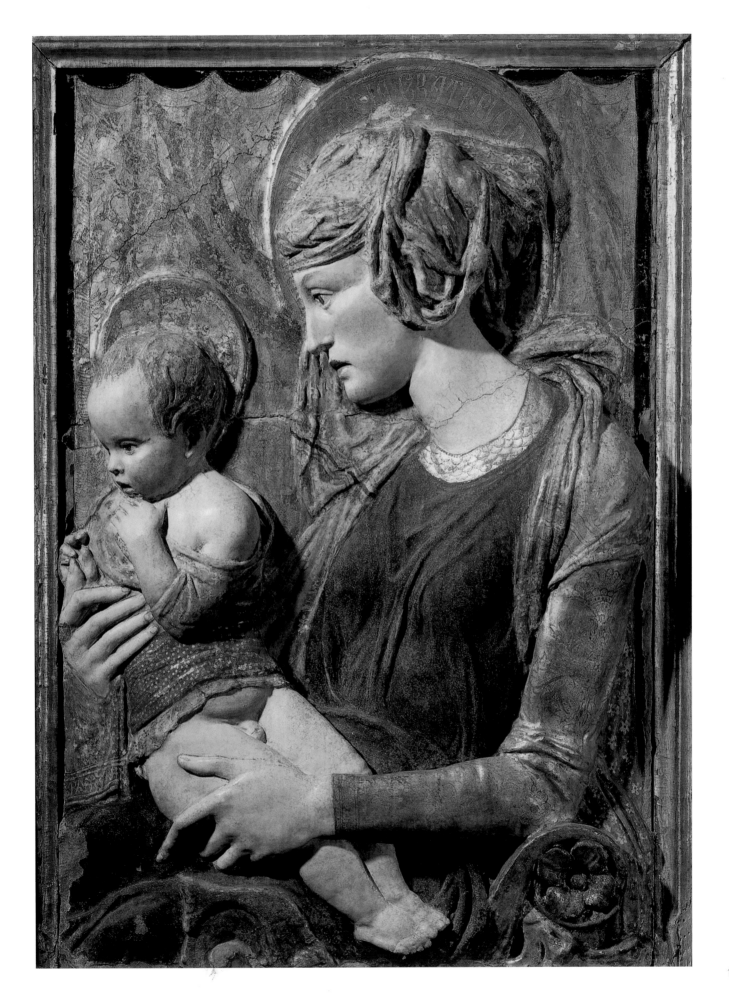

In Rome, however, there was an architect of the same standard as the Florentine master builders: Luciano da Laurana (1420/1425 to 1479), who had been working in Urbano until then, erecting parts of the ducal palace there. He imparted his feeling for monumental design, for relations as well as planning and execution of even the smallest details to his most important pupil, the painter and master builder Donato Bramante (1444 to 1514), who became the founder of Italian architecture during the High Renaissance. Bramante had been in Milan since 1472, where he had not only built the first post-Roman coffer dome onto the church of Santa Maria presso S. Satiro and had also erected the church Santa Maria delle Grazie and several palaces, but had also worked there as a master builder of fortresses before moving to Pavia and in 1499 to Rome. As was common in the Lombardy at that time, he built the Church of Santa Maria delle Grazie as a brick building, focusing on the sub-structure. Using ornamentation covering to cover all parts of buildings had been a feature of the Lombards' style since the early Middle Ages.

This type of design, with incrustations succeeding medieval mosaics, was very quickly adopted by the Venetians, who had always attached much greater value to an artistic element rather than an architectonic structural feature. Excellent examples of these facade designs are the churches of San Zaccaria and Santa Maria di Miracoli, looking like true gems and demonstrating the love of glory and splendour of the rich Venetian merchants. The Venetian master builder Pietro Lombardo (about 1435 to 1515) showed that a strong architectonic feeling was also very much present here with one of the most beautiful palaces in Venice at that time, the three-storey Palazzo Vendramin-Calergi.

The architect Brunelleschi had succeeded in implementing a new and modern method of construction. But gradually a sensitivity toward nature, defined as one of the foundations in Renaissance, becomes transparent in some sculptural work of the young goldsmith Ghiberti, which can be found almost at the same time in the Dutch painter brothers Jan (around 1390 to 1441) and Hubert (around 1370 to 1426) Van Eyck, who began the *Ghent Altar*. During this twenty year period, Ghiberti worked on the bronze northern door of the baptistery and the sense of beauty of the Italians continued to develop. Giotto had further developed the laws of central perspective, discovered by mathematicians, for painting – later Alberti and Brunelleschi continued his work. Florentine painters eagerly took up the results, subsequently engaging sculptors with their enthusiasm. Ghiberti perfected the artistic elements in the relief sculpture. With this, he counterbalanced the certainly more versatile Donatello, who, after all, had dominated Italian sculpture for a whole century.

Donatello had succeeded in doing what Brunelleschi was trying to do: to realise the expression of liveliness in every material, in wood, clay and stone, independent of reality.

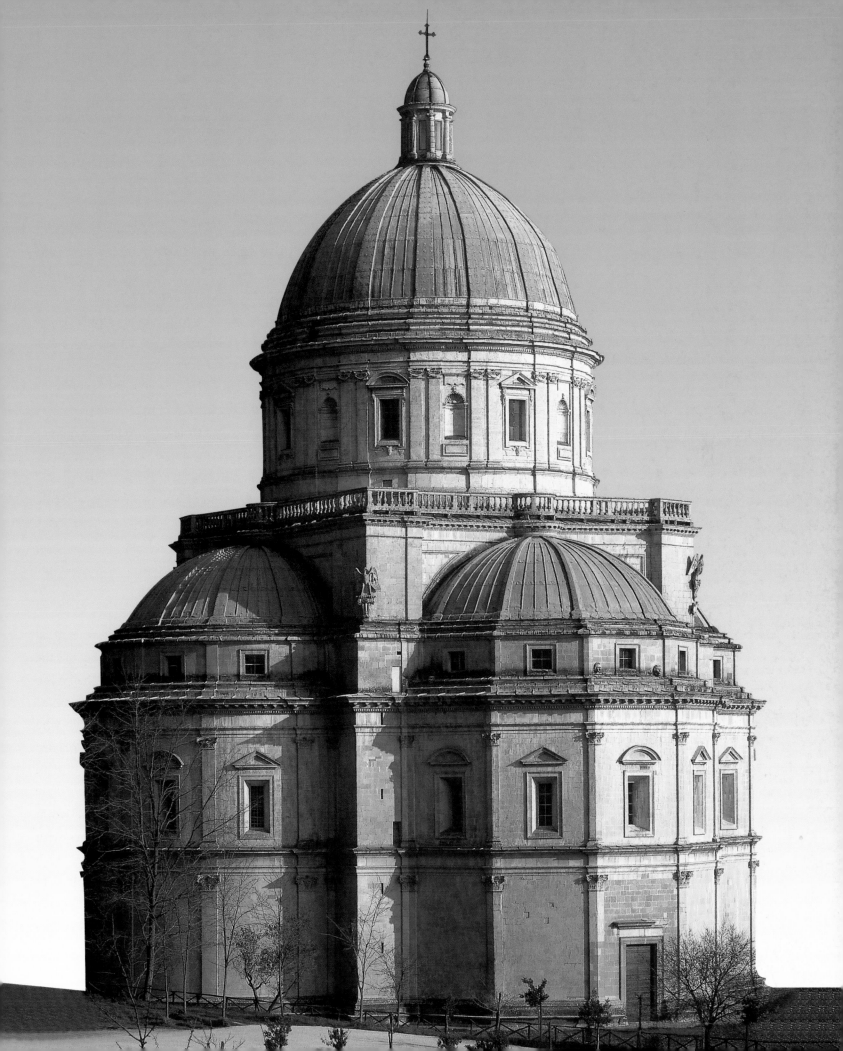

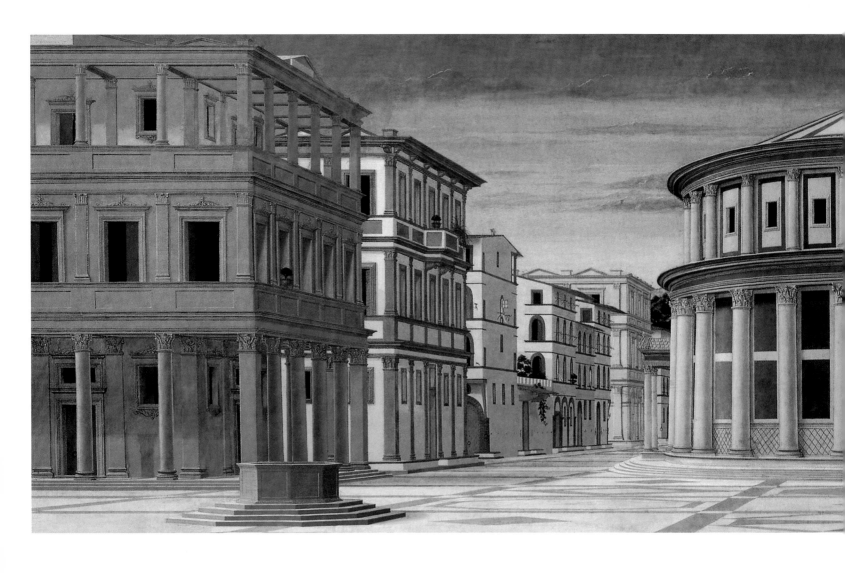

School of **Piero della Francesca**
(**Laurana** or **Giuliano da Sangallo?**),
Ideal City, c. 1460.
Oil on wood panel, 60 x 200 cm.
Galleria Nazionale delle Marche, Urbino.

The figures' terrible experiences of poverty, pain and misery are reflected in his reproduction of them. In his portrayals of women and men, he was able to express everything that constituted their personalities. Additionally, none of his contemporaries were superior to him in their decorations of pulpits, altars and tombs, and these include his stone relief of *Annunciation of the Virgin* in Santa Croce or the marble reliefs of the dancing children on the organ ledge in the Florentine Cathedral. His *St George*, created in 1416 for Or San Michele, was the first still figure in a classical sense and was followed by a bronze statue of David, the first free standing plastic nude portrayal around 1430, and in 1432 the first worldly bust, with *Bust of Niccolo da Uzzano*. Finally, in 1447, he completed the first equestrian monument of Renaissance plastic with the bronze *Equestrian Monument of Gattamelata*, the Venetian mercenary leader, (around 1370 to 1443), which he created for Padua.

Donatello's rank and fame was only achieved by one other person, the sculptor Luca della Robbia (1400 to 1482), who not only created the singer's pulpit in Florence

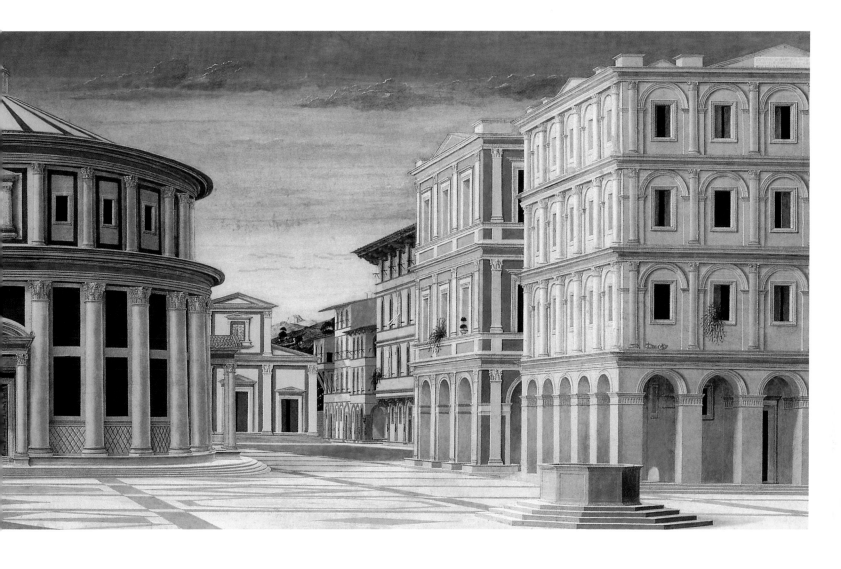

Cathedral (1431/1438), but also the bronze reliefs (1464/1469) at the northern sacristy of the Cathedral. His most important achievement, however, is his painted and glazed clay work. The works, which were initially made as round or half-round reliefs, were intended as ornamentation for architectonic rooms. But they found a role elsewhere - the *Madonna with Child accompanied by Two Angels*, surrounded by flower festoons and fruit wreaths in the lunette of Via d'Angelo is a rather splendid result of his creations. As Donatello's skills culminated in his portraits of men, Robbia's mastery is demonstrated in his graceful portrays of childlike and feminine figures – there was nothing more beautiful in Italian sculpture in the fifteenth century.

The demands on the design of these products rose to the extent with which the skills in manufacturing glazed clay work in Italy increased. In the end, not only altars and individual figures but also entire groups of figures were made using this technique, which left the artist complete freedom with regard to the design. Luca della Robbia passed his skills and his experience on to his nephew Andrea della Robbia (1435 to 1525).

Pisanello (Antonio Puccio),
Portrait of a Princess, c. 1435-1440.
Oil on wood panel, 43 x 30 cm.
Musée du Louvre, Paris.

Domenico Veneziano,
Portrait of a Young Woman, c. 1465.
Oil on wood panel, 51 x 35 cm.
Gemäldegalerie, Dresden.

He in turn, and his sons Giovanni (1469 until after 1529) and Girolamo (1488 to1566) developed the technique of glazed terracotta even further and together with them created the famous round reliefs of the *Foundling Children* on the frieze above the hall of the Florence orphanage during the years from 1463 to 1466.

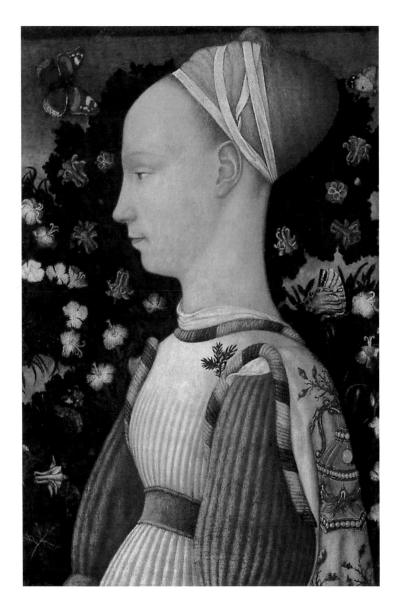

The fact that the production of the workshop of the della Robbia Family can still be admired nowadays in many places on Northern Italy demonstrates that the terracotta was not only to the taste of the general Italian public but also to that of the Europeans generally, and that the style was gaining more and more lovers. At the same time we should not forget that no other century was as favourably inclined towards sculptural design as the fifteenth century. Thus Donatello's seeds bore splendid fruit. His two most important students, the sculptor Desiderio da Settignano (approximately 1428 to 1464) and the painter, sculptor, goldsmith and bronze caster Andrea del Verrocchio (1435/1436-1488), continued to run his school in his way of thinking. Especially the latter not only created a number of altarpieces, but also became the most important sculptor in Florence. He cast the statue of *David*, for instance, (around 1475) and the *Equestrian Statue* (1479) of the mercenary leader Bartolomeo Colleoni (1400 to 1475) in Venice. Verrocchio's style prepared the transition to the High Renaissance.

Settignano has left considerably fewer pieces of art than Verrocchio and mainly occupied himself with marble Madonna reliefs, figures of children and busts of young girls. He passed his skills and knowledge on to his most important student, Antonio Rosselino (1427 to 1479), whose main piece of work is the tomb of the Cardinal of Portugal in San Miniato al Monte in Florence.

Among Rosselino's students was Mino da Fiesole (1431 to 1484), who, while originally a stonemason, became the best marble technician of his time and created gravestones in the form of monumental wall graves, and Benedetto da Maiano. Fiesole's art mainly lived on imitating nature, and was thus too limited to lend variety to his large production.

The second half of the fifteenth century shows the gradual transition from popular marble processing to the more austere bronze casting, and the two *David* statues are examples of this. Donatello's work shows a rather thoughtful David, the other, by

Verrocchio, in complete contrast, created in the ideal form of naturalism, a self-confident youth, who is smiling, satisfied with his successful battle, Goliath's head chopped off at his feet. This smile, which has frequently, but to no avail, been copied by stonemasons has become a trade mark of Verocchio's school. Only one artist really succeeded in conjuring this smile onto some of his own work: Leonardo da Vinci, also a student of Verrocchio. The sculptor Verrocchio has to share his fame with the painter Verrocchio, who has only left few paintings behind. Among them are *The Madonna* (1470/1475), *Tobias and the Angel*, also (1470/75), as well as the *Baptism of Christ*, painted in tempera colours (1474). As the painter, master builder and art writer Giorgio Vasari (1511 to 1574) recorded convincingly, Leonardo da Vinci painted the angel kneeling in the foreground in this picture. Later, he possibly painted over this picture in oil after Verrocchio had moved away to Venice.

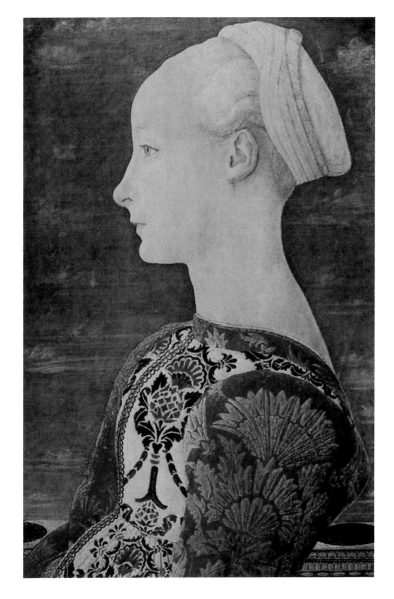

Apart from the statue of the young David, another sculpture belonging to his masterpieces is surely *Christ and St Thomas* in a niche in the Church of Or San Michele and the *Equestrian Statue of Colleoni*, which he did not live to see completed.

In Rome, the painter and goldsmith Antonio del Pollaiuolo (around 1430 to 1498) operated in a workshop, creating the first small sculptures there. His pen-and-ink-drawing, possibly a draft for a relief, *Fighting Naked Men* (approximately 1470/1475) and the copperplate engraving *Battle of the Ten Naked Men* (around 1470) were to break new ground in nude art. His most important works of art however, are the bronze tombs of the popes Sixtus V (1521 to 1590) and Innocent VIII (1432 to 1492) in St Peter's.

The development in the field of painting in Florence took place at about the same time as that in the field of sculpture, and raised it to a rich and splendid standard. Initially, the representatives of these two directions were irreconcilably opposed to each other, each stubbornly insisting on their own points of view. Finally, approximately in the middle of the fifteenth century, a certain fusion took place, the monumental always remaining a basic theme in Florentine art, which now found its expression in the monumental fresco-painting led by Masaccio and the Dominican monk Fra Giovanni da Fiesole, called Fra Angelico (1387 to 1455).

Fra Angelico, who first worked in Florence and later in Rome, combined Gothic influences with naturalism in his work, which was exclusively religious, distinguishing itself with its blissful depth of feeling. His artistic roots lay in his devout disposition, which was reflected in his numerous figures of the Virgin Mary and angels. His skilful work with colours is shown to their best advantage both in his numerous frescoes, which have mostly been well preserved, as well as in his panel paintings. The most important frescoes (around 1436/1446) can be found in the chapter house, the cloister and some cells in the former Dominican monastery San Marco. The *Coronation of the Virgin* is seen by many experts as outstanding amongst all other frescoes. Fra Angelico took up this subject several times.

One of Fra Angelico's most well-known successors is the Florentine Fra Filippo Lippi (around 1406 to 1469), who lived as a Carmelite monk for approximately five decades and was ordained priest in Padua in 1434, but later left the order. He took on Masaccio's school of thought and sense of beauty with his softly modelled line-work and splendid colours. He gave the female element a significant role – not only in his life but also in his frescoes and his numerous panel paintings. In his figures of angels, he uses girls from his surroundings as models and shows a sense and understanding for the fashion of that time. In his frescoes he achieved monumental greatness and left his most beautiful creations in his panel paintings. Similar to Fra Angelico, the *Coronation of the Virgin* (1441/1447) was also an important subject for him. Contrary to Fra Angelico however, he pushed the actual coronation somewhat to the background, and clearly put a lot more emphasis on the figures of the clergymen kneeling in the foreground as well as the women and children he portrayed. This tendency towards portraying and therefore honouring the individual is mainly demonstrated in his Madonna pictures, expressing significant religious feelings. This becomes increasingly apparent in his painting *Madonna with Two Angels* (mid-fifteenth century). In comparison, he created a lively background to the Madonna, who sits at the front with the portrayal of the confinement of St Anna on the round picture *Madonna and Child* (around 1452). This childbed served later artists as a welcome model.

Fra Filippo Lippi's most important student was without doubt Sandro Botticelli (around 1445 to 1510). But the headstrong Sandro, his *Adoration of the Magi* contains a self-portrait on the right side, insisted on becoming a painter, thus finally ending up at Fra Filippo Lippi's as an apprentice. Later on, he was close to the circle of humanists around the chief councillor Lorenzo de Medici (*The Magnificent*; 1449 to 1492). Botticelli was one of the first to become deeply involved in the subjects of antique mythology, for instance in the most famous of his paintings, the *Birth of Venus* (around 1482/1483), and he liked to include antique buildings in the background of his work. Above all, he created allegorical and religious work, and during his activities in Rome between 1481 and 1483

Fra Angelico (Fra Giovanni da Fiesole),
The Deposition of the Cross
(Pala di Santa Trinità), 1437-1440.
Tempera on wood panel, 176 x 185 cm.
Museo di San Marco, Florence.

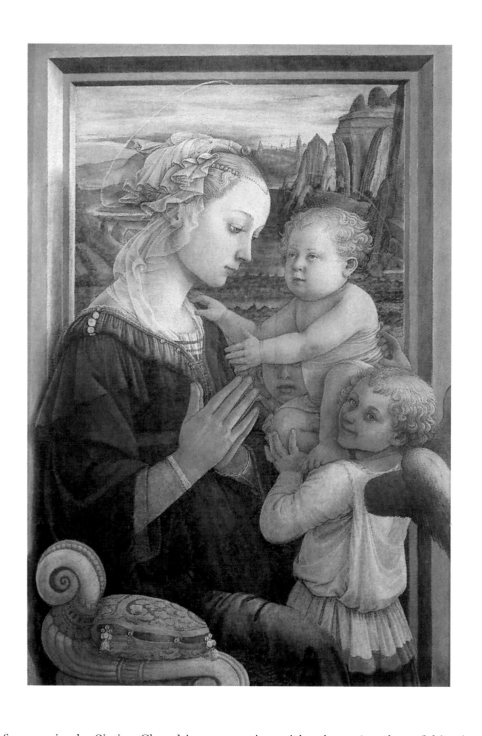

also frescoes in the Sistine Chapel in cooperation with others. Another of his pictures is *Spring* (1485/1487), in which the merry and festive life in Florence is reflected. In many of his pieces of work there is a lavish abundance of flowers and fruit, into which he places his slender girls and women with their fluttering, flowing gowns, as well as the Madonna's, surrounded by serious saints. In some Madonna portrayals we can feel the influence of the repentance-preacher and Dominican monk Girolamo Savonarola (1452 to 1498), of whom Botticelli remained an ardent follower, even after his violent death. He also repeatedly painted the *Adoration of the Magi*, once also commissioned by

Fra Filippo Lippi,
Madonna with the Child and Two Angels, 1465.
Tempera on wood, 95 x 62 cm.
Galleria degi Uffizi, Florence.

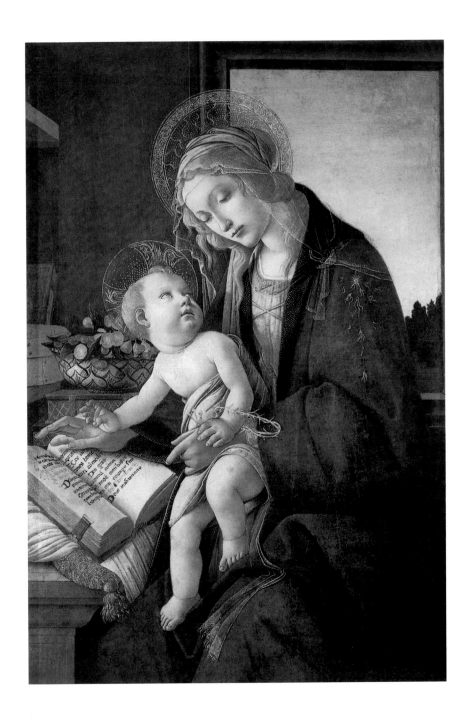

Lorenzo de' Medici, and in this painting we do not only see the members of this family but also their immediate circle of friends and his followers. His individual portraits such as *Portrait of a Young Man in a Red Cap* (around 1474), *Giuliano de' Medici* (around 1478) and *Portrait of a Young Woman* (around 1480/1485) prove that he was also a brilliant portraitist. From his time in Rome he also left one of his most mysterious paintings: *The Outcast* (1495), with the crying or desperate figure of a woman on the steps in front of the fortress-like wall with the closed gate. Botticelli, who had been wrongly forgotten for a long time, is now regarded as one of the greatest masters of the Renaissance.

Sandro Botticelli (Alessandro di Mariano Filipepi),
Madonna of the Book, c. 1483.
Tempera on wood panel, 58 x 39.5 cm.
Museo Poldi Pezzoli, Milan.

His most significant student was doubtlessly Filippino Lippi (around 1457 to 1504), the son of Fra Filippo Lippi. Initially strongly influenced by Botticelli, he later freed himself from him and created several significant pieces of work in his own right. Among these are an *Adoration of the Magi*, commissioned by the Medici, and following its interruption due to Masaccio's death, the completion of the painting of the Brancacci Chapel showing a fresco cycle with *Scenes from the Life of St Peter* (1481/1482), a *Coronation of the Virgin* and a *Madonna*.

In spite of these indisputable performances, his reputation and awareness level do not measure up to those of his contemporary Domenico Ghirlandaio (1449 to 1494). Like Botticelli, Ghirlandaio also first completed an apprenticeship as a goldsmith, and was already unquestionably successful when he dedicated himself entirely to painting. In 1480 and 1481 he created monumental and beautifully designed frescoes in the Sistine Chapel and in 1482/83 to 1485 in the Florentine Santa Trinità, among which *The Last Supper* in the Church of Ognissanti stands out in particular, and can be considered a forerunner to Leonardo's. Ghirlandaio included life around him into his work and did not hesitate at all to arrange biblical stories as scenes of contemporary Florentine good living, in order to give the viewer a better understanding of its deeper meaning. This is especially apparent in the frescoes he painted in the choir of Santa Maria Novella (1490).

Among the absolute masters of Italian painting outside of Florence is Piero della Francesca (1416 to 1492), who should be regarded as one of the most brilliant painters of the Early Renaissance and was particularly outstanding due to his excellent knowledge of anatomy and perspective. Piero della Francesca created a style that combines monumental size with the transparent beauty of colour and light, and therefore influenced the entire northern and middle Italian painting of the *Quattrocento*. His main work is the cycle of frescoes from the *Legend of the True Cross* in the choir of San Francesco in Arezzo (1451/1466) and a *Baptism of Christ* (1448/1450).

One of Piero della Francesca's most important students was Luca Signorelli (1440/1450 to 1523). His harshly modelled nudes, in movement and the adoption of ancient subjects, made him one of Michelangelo's role models. What kind of mastery he had already achieved in the portrayal of the human body as a young man is depicted in a mythological picture, rich in figures and probably commissioned by Lorenzo de' Medici. Michelangelo paid Signorelli his respects, when he adopted the woman riding on the Devil's back in one of his pieces of work, without any changes. But we can also still find Signorelli's frescoes and altarpieces in other large and small villages and towns in southern Tuscany and in Umbria. From their relatively good condition in relation to the colours, we may conclude that he made use of the new

Piero di Cosimo,
Portrait of Simonetta Vespucci, c. 1485.
Oil on panel, 57 x 42 cm.
Musée Condé, Chantilly.

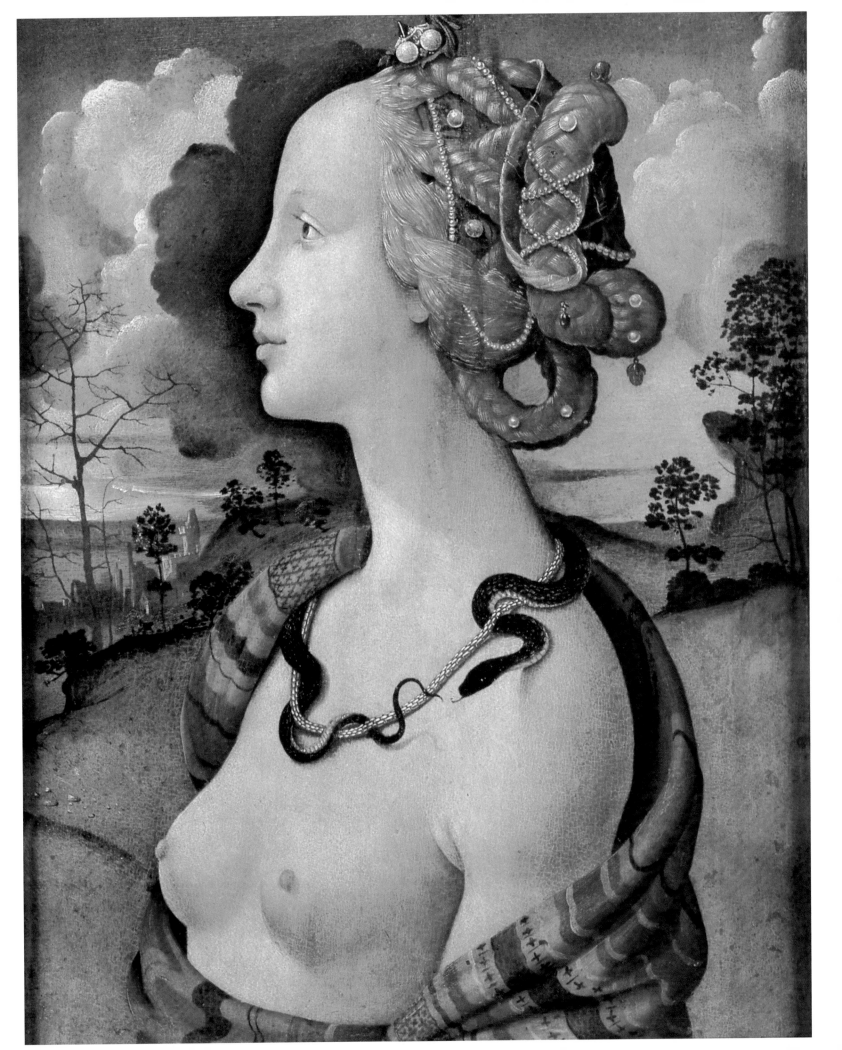

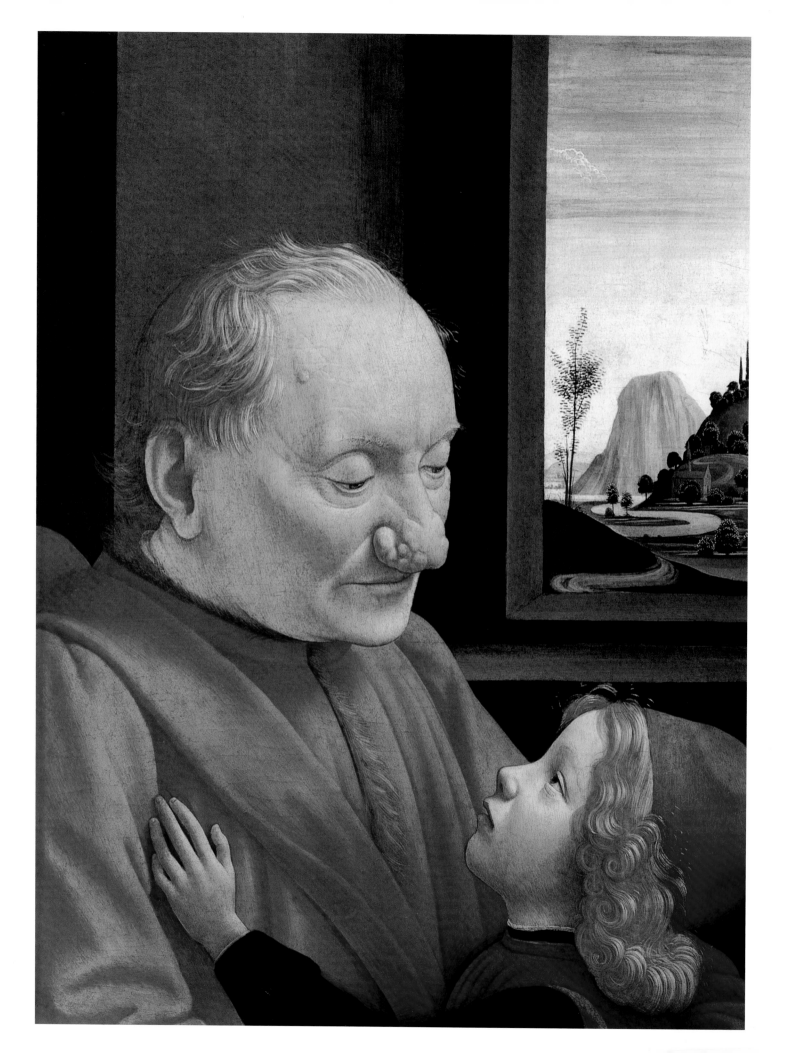

technique with oil-paint that originated in the Netherlands. Signorelli also worked in Rome for some years, where in 1481/1482 he painted the fresco with *The Testament and Death of Moses* in the Sistine Chapel. In Venice, Jacopo Bellini, the father of the famous Gentile Bellini became his student. Among Jacopo's main work is the altar with the *Adoration of the Magi* (1423) as well as frescoes, of which only one *Madonna* (1425) has been preserved in the Orvieto Cathedral.

Another Umbrian painter was Lehrzeit Perugino (around 1448 to 1524). Although he was one of the most important masters of Umbrian style and thus held in high esteem by his contemporaries, he achieved greater significance as a teacher of Raphael, whose first stage of development he had a crucial influence on, than as an artist in his own right. Perugino later also had close contact with the Florentine circle around Verrocchio. However he, only initially and very hesitantly, adopted the view of naturalism prevailing there, and preferred to remain true to his softer, successful style. This was because his contemporaries always demanded sensitive devotional pictures, which nobody except he knew how to paint with such a beautiful lustre of colours. In his paintings *St Sebastian* and *Madonna and Child enthroned with St John the Baptist* this becomes quite clear. The disadvantage of the popularity of his paintings was, of course, that it led to a mass production, during which even the expression of the greatest heavenly rapture became a cliché. But the series of frescoes he painted in the Sistine Chapel from 1480 with, among others, *Christ gives Peter the Key to the Kingdom of Heaven* or the altar with *Adoration of the Child* (1491), or the *Vision of St Bernhard* (around 1493), which was probably painted for the Cistercian church del Castello in Florence, belong to the absolute masterpieces of religious paintings. But he also became familiar with ancient art.

However, in these classical portrayals his student Bernadino Pinturicchio (1455 to 1513) was far superior to him. In 1481 to 1483 he worked together with Perugino in the Sistine Chapel on frescoes with subjects from the Old and New Testament, but he also created his own frescoes, whose meticulous execution was reminiscent of miniature painting, in the Vatican Hall of Saints. This earned him the approval and goodwill of his clients, as well as did his well-developed sense for fitting out a large room in a unified, decorative style. This talent made him the founder of Renaissance decoration.

Apart from the Umbrian school, there were also schools in Padua, Bologna and Venice, which were of significance in the second half of the fifteenth century.

From the artists of these schools, Andrea Mantegna (1431 to 1506) is doubtlessly to be regarded as one of the greatest. Mantegna's greatness lies in the depiction of important characters that he mainly found in classical works of art. This enthusiasm for classical art, which he wanted to match, dominated Mantegna's life. He had been working in Mantua for the margrave Ludovico Gonzaga since 1460 and provided the

Domenico Ghirlandaio,
An Old Man with his Grandson, 1488.
Tempera on panel, 62 x 46 cm.
Musée du Louvre, Paris.

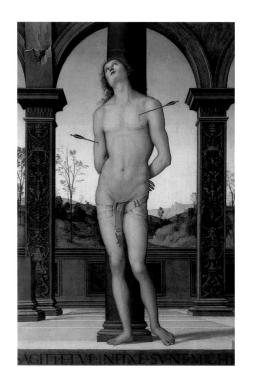

spouses' room with wall and ceiling decorations in their Castello di Corte in 1473 and 1474. In this work he proved his skills in perspective foreshortening in vault frescoes, and by far surpassed his professional colleagues in Florence regarding power and greatness of the characteristics. For a series of paintings destined for a room in the margrave's palace, he also proved his change of direction to the classics. More than once Mantegna demonstrates a certain sympathy for the "underdogs". One of the examples for this attitude is his dignified portrayal of the lower classes in religious pictures and the illustration of the prisoners in *Triumph of Caesar* (1488/1492). His art always remained directed towards the great and serious, and he only seldom moderated his harsh forms through pleasing gracefulness. Examples for this are among others the *Madonna della Vittoria and John the Baptist* (1496) in which the kneeling Duke Francesco Gonzaga is being blessed, as well as the tempera painting the *Parnassus* (1497) with Mars and Venus on a fanciful rock throne with the muses dancing in front and Apollo's string playing. Mantegna's revival of classical antiquity was so convincing that it even cast its spell over Raphael.

Whilst Gentile Bellini is more of an art historian, Giovanni continued the artistic lines of his father and brother-in-law Mantegna. Giovanni Bellini's favourite subject was without doubt the Madonna, portrayed alone, with child or sitting enthroned as a Madonna surrounded by saints. In these figures, as well as old and young or male and female figures he created types of beauty, which have not been surpassed in their rapturous emotional state of mind. In the composition of the colouring there is always a harmony reminiscent of music, and this element of life, indispensable to Venetians, is not missing on any of the Bellini altarpieces. In contrast, many devotional pictures of the Florentines and Paduans originating from this time seem austere and stern, and those of the Umbrian painters detached and tearful. They were all much less likely to evoke devotion than the paintings of the Venetians.

In the colourful art of the Early Renaissance, represented by Bellini, we can already feel the transition to the High Renaissance approaching that was then actually made by his students, and in his mythological paintings he had already thrown open the door to the High Renaissance.

The Italian High Renaissance

In Italy, art flourished and reached its highest peak with the three unsurpassable masters Leonardo (1452 to 1519), Michelangelo (1475 to 1564) and Raphael (1483 to 1520). They have left an inestimable treasure for future generations. Once again, Florence was indeed a starting-point, but not the only scene for this development. Leonard soon left for Milan and Michelangelo and Raphael worked in Rome.

Perugino (Pietro di Cristoforo Vannucci),
St Sebastian, c. 1490-1500.
Oil on wood, 176 x 116 cm.
Musée du Louvre, Paris.

Andrea Mantegna,
St Sebastian, c. 1455-1460.
Tempera on wood, 68 x 30 cm.
Kunsthistorisches Museum, Vienna.

Andrea Mantegna,
Mars and Venus, c. 1497-1502.
Tempera on canvas, 150 x 192 cm.
Musée du Louvre, Paris.

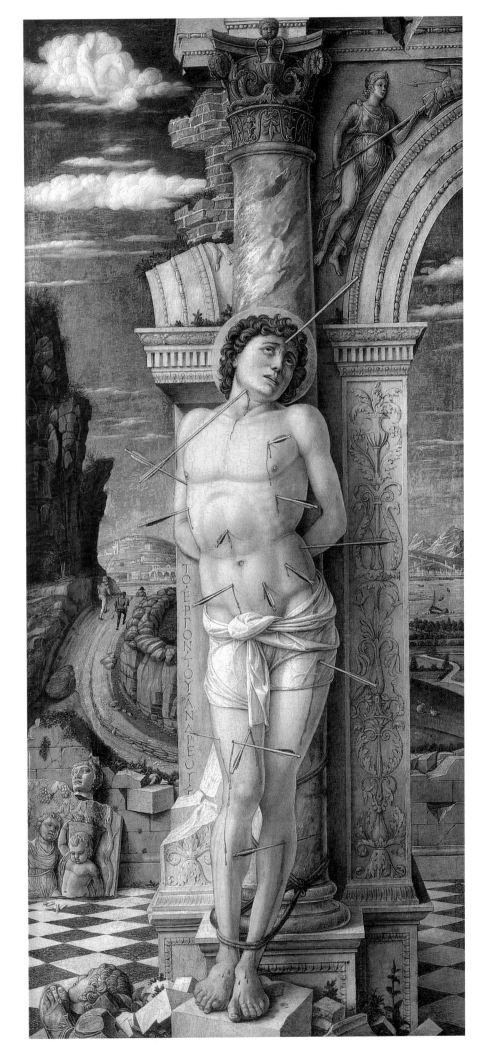

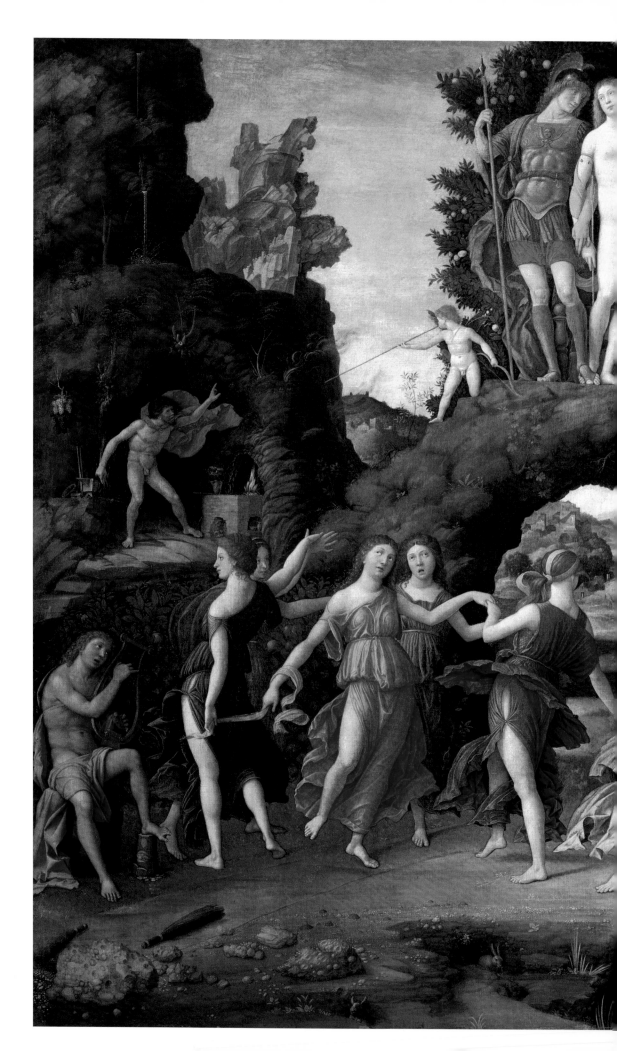

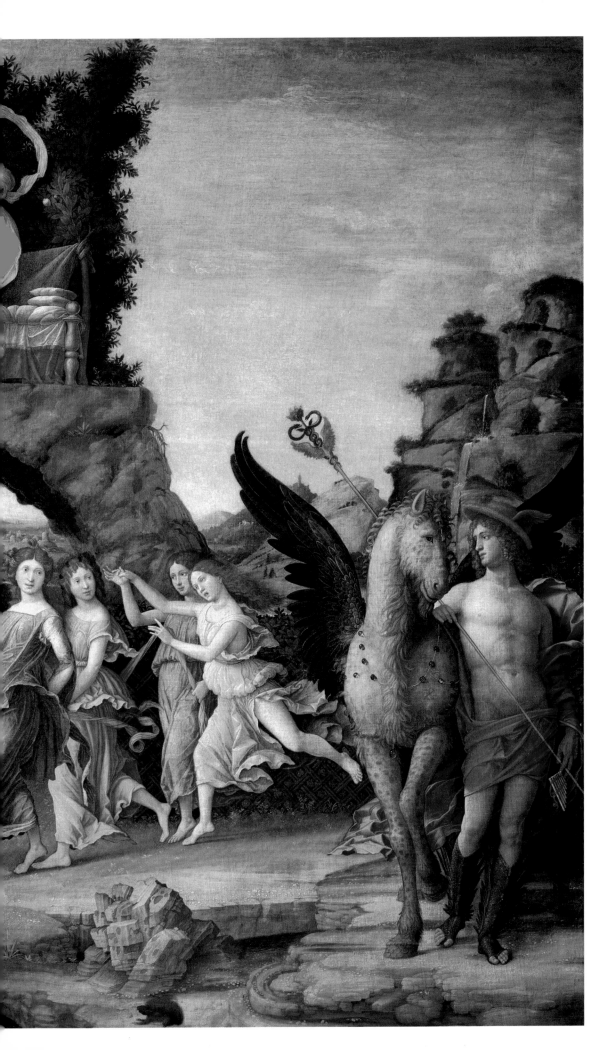

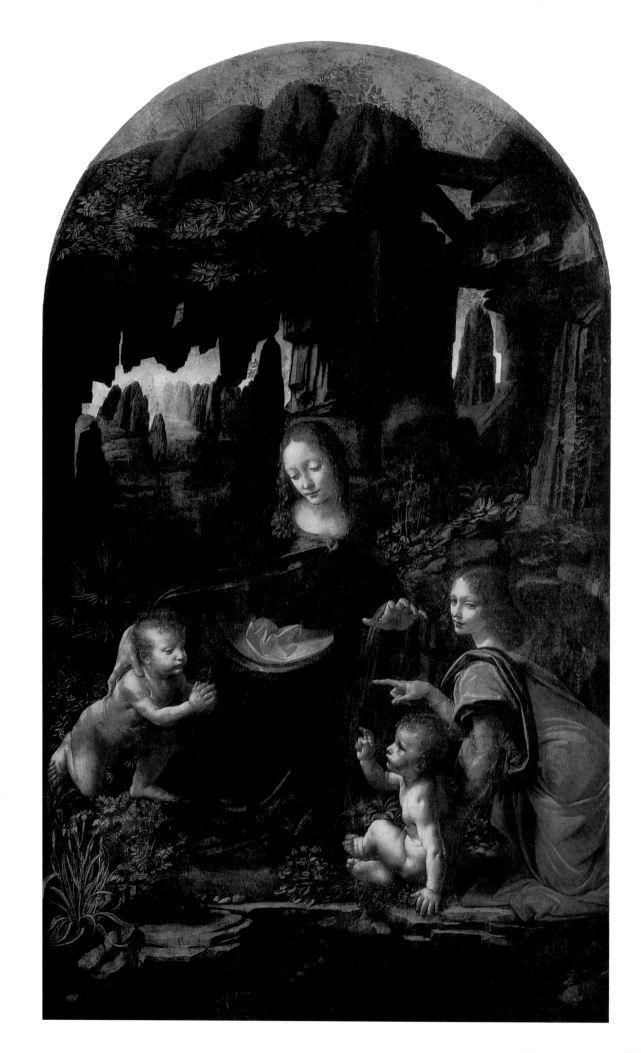

Leonardo da Vinci

Leonardo started his apprenticeship with Andrea del Verrocchio in approximately 1469, and was accepted into the master guild in Florence in 1472. How soon he was his master's equal can be recognised in the *Baptism of Christ* (around 1475), with the angels and parts of the landscape he painted into the picture. Even at that time, his view of nature differed, due to the size of the structure of the form and his characteristic of the performances, which were seen as the peak of Florentine art. But the large picture handed over to him after he had completed his apprenticeship, an *Adoration of the Magi*, intended for a monastery church, was not finished. He really wanted to surpass all reputable Florentine artists with this painting; his plan never went further than the first undercoat of paint, despite many thorough preliminary studies. Even if his tendency as a painter and sculptor dominated, he also worked as an art theoretician and left behind many significant objects as an inventor and naturalist, as an architect, master builder of fortresses and a designer of engines of war. In the end, Leonardo's creative power was no match for this universality, so later in his life, the completion of his pieces of work that had been prepared with a great deal of time, was occasionally at risk. Florence quickly became too constrictive for him, so that very soon he took an appointment to Milan to the court of Ludovico Sforza (1452 to 1508). His absolute masterpiece, *The Last Supper* (1495/1497) had to be restored for the first time as early as the sixteenth century, as it was subject to extensive decay, partly due to his appetite for experimenting, partly to climatic influence and wilful destruction. The gestures of his apostles, scenically arranged and summarised in a billowing movement, stand for his demand to depict "the intention of the soul" through movement.

The end of Ludovico Sforza's reign was a catastrophe for Leonardo. He managed to save himself in time, and spent the years from 1499 to 1506 alternating between Florence and Venice and some other towns of the Romagna. He worked three years on his other absolute masterpiece, the picture of the genteel Florentine lady (Madonna) *Mona Lisa* (1503/1505), the wife of Francesco del Giocondo, and when they finally took it away from him, he explained that he had not finished it yet. Here, the atmosphere nestles around all forms, taking away any hardness and dissolving the sharp sculpture into a gentle blending together of all contrasts of colours and forms. This is where the great revolution, which broke new ground for painting, took place.

In 1506, Leonardo travelled to Milan again and, apart from short interruptions, stayed there for ten years. During this time, Leonardo dedicated himself to his students and, increasingly, to his scientific studies and research. It is hard to comprehend the number of subjects in the various technical fields across which Leonardo occupied himself.

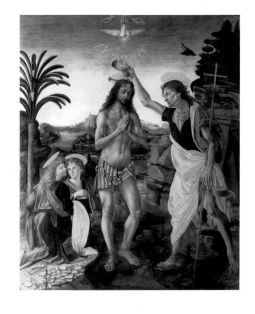

Leonardo da Vinci,
The Virgin of the Rocks, 1483-1486.
Oil on panel, 199 x 122 cm.
Musée du Louvre, Paris.

Leonardo da Vinci and **Andrea del Verrocchio,**
The Baptism of Christ, 1470-1476.
Oil and tempera on wood panel,
177 x 151 cm.
Galleria degli Uffizi, Florence.

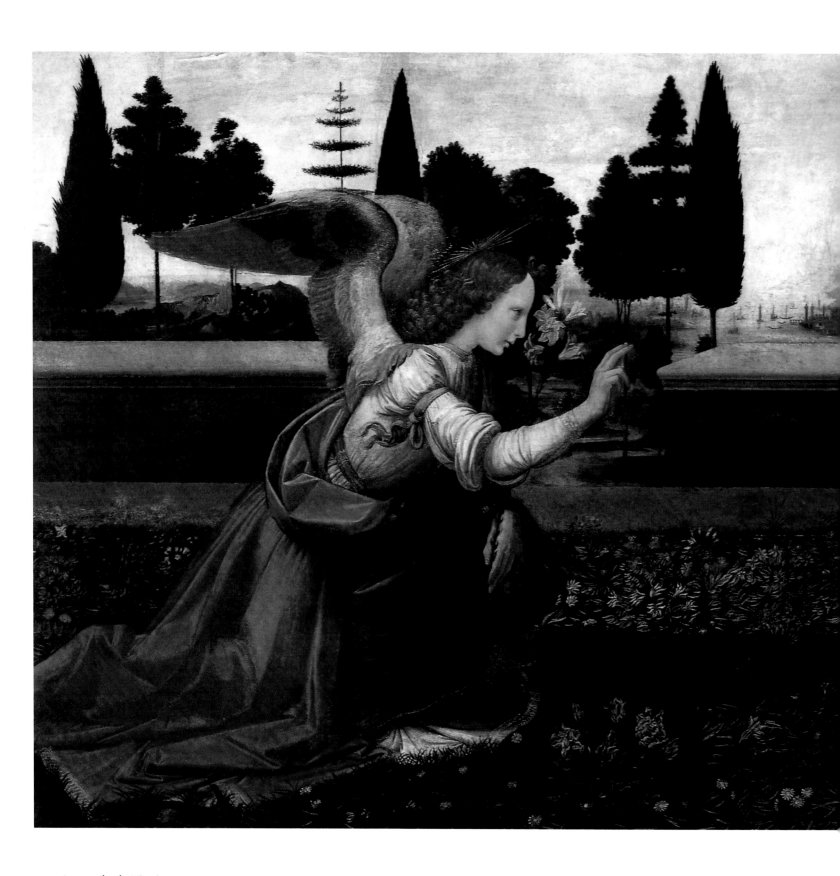

Leonardo da Vinci,
The Annunciation, 1472-1475.
Oil on wood panel, 98 x 217 cm.
Galleria degli Uffizi, Florence.

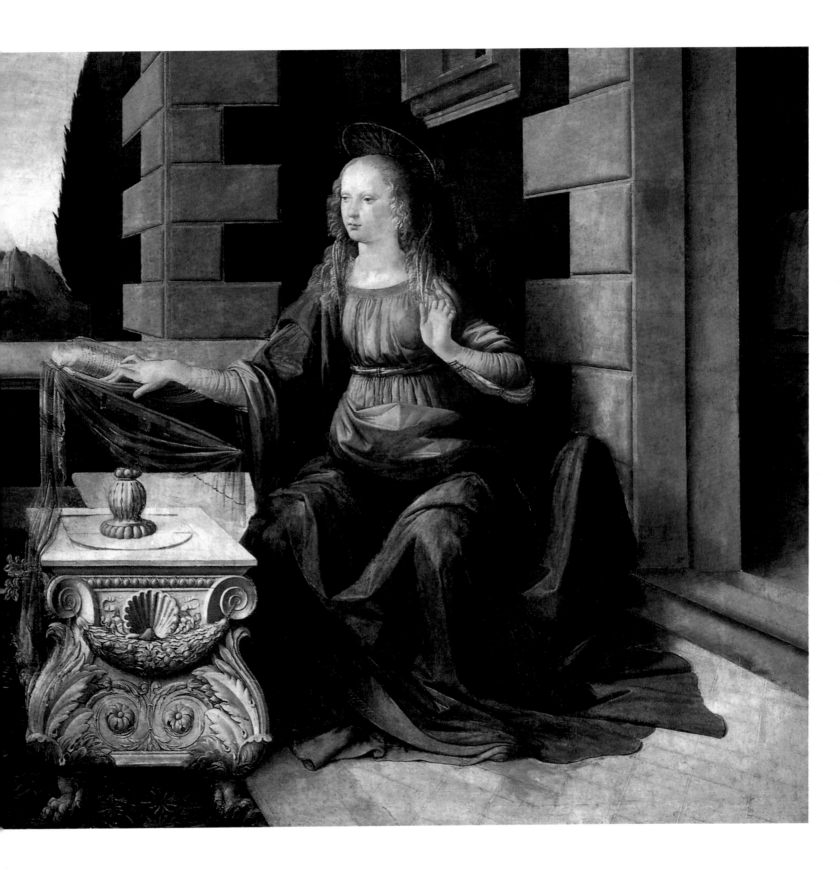

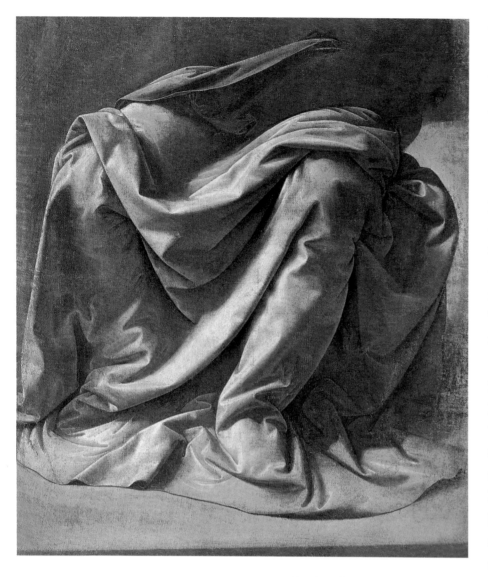

Among the drawings he left – the *Codex Atlanticus* alone contains 1,119 – there are ideas for a rope producing machine or float to walk on water, a suggestion for a bridge that could be put up quickly, for a canon on a gun-carriage, for a parachute, for a (wind up) automobile, which, as experts found out, really works, and many more other indescribable things. The approximately 1000 sheets of the three-part *Codex Forster* contain drawings for hydraulic machines, theories on proportions and mechanics, notes on architecture and urban studies. A third Codex, the *Codex Arundel*, comprises in more than 280 sheets of drawings, of tanks and projectiles. Then there is a book on the human body, one on flights of birds, and, in the *Codex Madrid* with its 140 sheets, Leonardo deals with subjects such as painting, architecture, maps of Tuscany, as well as problems in geometry and mathematics and other things. And, regarding his 780 drawings on anatomy, it is quite appropriate that a British heart surgeon adopted these notes in 2005 and changed his operating technique accordingly. This listing is by no means complete and can only convey an approximate idea of Leonardo's incredible spectrum of interests and skills.

During his years in Milan, the only painting that was finished was a youthful *John the Baptist*. In his studies of male and female heads he paid tribute, at least with the female heads, to the smile and often also beauty, and captured the range of expressions from grace and beguiling charm to proud dignity and arrogance. For the male heads, however, he captured more of the individual characteristics, which he then even sometimes exaggerated as caricatures. Such caricatures, with hideous, distorted features, found unusual approval and even turned up as copper engravings. Perhaps Leonardo had grown tired of his homeland despite all of his success, perhaps he simply wanted to avoid further confrontation with the younger Michelangelo – whatever the reason, he accepted the invitation and at the beginning of 1516 followed the king, who provided him with a flat in the Palace of Cloux near Amboise. There, no longer creative, but only giving advice in artistic matters, he spent the last years of his life and died on 2 May 1519.

Leonardo da Vinci,
Drapery Study for a Sitting Figure, c. 1470.
Pen, grey tempera and white highlights,
26.6 x 23.3 cm.
Musée du Louvre, Paris.

Leonardo da Vinci,
The Virgin and Child with St Anne, c. 1510.
Oil on wood, 168 x 130 cm.
Musée du Louvre, Paris.

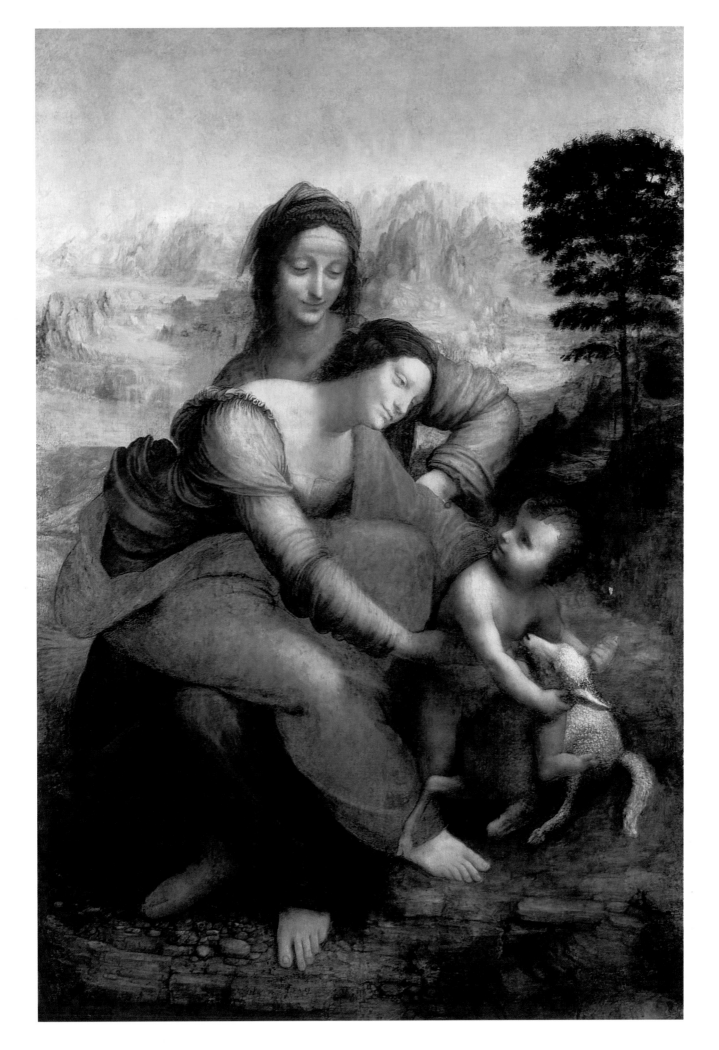

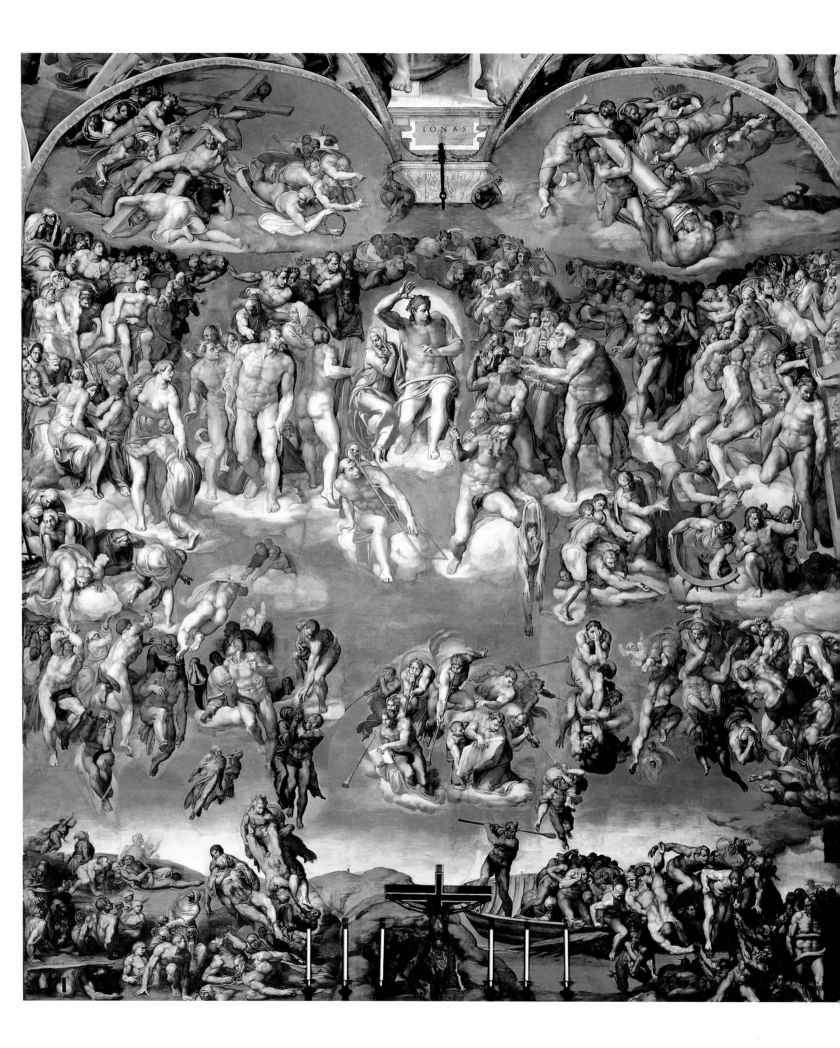

Michelangelo Buonarroti

The universal artistic talent of Michelangelo, the other Grand Master of Italian Renaissance, is equal to that of Leonardo. Although he cannot measure up to Leonardo, particularly in the field of natural history, he far surpassed him as a poet and philosopher. Michelangelo's life also includes tragic complications, which have left their traces in his work. Just as Leonardo, who was born to paint but also nursed an ambition to create great sculptural work, Michelangelo, the greatest sculptor since Phidias, was convinced that he could do great things as a painter and architect. As an architect and master builder, his greatest piece of work was the dome in St Peter's, as a painter he left examples of art, which even today require the utmost admiration, especially when taking into account that his moods, arbitrariness and impetuous temperament now and then spoilt the boldest drafts.

His life was just as restless as that of Leonardo's. He went to Bologna in 1494, after having provided the first samples of his artistic talents with the high relief of a centaur fight and a Madonna in front of a staircase. There he created a kneeling angel carrying a candelabrum and a statuette of *St Petronius* for the Basilica of San Domenico. But then, in 1496, he returned via Florence to Rome. For a merchant, he made a life-size statue of *Bacchus* (1496/1498), who, obviously already merry on wine, raises the wine cup with his right hand, whilst his left hand takes hold of the grapes, offered him by a small satyr, standing behind him.

In his second great piece of work in Rome, the *Pietà* (1499/1500), found in St Peter's, the classical influence completely disappeared, both as far as Christ's body and his facial expression are concerned, and in the composure of the Mother of God, conquering her pain. Michelangelo moved back to Florence in 1501, in order to start his, so far, greatest task. The chairmen of the Cathedral had provided a marble block for the execution of a large statue, and Michelangelo decided to depict the young *David* (1501/1504), as he takes the sling from his left shoulder, whilst the right hand already has the stone ready. None of Michelangelo's other pieces of work achieved this kind of popularity. With his first significant painting the tondo *The Holy Family* (1501), he wanted to demonstrate his firm determination to break with traditional composition and the previous portrayal of the figures. Furthermore, he wanted to show that and how movement could be included in a small sized picture.

Pope Julius II (1443 to 1513) summoned Michelangelo to Rome in 1505, entrusting him with the design for his tomb. A different commission from Julius II was completed during his lifetime: decorating the ceiling (1508/1512) of the Sistine Chapel with a number of pictures, which in rigorous structuring and grouping, through a painted architectonic frame, depict the creation of the world and mankind as well as the Fall

Michelangelo Buonarroti,
The Last Judgment, 1536-1541.
Fresco, 12.2 x 13.7 m.
Sistine Chapel, Vatican.

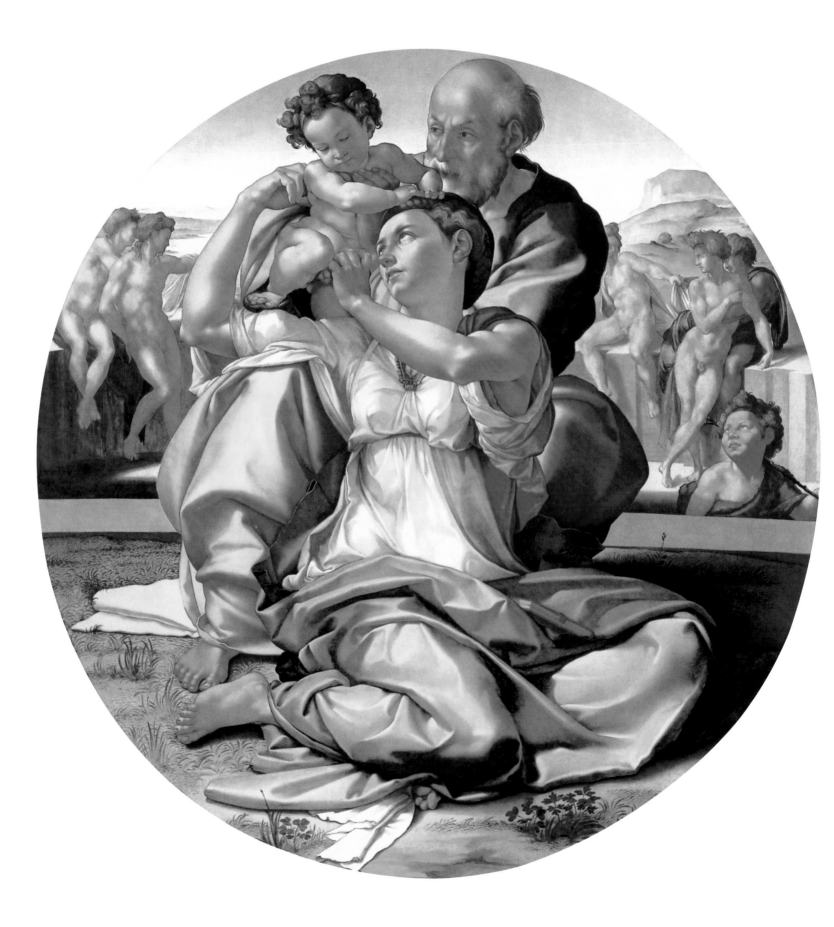

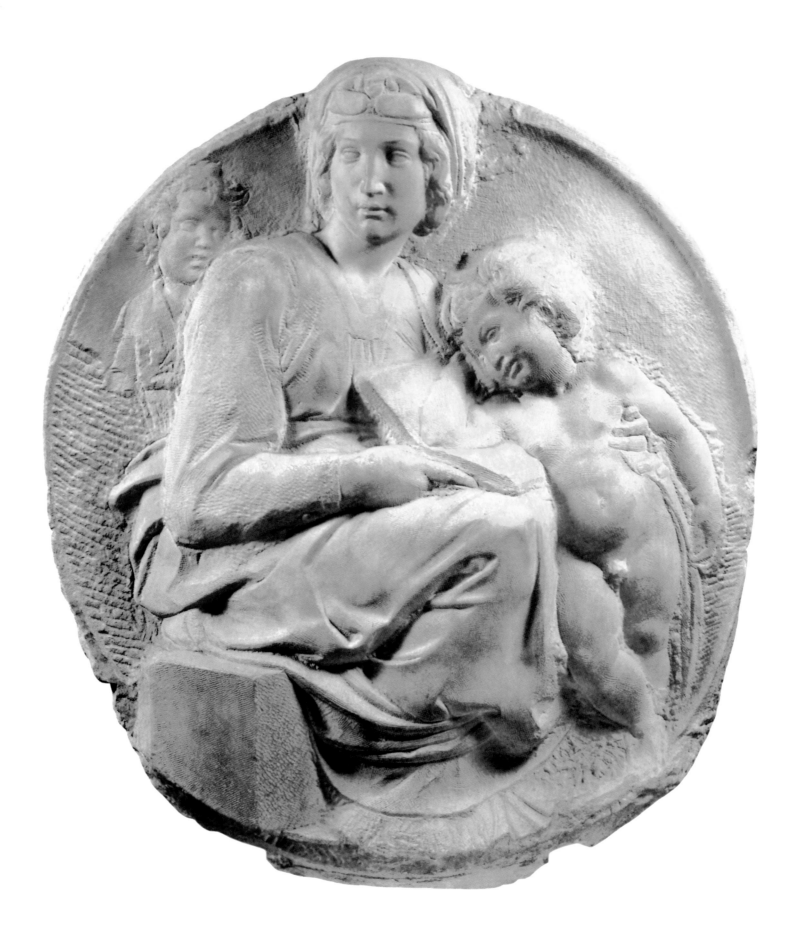

of Man and its consequences. After the manifold fates of the Israelites, *The Fall of Man* was to be followed by the redemption, and the redeemer even come from its midst. The powerful figures of the prophets and the sibyls prepare for this, which surround the mirror of the ceiling vault and the transition between it and the vault pendentives on all sides. These paintings are perhaps only comprehensible to the individual when he reduces them to their parts and looks at each picture in itself, only then will the abundance of beauty which may find its best expression in the *Creation of Eve* (around 1508) be fully revealed. The ceiling paintings were completed with *The Last Judgment* (1536/1541). This painting is doubtlessly the greatest piece of work of the Italian High Renaissance, which, through its superabundance of figures and the guidance of their movement, prepares for those exaggerations which developed in the Late Renaissance and in the Baroque period. In all these figures Michelangelo made one thing clear: to reveal his uncompromising will; his absolute control of the anatomy of the human body in such a way that no other artist before or after him could counter with anything. With the contempt for humanity, which became second nature to him in his late years, he wanted to force all artists around him, friends as well as opponents, to look to him in admiration. That is why in Michelangelo's work the human being can never be separated from his work. He thus considered himself the measure of all artistic matters.

Among his work are also the marble Medici tombs in the Florentine Chapel near the church of San Lorenzo. Originally planned as the tomb of the entire Medici Family, only a small, laborious and frequently interrupted part of this great project by Michelangelo, who also created the architectonic design of the chapel (1519/1534), was realised. Only the two statues of the dukes Giuliano Lorenzino, who was murdered in 1547, were finished by Michelangelo, so that they could be put up in the quadrilateral chapel in 1563.

Fate did not look upon Michelangelo the master builder very favourably either, though he was awarded the greatest task commissioned in Rome at that time: the construction of St Peter's Cathedral. Pope Julius II had had the old basilica demolished, in order to erect an imposing new building in its place. Donato Bramante, who had been commissioned with the design and execution, intended a ground-plan in the shape of a Greek cross and a mighty dome above the crossing. When he died in 1514, only the four dome pillars with their connecting arches had been completed.

Michelangelo reached old age. He died at the age of 89, on 18 February 1564 in Rome. But the Florentines demanded his body and he was entombed in the Pantheon of their illustrious men, in the Basilica of Santa Croce.

Like Leonardo, Michelangelo also surrounded himself with numerous students and passed his knowledge on to them.

Michelangelo Buonarroti,
Holy Family (Tondo Doni), c. 1504.
Tempera on wood, diameter: 120 cm.
Galleria degli Uffizi, Florence.

Michelangelo Buonarroti,
Virgin with Child and St John the Baptist as a Child (Tondo Pitti), 1504-1505.
Marble, 85 x 82.5 cm.
Museo Nazionale del Bargello, Florence.

Michelangelo and **Giacomo della Porta,**
St Peter's Basilica, Drum of the Cupola (North-West view), 1546-1590.
St Peter's Basilica, Rome.

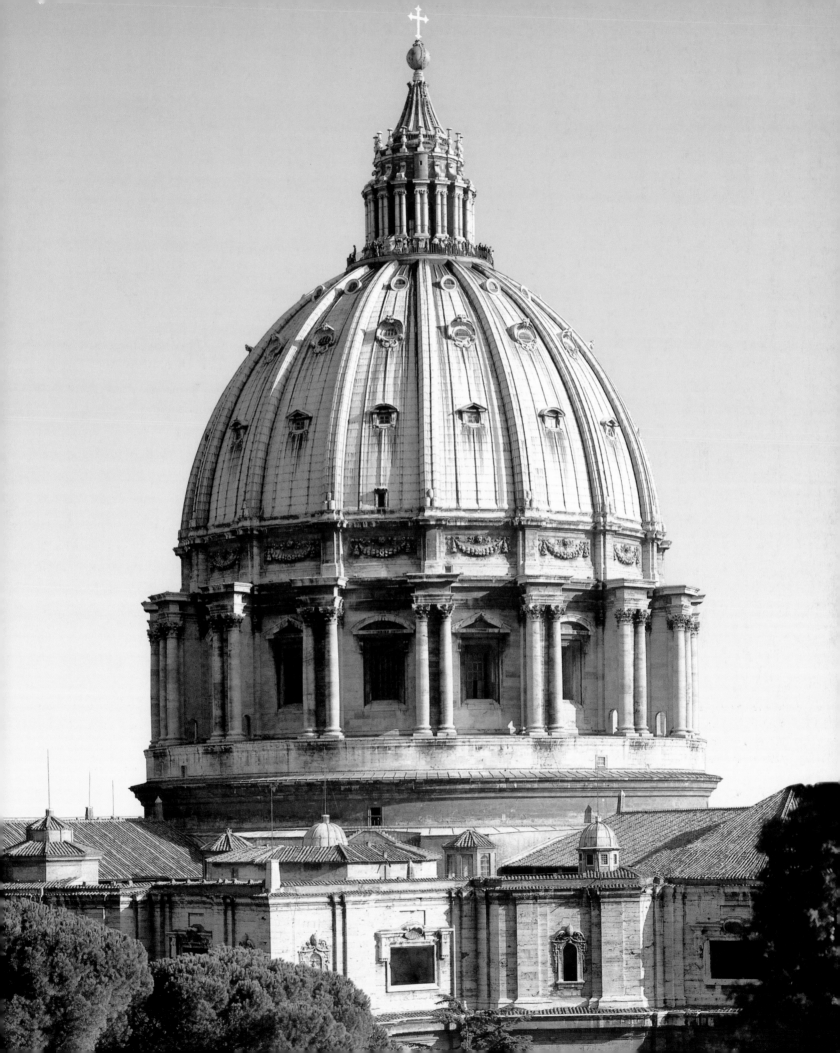

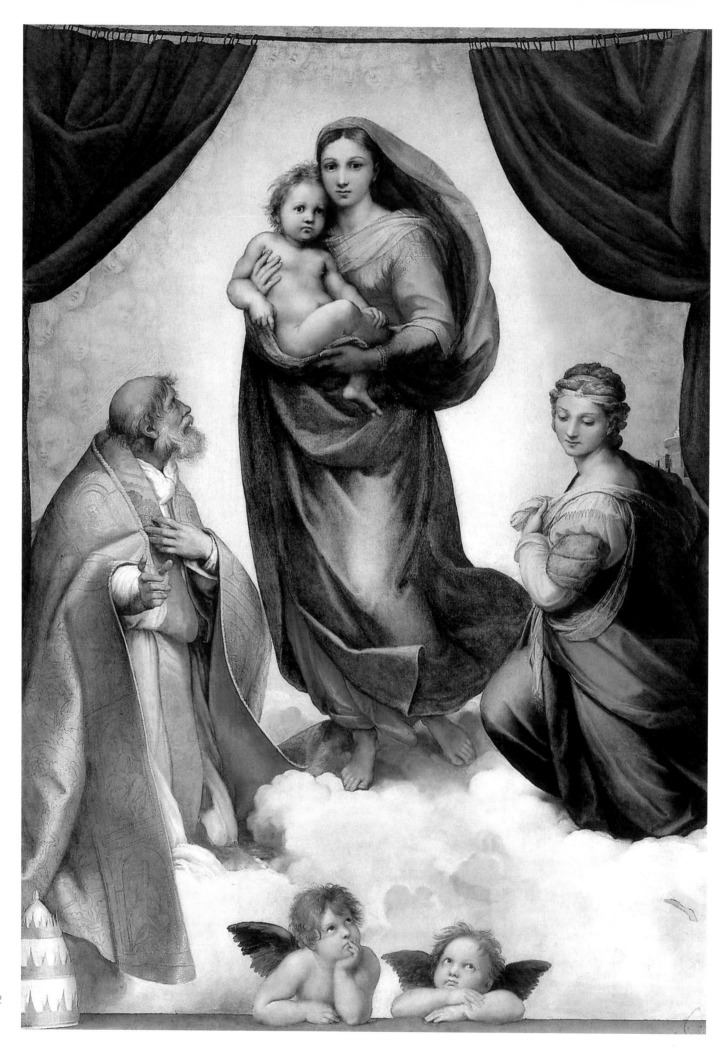

Among the sculptors who were not under Michelangelo's influence, it is primarily Andrea Sansovino (around 1460 to 1529) and Benvenuto Cellini who stand out. The former was trained by Antonio del Pollaiuolo in Florence, but also worked in Portugal, Rome and in Loreto as a master builder for churches, where he was occupied with decorating the Casa Santa from 1514 to 1527. Among his work is the marble group above the main portal of the baptistery *The Baptism of Christ* in Florence, the *Group of St Anna Selbdritt* in Rome's San Agostino, and the two tombs of the cardinals Basso and Sforza Visconti in Santa Maria del Popolo.

The goldsmith Benvenuto Cellini (1500 to 1571) worked for the popes in Rome, for the Medici in Florence and for King Francis I in France, for whom he created the famous *Saliera*, the rather unwieldy *Salt Cellar* (1540/1543). Another piece of work proves that Cellini was also an excellent sculptor is the bronze figure of *Perseus* (1545/1554), who is holding up the decapitated head of Medusa, which is standing in the Loggia dei Lanzi.

Raphael

The third in the series of Grand Masters of the Italian High Renaissance, Raffaello Sanzio, who was born between 1483 and 1520, the son of an Umbrian painter and who was a man with universal talents. In Rome, he gained the favour of Pope Leo X (1475 to 1521), a fact which also brought him the highest regard. He did not only work as a painter, but also as an architect and sculptor, and wrote, similar to Michelangelo, some sonnets. As an architect, Raphael developed plans for several palaces and villas, such as for the Palazzo Pandolfini in Florence, the Villa Madama near Rome or the Villa Farnesina, whose execution, however, was left to other master builders. As the architect of St Peter's Cathedral, Raphael did indeed submit a plan. The sculptural work allocated to him only materialised into preliminary work using clay outlines, and it was subsequently executed by marble sculptors.

The focus of his early work is portrayals of the Madonna. The political uncertainties in Florence resulting in a lack of commissions, forced Raphael, like Leonardo, Michelangelo and many other Florentine artists, to leave the town. He began with the first papal apartment, in which the Pope carried out his governmental acts, and in which the highest court of the Holy See, the Segnatura Gratiae et Iustitiae, had its sessions. It contains the wall frescoes the *Disputà* (1509/1510) with the portrayal of a meeting of the Fathers of the Church discussing supernatural truths, *The School of Athens* (1510/1511), depicting a meeting of Greek scholars and philosophers, and the *Parnassus* (around 1517/1520) with Apollo, playing the violin, surrounded by the nine muses. The frescoes in the vault complement the wall frescoes

Raphael (Raffaello Sanzio),
Sistine Madonna, 1512-1513.
Oil on canvas, 269.5 x 201 cm.
Gemäldegalerie, Dresden.

Raphael (Raffaello Sanzio),
The Madonna of the Goldfinch, 1506.
Oil on wood panel, 107 x 77.2 cm.
Galleria degli Uffizi, Florence.

Raphael (Raffaello Sanzio),
Portrait of a Young Girl also called *The Lady with a Unicorn*, 1506.
Oil on wood panel, transferred to canvas, 65 x 51 cm.
Palazzo Pitti, Florence.

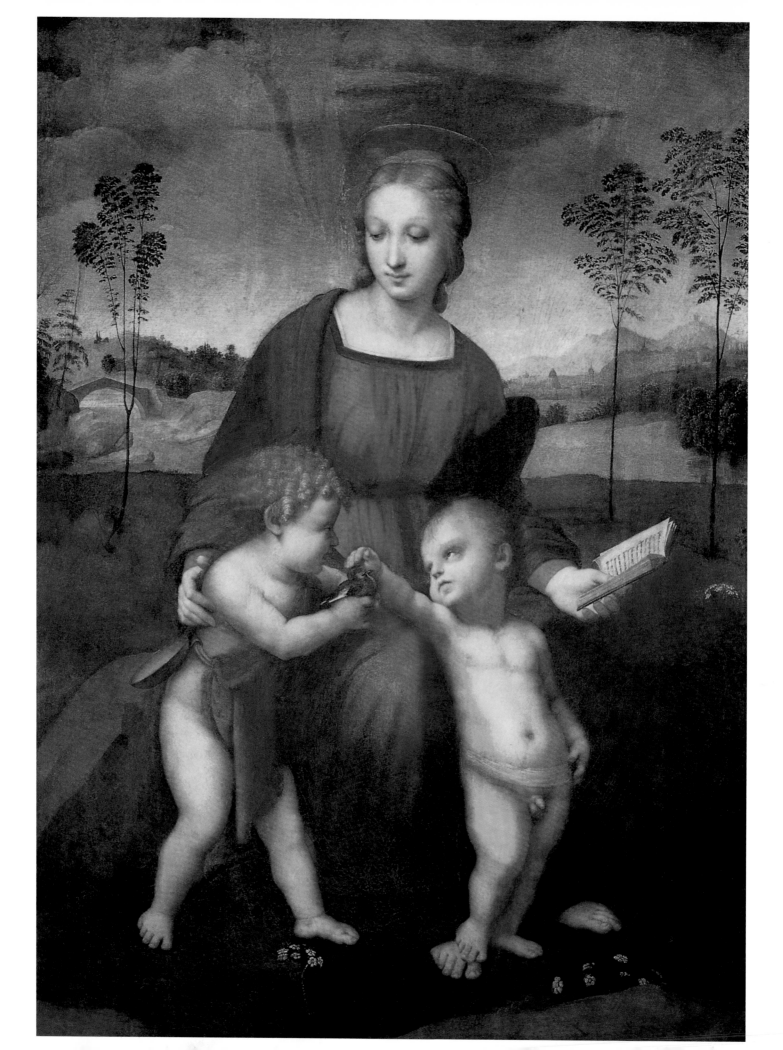

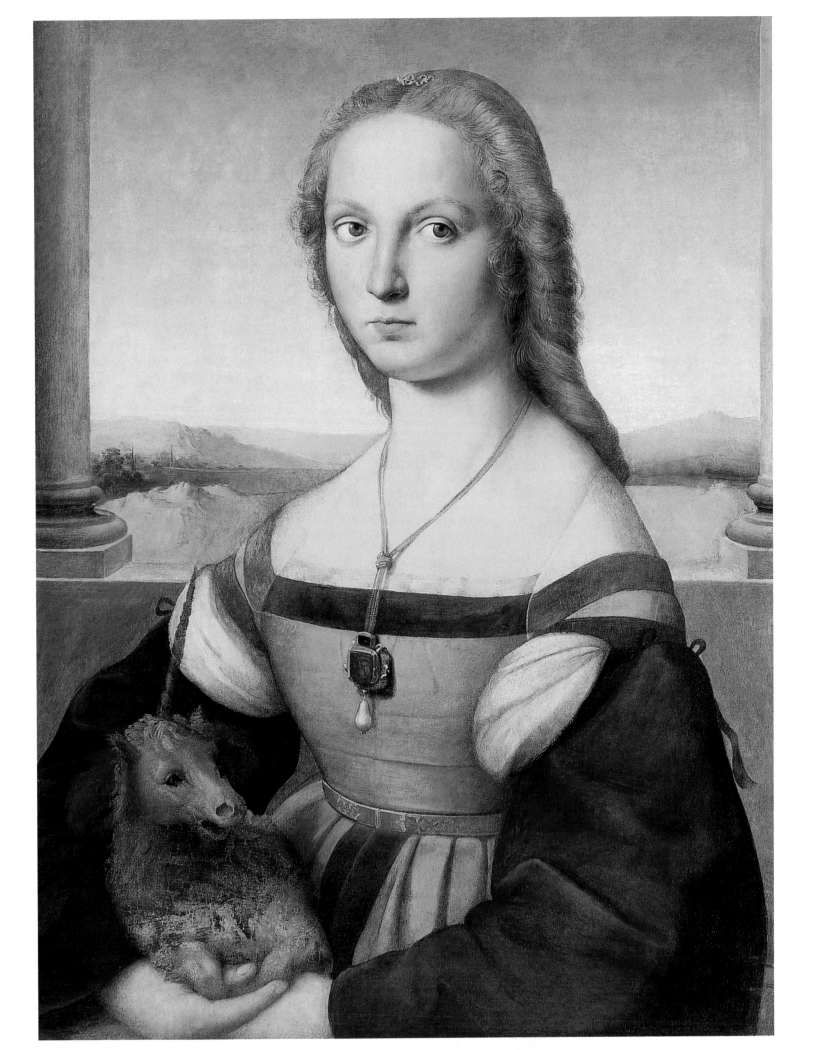

and show the *Law, Poetry, Theology and Philosophy*, which are each embodied through female figures surrounded by two angels. Julius II died on 21 February 1513. His successor, Leo X, who loved splendour and magnificence, continued the tradition, making great demands on Raphael, who was now not "only" a painter, but was also appointed master builder of St Peter's Cathedral, in 1514. As a painter, Raphael covered the entire field of his art and performed great work. This also applies to his portrait-painting, where he gave calm and objective, psychologically captivating and historically valuable documentation, thereby painting a picture of his time. He was not a flatterer, or else he would not have painted such lifelike portrays of the ungainly Leo X or the squinting prelate, Inghirami.

As a drawer, Raphael was no less diligent than Leonardo or Michelangelo. He painted because he wanted to gain absolute confidence with each posture and movement of the human body, each figure – even his Madonnas were based on a nude model, before they were provided with clothes. The *Sistine Madonna* (1513) also depicts the beauty of an absolutely normal person heightened to the extreme – perhaps even of a woman close to him. He left us her image with *La Donna Velata*, the woman with the veil (around 1512/1513). In contrast, *La Fornarina* (1518), the baker, originating from Raphael's workshop, was probably his lover. However, *St Cecilia* (1514) is of the same standard as the *Sistine Madonna*.

Painting in Middle and Upper Italy

While there was a decline in the quality of Roman painting, Venetian painting had reached its peak. Further, artists were also working in Parma, Siena, Florence and Ferrara producing work close to those three Grand Masters. In Florence, there was one primary person in our field of interest: Andrea d'Agnolo, who, owing to his father's tailoring trade, was renamed Andrea del Sarto (1486 to 1531). He made his way from early on and developed into the greatest colourist in sixteenth century Italy. Andrea del Sarto proved that painting could also produce those powerful effects that so far had been reserved for drawings and the composition of figures. These great colouring skills, which had the effect of a revelation in Florence, were combined with a seriousness and greatness of composition were reminiscent of Fra Bartolommeo as far as the architectonic structure was concerned, of Michelangelo regarding the movement of the figures as well as the arrangements of the folds, but at the same time were something completely new, given the magic of the beguiling colouring. This becomes especially apparent in the portrayals of the famous *Madonna of the Harpies* (1517), enthroned between saints. How soon del Sarto had detached himself from his teachers and role models, can be seen from the *Annunciation* (1513). Although he loved

Raphael (Raffaello Sanzio),
Madonna of the Chair, 1514-1515.
Oil on panel, Tondo, diameter : 71 cm.
Palazzo Pitti, Florence.

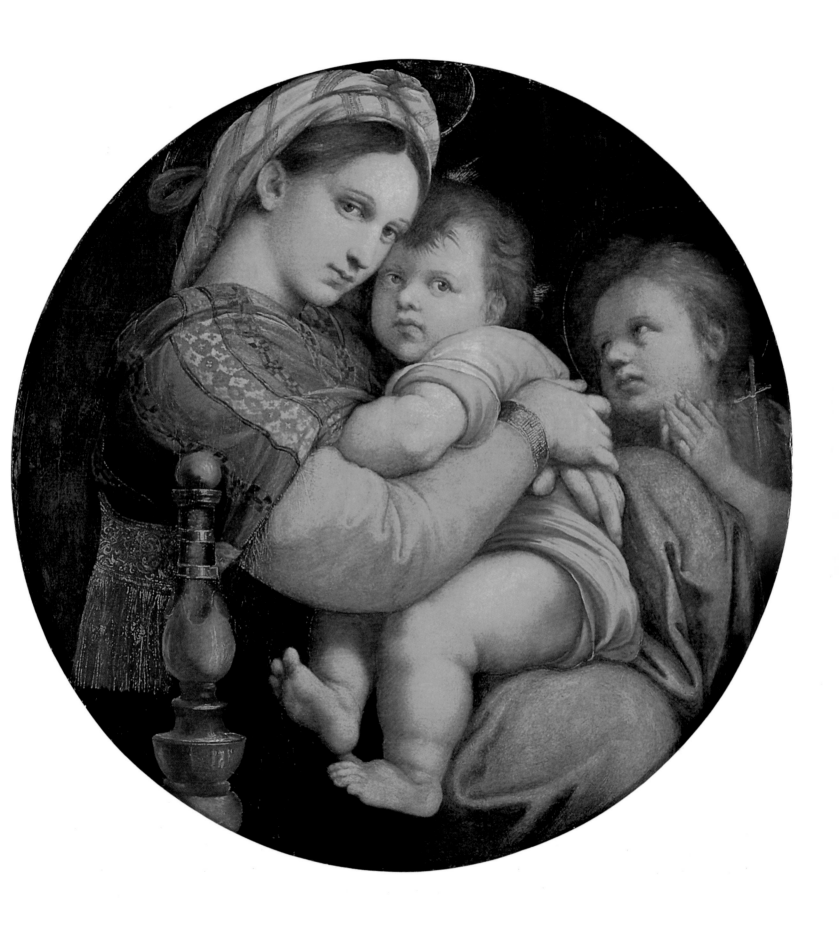

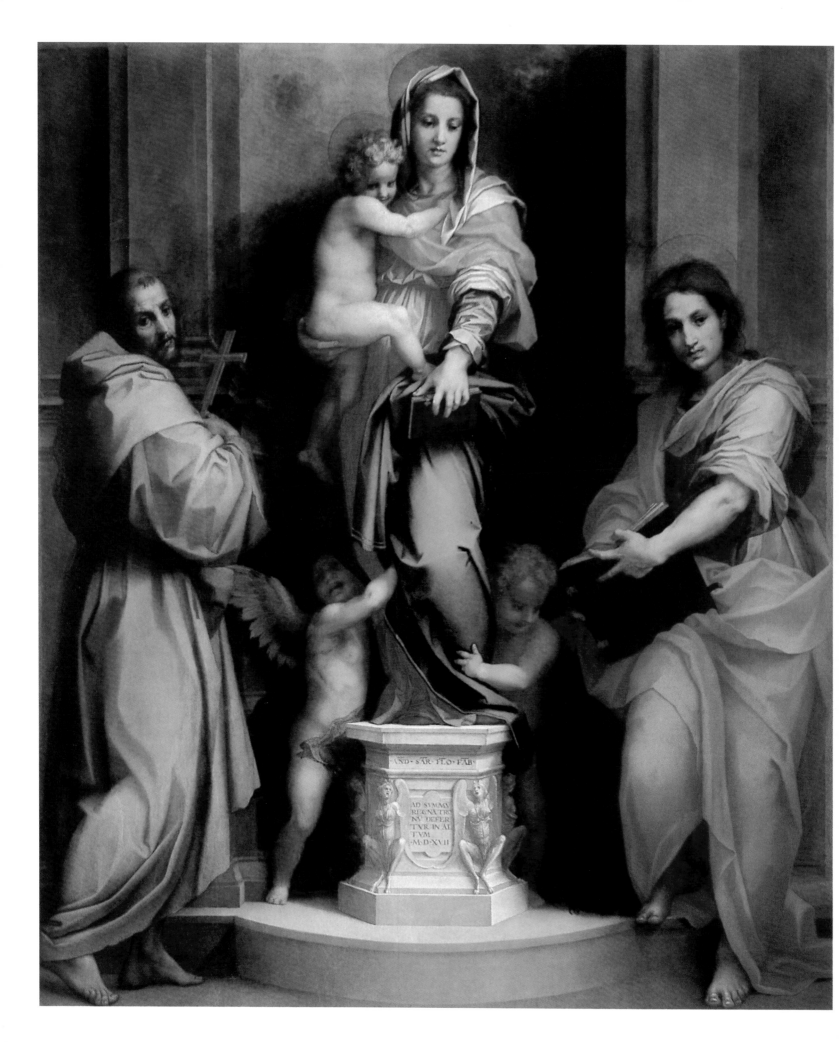

the women's pride in his pictures, he did not heighten it to arrogance. This can also be recognised from his frescoes, with which he decorated the portico of the Annunziata and the cloister of the monastery dello Scalzo with ten pictures from the *Life of John the Baptist* (1511/1526). In at least two of his major pieces of work, the *Madonna del Sacco* (*Madonna with the Sack*, 1525), which has its name from Joseph leaning on a sack and the *Last Supper* in the refectory of the monks in the monastery of San Salvi, he not only came close to the Grand Masters in terms of colour but also in the monumental effect of his frescoes.

However, next to the three Grand Masters of the Italian High Renaissance a fourth should be named: il Correggio, whose name was actually Antonio Allegri (around 1489 to 1534), but who became famous and popular as Correggio. He brought the holy figures close to the people like no other Italian painter, for his figures invite the devout with friendly gestures to join them. This approach to the people is also the basis of the magic in *Adoration of the Shepherds* (*The Holy Night*, 1529/1530). His greatest achievement, however, lies within his sense of reality, in the way he visualises the people in the picture, so that they really seem to be moving. He adopted what he heard of this style from Leonardo, Mantegna and perhaps also from or about Titian. He adopted this new learning so fast that in his main piece of work *Madonna with St Francis* (1515), he can be found as an artist with a personal style. In 1518, Correggio moved to Parma and worked there for almost twelve years. During this time he dissolved the strict symmetry of the traditional compositional patterns into light and movement, the divine majesty becomes the fair giver of mercy, surrounded by rejoicing angels and saints. *The Madonna with St Jerome* (*The Day*, 1527/1528), the pendant to *Adoration of the Shepherds* (*The Holy Night*), and the *Madonna with St Sebastian*, as well as the *Madonna with St George* illustrate the main stages of this development. The progress of his art becomes even more apparent in his frescoes. Thus, the dome painting in San Giovanni (1520/1521), showing Christ ascending to heaven, the apostles sitting below him, is already a genuine Correggio.

What Corregio had managed to do excellently was to further intensify the decoration of the dome, by his depiction of Mary in the *Assumption of the Virgin*, encircled by rejoicing heavenly hosts with the Archangel Gabriel coming to meet her. This picture is full of movement, full of entwinements and correct foreshortenings. Correggio revealed a joyful world, and the urge for beauty revealed itself in full splendour in his mythological paintings. In his masterpiece *Danae* (1531/1532), he went exactly up to this borderline. The artistic skills revealed here also ennoble *Leda and the Swan* (1531), a rather voluptuous painting, *Io* (around 1531) according to the taste of that time and *Jupiter and Antiope* (1528).

Andrea del Sarto,
Madonna of the Harpies, 1517.
Tempera on wood, 208 x 178 cm.
Galleria degli Uffizi, Florence.

Correggio (Antonio Allegri),
Assumption of the Virgin, 1526-1530.
Fresco, 1093 x 1195 cm.
Cathedral of Parma.

Correggio (Antonio Allegri),
Vision of St John the Evangelist on Patmos, 1520.
Fresco.
San Giovanni Evangelista, Parma.

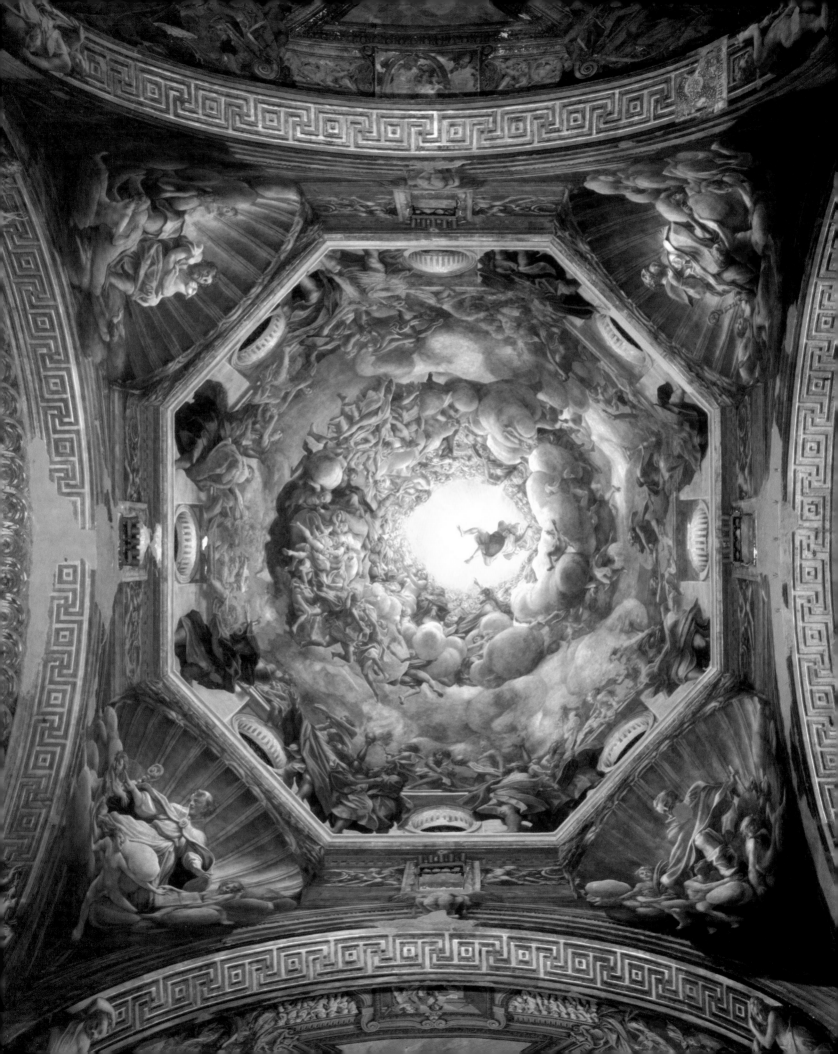

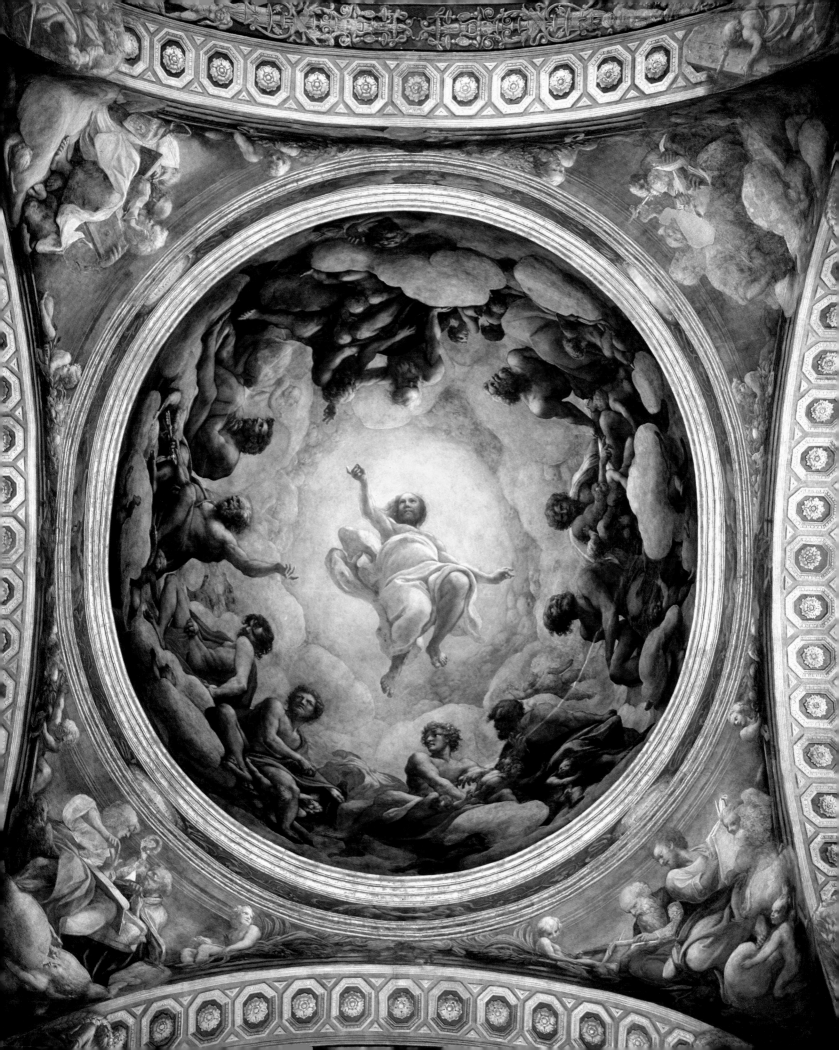

Painting in Venice

In the last years of his life, Giovanni Bellini was able to witness how his students were leading Venetian painting to new heights. From what we know nowadays however, Bellini had already been surpassed by Palma il Vecchio, Titian and Giorgione, even if their performances had not yet been recognised by the general public due to their relative youth. These three are often regarded as the Grand Masters of Venetian painting, although at least Paolo Veronese and Jacopo Tintoretto should be included in this group.

Giorgione (around 1478 to 1510) must have reached Venice quite early on, and made such incredibly speedy progress during his apprenticeship with Bellini that he became a role model for his peers as a young man. One of his paintings completed under Bellini's influence is *The Three Philosophers* (1507/1508), which depicts three scholars in antique-style clothes in front of a hilly background and the entrance to a cave. In Castelfranco, Giorgione already made a commission from the commander Tuzio Costanzo into a masterpiece, The *Castelfranco Madonna*, an enthroned Madonna with the two saints, Liberalis of Treviso and Francis (around 1504/1505). This painting, with its two strange saints and his delicate colouring, marks the farewell from traditional Venetian art. It is painted with tiny, interrupted brush-strokes. This created the "magic" light and helped him to achieve his fame. Together with Palma's *St Barbara*, Titian's *Assumption of the Virgin* (1516/1519) and his *Madonna with Saints and Members of the Pesaro Family* (1519/1526), this piece of work is a highlight of Venetian painting.

In the field of female nudes, Giorgione was among those who led the way, and here Titian is also one of his competitors. Titian, together with Correggio, completed what Giorgione had begun. His *Sleeping Venus* (around 1508/1510), which was never finished, is lying on a white sheet in a heavenly landscape. Originally there was a Cupid at her feet, painted by Titian but then later painted over. This Venus is surely the classical model for similar portrayals by Palma, Titian and other Venetian artists.

Jacopo Negretti (1480 to 1528), called Palma "il vecchio" (the Old One), also came to Venice at a very young age and there became Giovanni Bellini's student. At times he must have worked very closely together with Titian and Giorgione, as the influence on him by the two of them is unmistakable. Palma was at his best when he could paint holy families or Venetian beauties in idyllic landscapes.

The second in this group was Titiano Vecellio (1488 to 1576), called Titian, who already came to Venice as a ten-year-old, starting an apprenticeship with Giovanni Bellini. Although he underwent several transformations in his long life, he ultimately became the principal master of the Venetian High Renaissance, one

Giorgione (Giorgio Barbarelli da Castelfranco),
The Tempest, c. 1507.
Oil on canvas, 82 x 73 cm.
Galleria dell'Accademia, Venice.

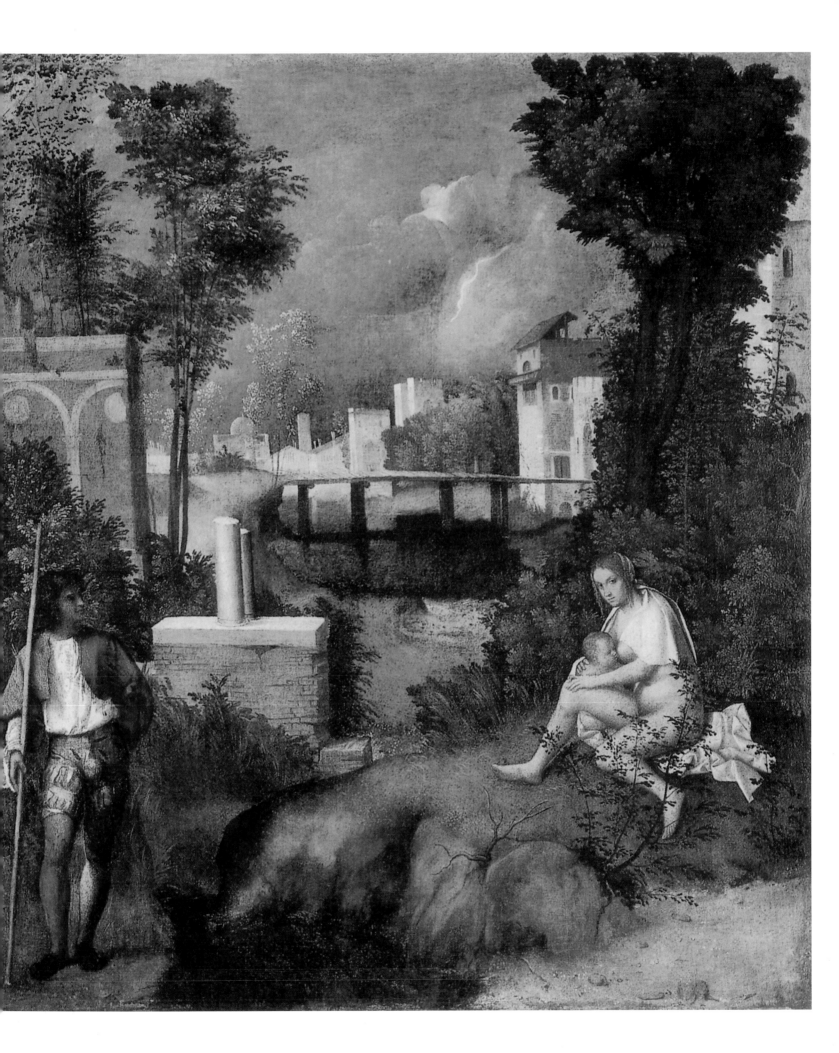

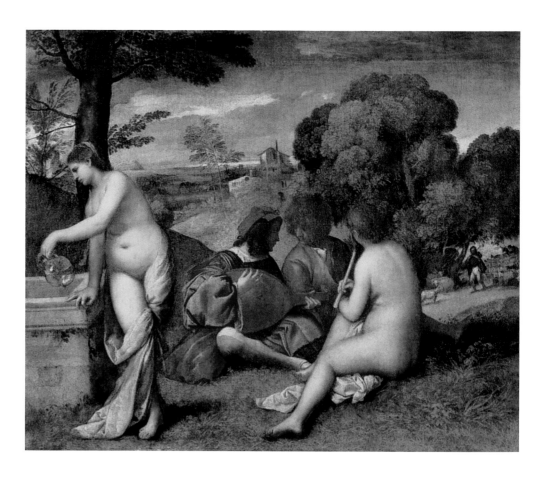

whose entire work was not equalled by anyone. He was a painting psychologist or a psychological painter. This becomes the most apparent in his major piece of work belonging to the first creative period, approximately 1510 to 1520, in *Der Zinsgroschen* (around 1515).

Among his few frescoes is the *Scenes from the Life of St Anthony of Padua* (1511), in which he demonstrates his feeling for the monumental. In his second major piece of work from this period, in *Sacred and Profane Love* (1515) he has not yet surpassed the ideal of beauty, which links him to Palma and Giorgione. These portrayals include *Venus of Urbino* (1538), *Venus with a Mirror* (around 1555) and also *Venus and Adonis* (1553), commissioned by Philip II (1527 to 1598) of Spain.

Titian's speedy rise between 1500 and 1520 can be followed with the help of two Madonna paintings. The first is the *Gypsy Madonna* (1512), a plain, dark-haired woman belonging to the Venetian people; the second one is the *Cherry Madonna* (1516/1518) surrounded by a small John and by Joseph and Zacharias. The milestones of his greatest development of energy are three large altarpieces: the painting *The Virgin's Assumption*, frequently called *Assunta* in short (1516/1518), *The Madonna of the Pesaro Family* (1519/1526), and finally the *Death of St Peter Martyr*.

Giorgione (Giorgio Barbarelli da Castelfranco),
The Pastoral Concert, c. 1508.
Oil on canvas, 109 x 137 cm.
Musée du Louvre, Paris.

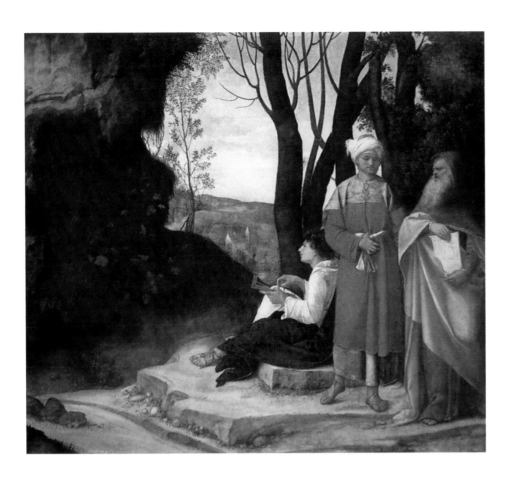

However, Titian also painted princes' portraits, and gave them missing intellectual and distinguished appearances, and whose open or secret apartments he decorated with his paintings under a mythological pretext, a genuine reflection of that time. In 1522/1523 he illustrated the classical mythology of doings amongst the followers of Bacchus in a cycle of pictures, using all his imagination for colours in *Bacchus and Ariadne* for his royal commissioner, the Duke Alfonso I d'Este in Ferrara. His artistic power to surround such work with the sensual appeal of colour did not fade in his later years either. This beauty cult had grown from the studies of numerous individual people. Thus, *Flora* (around 1515) or the *Penitent Mary Magdalene* (around 1533), surrounded by her long flowing hair, are excellent examples of Titian's art of idealisation, which is only countered by *La Bella* (around 1536), the famous portrait of Isabella d'Este (or Eleonora Gonzaga?). Titian portrayed the Emperor Charles V (1500 to 1558) on horseback, in full armour with a spear, galloping towards the battlefield. With this, he painted one of the most beautiful equestrian pictures in art history, which, as a result of the combination of the rural atmosphere and the character portrayed, who is pursuing his goal with fierce resolution, is at the same time a masterpiece in painting. Over the course of his life, Titian, in the end, dominated the entire Venetian world of painting.

Giorgione (Giorgio Barbarelli da Castelfranco),
The Three Philosophers, 1507-1508.
Oil on canvas, 123.5 x 144.5 cm.
Kunsthistorisches Museum, Vienna.

Palma il Vecchio (Jacopo Negretti),
The Holy Family with Mary Magdalen and the Infant Saint John the Baptist,
c. 1520.
Oil on wood, 87 x 117 cm.
Galleria degli Uffizi, Florence.

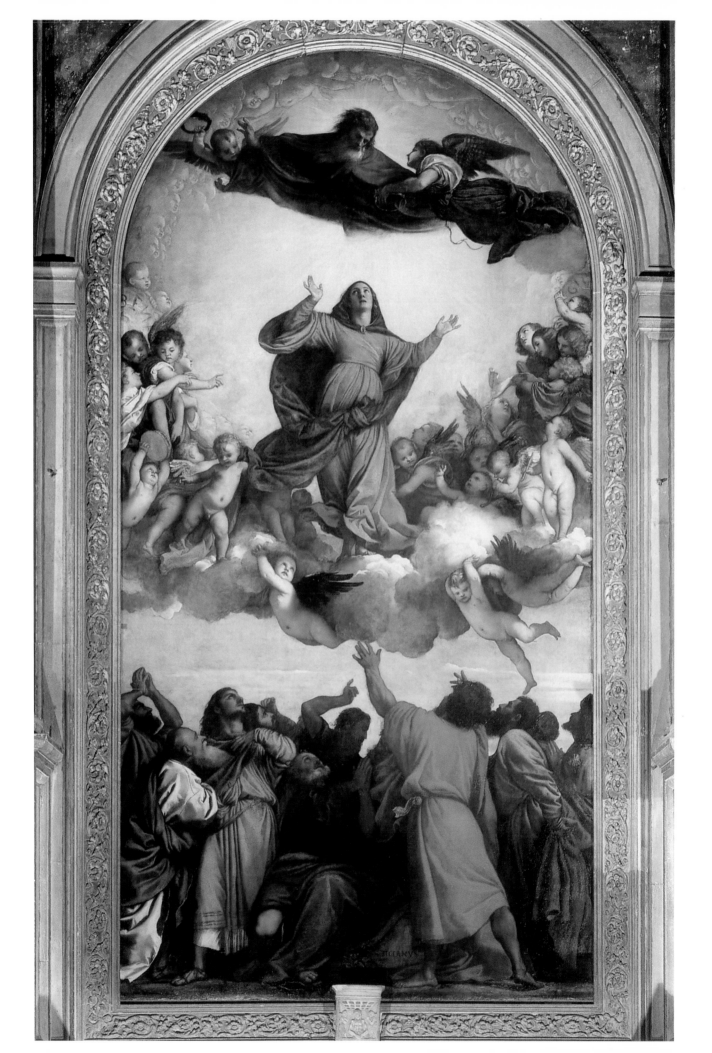

Even a restless painter, who was easily susceptible to foreign influences, such as Lorenzo Lotto (around 1480 to 1556), one of the most imaginative painters of that time, used Titian as a role model. He was one of Giovanni Bellini's students and gained crucial impressions from both he and Giorgione. Lotto tried again and again to combine the splendour of Venetian colouring, Correggio's chiaroscuro, and the movement of his figures with his ambition for foreshortenings. But he did not succeed until he moved back to Venice in 1526 and competed there with Titian. In some altarpieces, Lotto came quite close to his model Titian, for instance, with the figure of *St Sebastian*, emerged in flowing movement and an almost golden light. Once, Lotto, who was said to have been an ascetic and unworldly man, even made an attempt at nude painting with *Triumph of Chastity*, showing a demurely clothed young woman putting the naked Venus and a frightened Cupid to flight with an imperious gesture. The movement and treatment of the naked female body testify to the fact that Lotto could have matched Titian in this field, if his extreme devoutness had not estranged him to the world.

The influence of Venetian painting stretched beyond the borders of Venice, and could be found especially in Verona. Paolo Caliari, who came from the region, and who was later given the epithet Veronese (1528 to 1588) had already created independent work before coming to Venice in 1555 but did not reach final maturity until he had studied Titian's work and that of the other great painters.

In some of these cycles of paintings and in the allegorical and mythological frescoes in the Villa Barbaro (1566/1568) near Treviso he created masterpieces of unified, decorative painting. He was so keen on creating the greatest possible splendour that he could not restrain himself when portraying Christian martyrdoms. Thus, his paintings of martyrs being led to their places of execution quite often reflect the extravagance and the crowds of people as if they were at public festivals. The biblical subject was only an excuse for the classical monument of the Venetian contemporary pictures of life, The *Wedding at Cana* (1563) or the inordinately large *Dinner in the House of the Pharisee* (1573) to gather a splendid banquet with strapping men and beautiful women of Venetian society around Christ, including the contingent of servants, musicians and actors, usual for that time.

Veronese also liked to portray stories from the Old Testament if they provided an excuse to show women and girls in aesthetic poses or graceful movements. As, for instance, with the *Story of Esther* (1556) or the *Finding of Moses* (1580), subjects which he treated with the same devotion as the Greek mythologies of the gods, among which *The Rape of Europe* (1580) is one of his absolute masterpieces.

In Venice's doge palace, Veronese created the most beautiful works his art had to offer when it changed from the cheerful, decorative style to the monumental. His work was absolutely in line with his quiet, modest life style, in complete contrast with the distinguished, worldly Titian, the favourite of emperors, kings and princes.

Titian (Vecellio Tiziano),
Assumption of the Virgin, 1516-1518.
Oil on panel, 690 x 360 cm.
Santa Maria Gloriosa dei Frari, Venice.

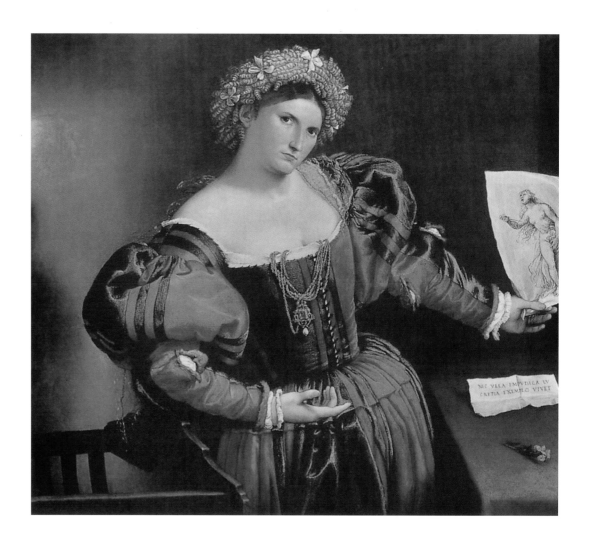

The temperamental Venetian Jacopo Robusti (1518 to 1594), better known by his nickname Tintoretto (the little dyer), was of a totally different type than Veronese. He tried to include in his paintings that which had perhaps been missing from Venetian painting until then, dramatic life intensified to passionate emotionalism. He owes the colouring, and especially the golden colour that can be found in his early work, to his short apprenticeship with Titian. This golden colour can be found in his mythological portrayals, as for instance, in *Venus, Vulcan and Mars* or *Adam and Eve* or also in his series of paintings *Miracle of St Mark* (1548), which belonged to the symbols of Venetian art. Tintoretto's basic focus in his art was naturalism. He included this naturalistic principle in Venetian painting by imitating Michelangelo. He was what we would call a "workaholic" today – creating more paintings than Titian and Veronese put together. An artist like Tintoretto, who could do anything and wanted everything, also painted portraits, of course performing excellent work, but without matching the soul-searching skills that Leonardo, Raphael and Titian demonstrated. But the doges, princes, commanders and dignitaries he painted in a solemn, representative manner bear incomparable historical testimonies.

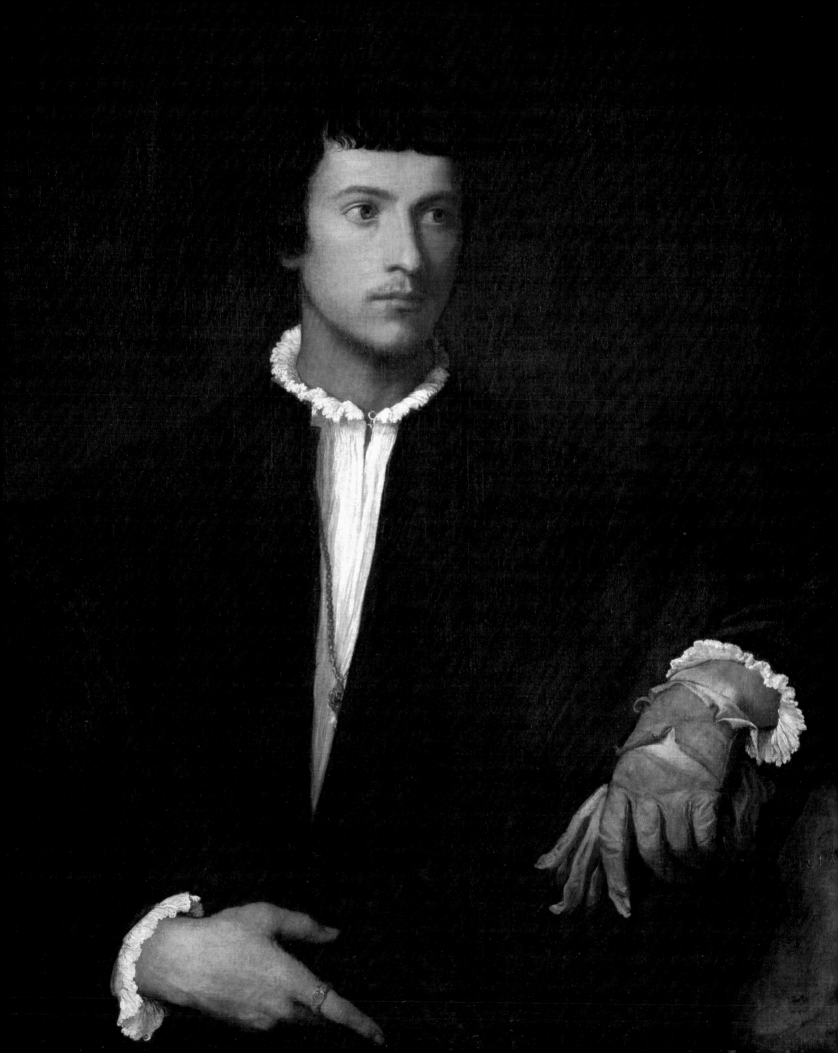

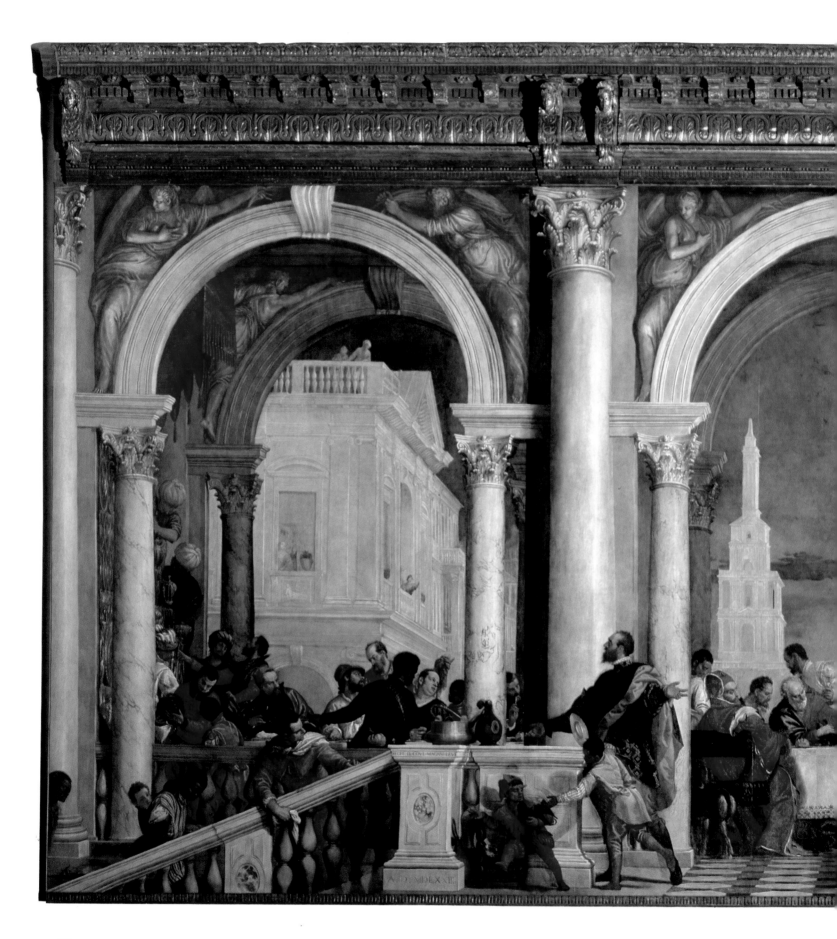

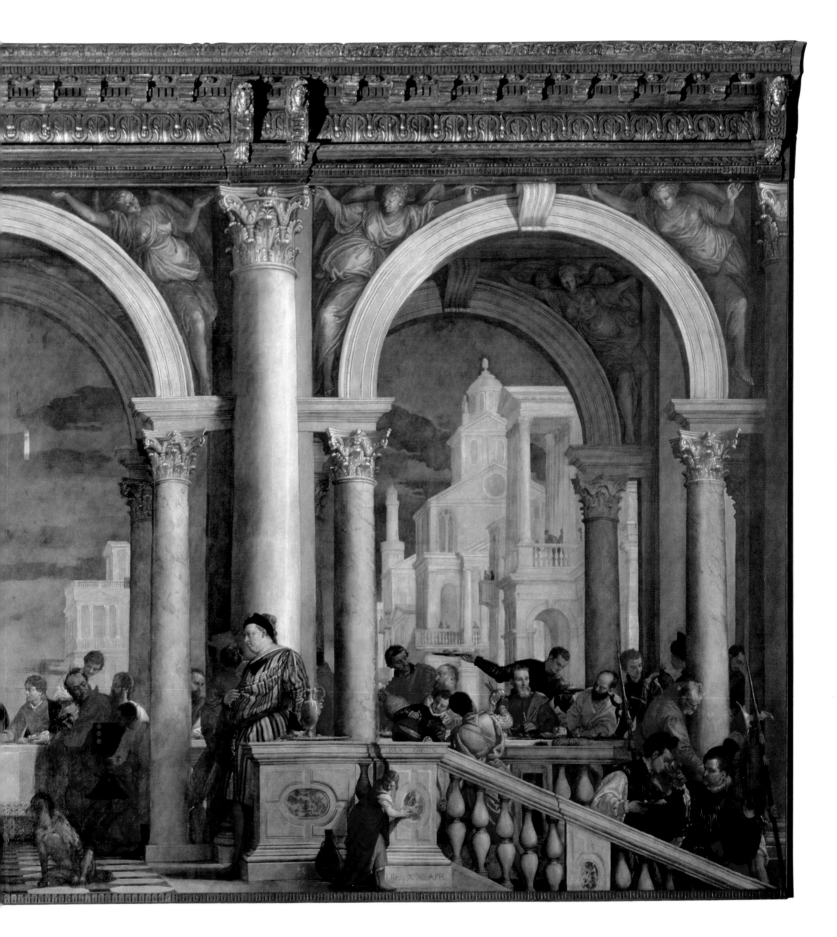

Architecture in Northern Italy

Roman architecture was, like the art of the sculptors, for a long time under the influence of the Florentine artists that had emigrated and built mainly town palaces. One of the last buildings of the Florentine-Roman style was the papal office, the Cancellaria, whose facade had already been completed when Bramante arrived in Rome. With him, the endeavour for a perfect imitation of the classical building structures adopted by Raphael, Baldassarre Peruzzi (1481 to 1536) and Antonio da Sangallo (around 1483 to 1546), was shown to its best advantage. A different master builder, who drew attention to himself with his writing, was Giacomo Vignola (1507 to 1573), Michelangelo's successor in supervising the construction work on St Peter's. As an architect he followed his own textbook.

Jacopo Sansovino (1486 to 1570), who had a similar influence on architecture in Florence as Titian on painting, also came from the school of Bramante. Sansovino's heyday began when he came to Venice in 1527 and was appointed master builder of the Republic. Among his best works are the mythological reliefs on a plinth, the four bronze statues (*Peace, Apollo, Mercury and Pallas Athene*) and the gilded group in burnt clay *Madonna and the Infant John* in the inside of the hall in front of the bell tower of San Marco, as well as *Mars and Neptune*, the two giants on the steps of the doge palace (around 1554).

The actual master builder of churches in Venice in the second half of the sixteenth century was the stonemason and architectural theoretician Andrea di Pietro, called Andrea Palladio (1508 to 1580). He had been working as an architect since 1540, first in Vicenza, then in Venice. His main work in Venice, the desire for palaces, had already been covered by the native architects, so that Palladio worked there as a church builder and realised his magnificent ideas for construction in the two churches San Giorgio Maggiore on the island opposite and Il Redentore on the Giudecca.

From about 1530, Genoa, with its natural harbour, had become a powerful competitor to the Republic of Venice. But only when Genoa had seized part of the foreign trade, were the riches that had been gradually accumulated used for building magnificent palaces. At the beginning of the seventeenth century, these buildings enthused a young Flemish artist in such a way that he collected drawings of these palaces and later had them engraved in copper to help the native building trade on their way. Peter Paul Rubens (1577 to 1640), who had travelled to Rome, Mantua and Venice, recognised that these Genuese palaces already constituted a further stage of development compared to the Venetian palaces, as they did not only know how to build magnificent facades, but transferred the rooms for representation into the interior of the building, even taking certain human living requirements into account.

Veronese (Paolo Caliari),
The Feast in the House of Levi, 1573.
Oil on canvas, 555 x 1310 cm.
Galleria dell'Accademia, Venice.

Tintoretto (Jacopo Robusti),
Crucifixion (detail), 1565.
Oil on canvas, 536 x 1224 cm.
Scuola di San Rocco, Venice.

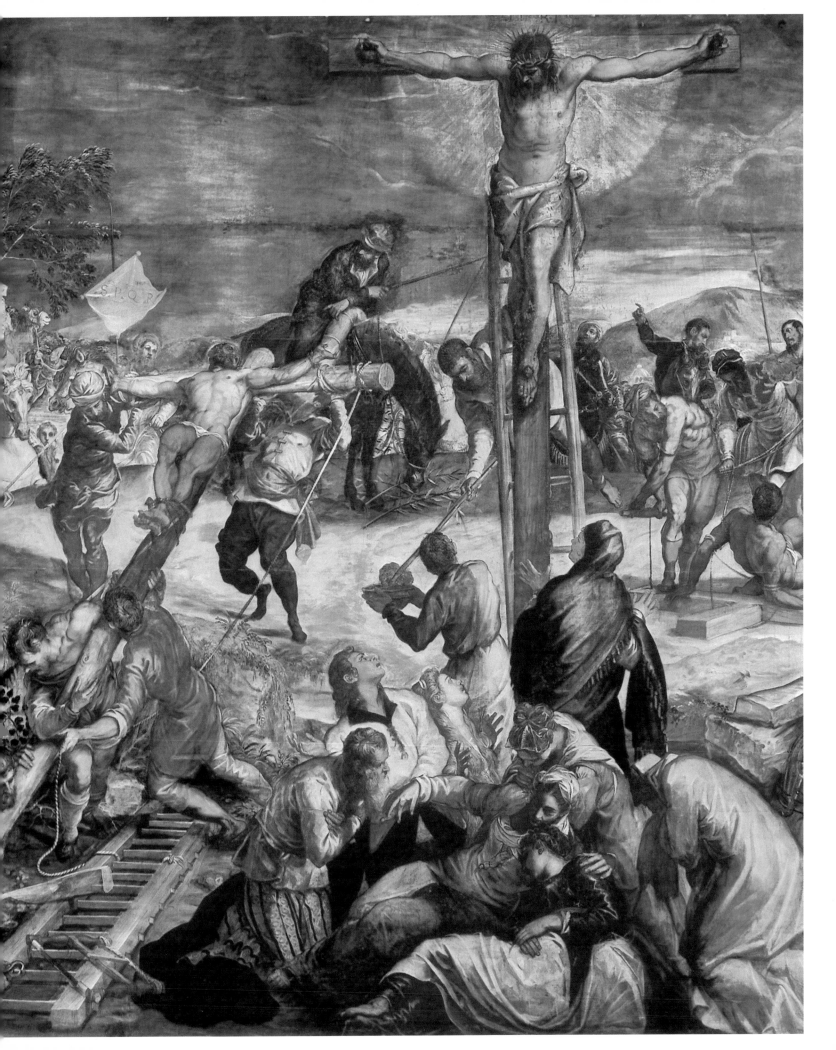

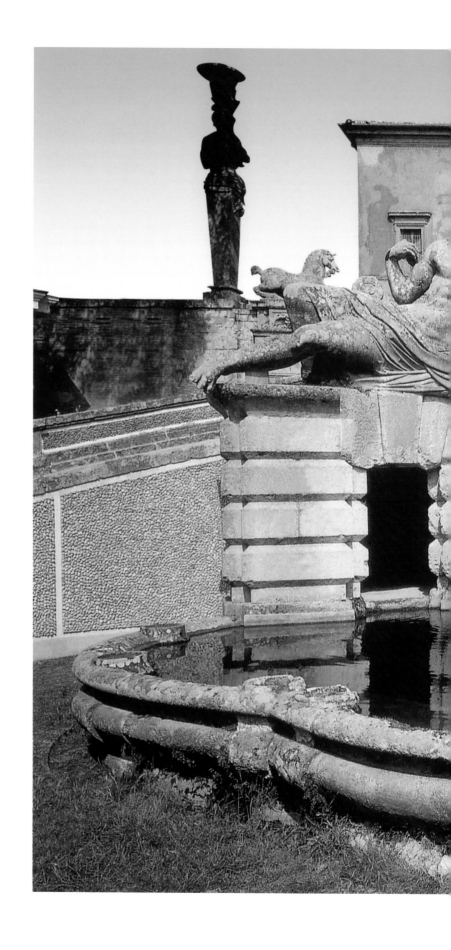

Vignole (**Giacomo** (or **Jacopo**)
Barozzi da Vignola),
*Fountain of the Villa Farnese, with River
Gods,* c. 1560.
Villa Farnese, Caprarola.

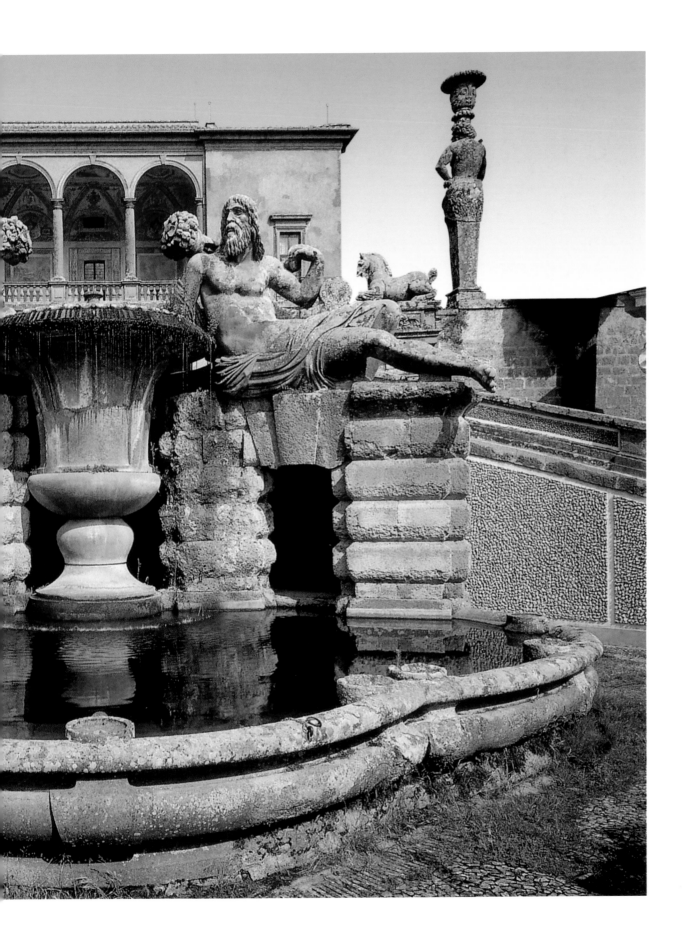

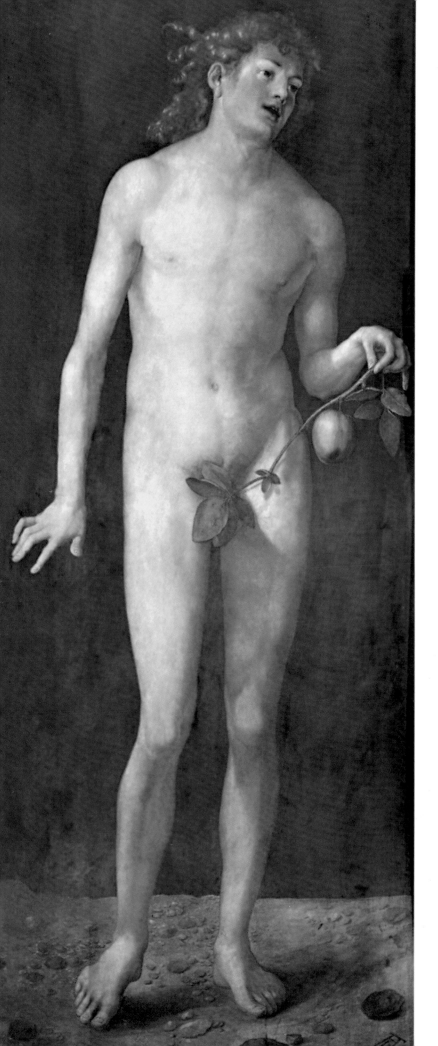
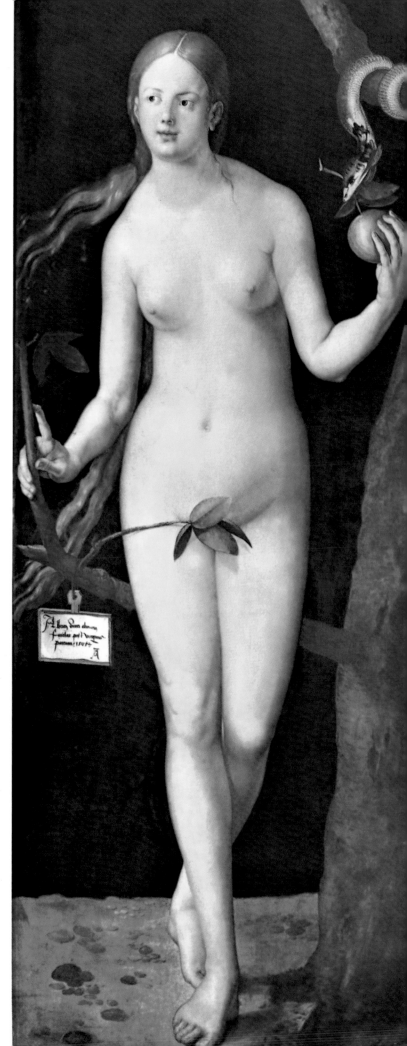

II. Art in Germany and the Rest of Northern Europe

The peculiarities, characteristic of art in the Italian Renaissance, only exist to a limited extent in German art of the sixteenth century, so that the term Renaissance is rather inadequate for its characteristic. The renewal of German art in the fifteenth century had completely different roots and causes than Italian art. In Germany, modelled on the Netherlands, nature was the starting-point for the new direction. The Grand Masters in Germany, such as Dürer, Holbein and Cranach, did not entirely reject the new ideas coming from across the Alps, but limited their application either to ornamental accessories or designed the work that was stimulated by the humanists according to Greek-Roman mythology and history in connection with the partly fantastic medieval ideas, in a rather independent way.

Albrecht Dürer

With Dürer (1471 to 1528), art in Germany of that time had reached a peak in its steady development that had been underway since the Middle Ages. As a result of his travels, his creative period is almost compellingly divided into three gently merging periods. He created oil paintings and murals, he worked with distemper and water colours, he did copper engravings, drew for woodcutting and, lastly, produced drawings, which were considered independent works of art. Thus, he mastered all techniques that were known at the time. His early creative period is still under the impression of his role models. And if he already then ventured to attempt such an enormous task as the series of pictures on the Revelation of John, he would have had to struggle in particular with the difficulties the clear arrangement and grouping of such numerous figures were causing him. In his altarpieces from these years, the influence of the Nuremberg and Colmar Schools are still perceptible. This applies especially to *Mary's Altar* (around 1496), *Lamentation for Christ* (around 1498) and the *Paumgartner Altar* (around 1503). But in *Adoration of the Magi* (approximately 1504) he had already completely detached himself from his models. Other important pieces of work from this creative period are *Green Passion*, a series of eleven pen-and-ink drawings in black (1504) on green-tinted paper

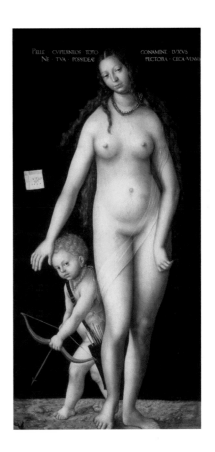

Albrecht Dürer,
Adam and Eve, 1507.
Oil on canvas, 20.9 x 8.2 cm.
Museo del Prado, Madrid.

Lucas Cranach the Elder,
Venus and Cupid, 1509.
Oil on canvas transferred from wood panel,
213 x 102 cm.
The State Hermitage Museum, St Petersburg.

produced in chiaroscuro style, and as proof for his skills and constantly growing self-confidence a *Self-Portrait* (1500).

The immediate reason for Dürer's second trip to Venice was a commission from one of the German merchants there, who wanted to order an altarpiece for their Church of San Bartholomew. He already started this work at the beginning of 1506, but because of the multitude of figures that had to be accommodated and his usual care, it was not completed until the autumn. The picture, known under the name *The Rosary Celebration*, was later purchased by Rudolf II (1552 to 1612) and taken to his residence in Prague.

In his pictures created after his return to Nuremberg, he clearly kept the heartfelt, soul-felt characteristic of his heads, but adopted the Venetian colouring. His taste had also been considerably reformed, both in the development of nude bodies as well as the treatment of robes, whose folding differed more and more from the crumpled fussiness of Gothic art. This transformation can best be followed by means of the paintings created during the years 1507 to 1511. Among those are primarily the two larger than life-size panels of *Adam and Eve* (1507). As for instance in the *Martyrdom of the Ten Thousand* (1508), in the *Heller Altar* (around 1508) with the Assumption of the Madonna in the middle and the donor couple on the two side panels, as well as with *All Saints Day* (1511). In the following years he had to earn his living by producing copper engravings, drawings for wood cuttings and minor work. In this time of extensive work we also place those three copper engravings, which for a long time could not be interpreted: *Knight*, riding fearlessly with *Death and Devil*, *St Jerome in his Study* and finally *Melancholia*, that massive winged woman surrounded by scientific instruments, who abandons herself to examining contemplation. It is likely that Dürer was setting down his experiences and some conclusions to his thoughts on the enigma of mankind. He continuously had to struggle with forgers and swindlers, who copied his woodcuttings and engravings despite the protection through an imperial privilege and – of all the cheek – even offered them for sale in Nuremberg.

In Nuremberg he also created two of his masterpieces as a portrait painter: the portrait of Jacob Muffel (1526) and that of Hieronymus Holzschuher (1526). The latter was a follower of the reformation efforts, which Dürer was also, possibly, favourably inclined towards. His idea to portray the four apostles probably also developed from this consideration: the most magnificent masterpiece of his art. This is not only a portrayal of the four apostles who were the most effective for Christ's teachings – on the one panel Peter and John, on the other Mark and Paul - but the four temperaments are described at the same time, which, according to the psychological knowledge of that time, describe the human character: the phlegmatic and melancholic in Peter and John, the choleric and sanguine temperament in Mark and Paul.

Albrecht Dürer,
Portrait of a Young Woman, 1505.
Oil on wood panel, 26 x 35 cm.
Kunsthistorisches Museum, Vienna.

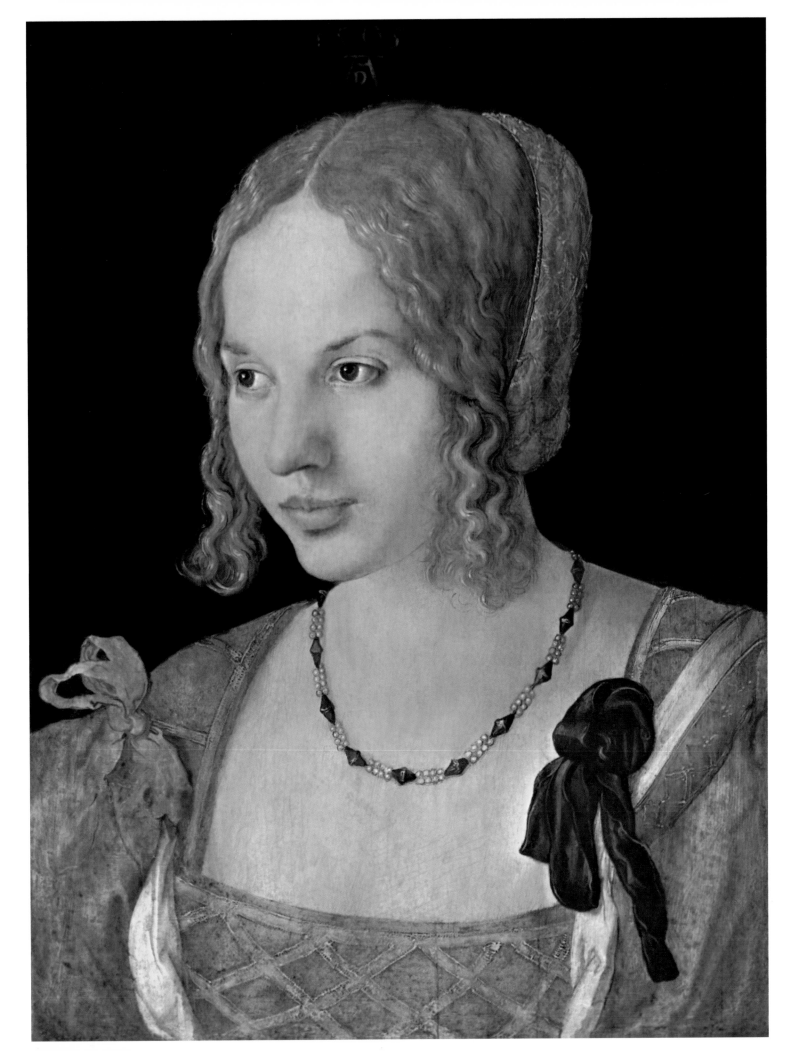

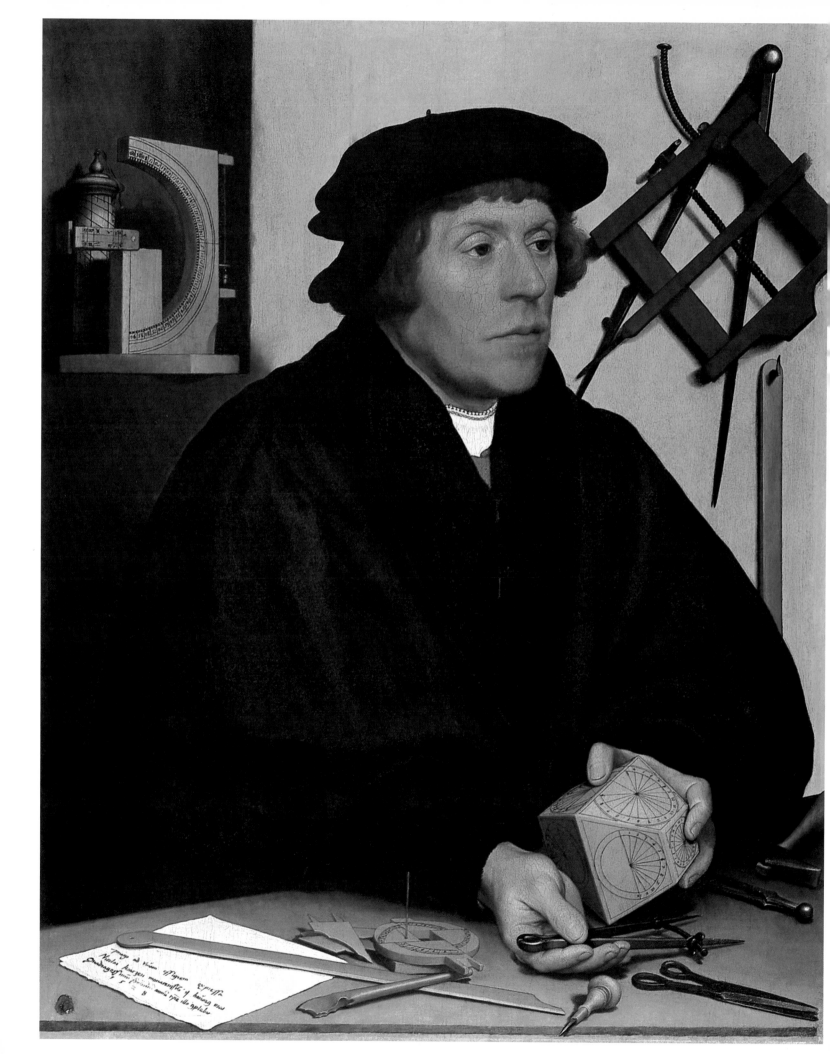

Hans Holbein the Younger

Apart from Albrecht Dürer, the indisputable second Grand Master of the sixteenth century in Germany is Hans Holbein the younger (1497 to 1543). In contrast to Dürer, Holbein, because he knew how to liberate himself from the medieval tradition and ultimately achieved the absolutely objective imitation of nature, is the actual master of the German Renaissance. In Basle, where from 1515 he initially worked as a drawer for word cuttings, familiarising himself with classical ancient times, he created his first early piece of art, a double portrait of *Jacob Meyer zum Hasen and his second wife Dorothea Kannengießer* (1516). This portrait was, for a long time, an unsurpassed example of that genre of portraits, where the painter assumes a total subordinate role to the personality he is portraying. The objectivity in reproducing all appearances is combined with a psychological perspicacity, which turns the inside of a person to the outside. This ability, which Holbein obviously had to an unlimited extent, makes him stand out from all other portrait painters of his time. He can certainly be considered a painting psychologist, and how good he was becomes apparent in his portrait of *Erasmus of Rotterdam* (1523).

Among his early work is the *Passion Altarpiece* (around 1523). The outer left panel contains *The Mocking of Christ* and *Christ on the Mount of Olives*, the inner panel *The Carrying of the Cross* and *The Kiss of Judas*. The outer right panel shows the Castigation and the Entombment of Christ, the inner right panel Christ in front of Pilate and the Crucifixion.

Holbein owes a further commission to the Mayor of Basle, *The Darmstadt Madonna* (1526/1530), an altarpiece for his private chapel that shows Jacob Meyer, his son, his wife and his daughters. According to the custom of that time, the mayor, married for the second time, had his late wife painted next to the living one on the right side.

Holbein was so enthusiastic about classical art that he saw a greater ideal of beauty in it which he tried to follow. For this reason he walked across the Alps to Northern Italy. In his work, the influences of the Italian Renaissance become perceptible, revealing themselves in particular in the *Solothurn Madonna* (1522). In its structure and composition, it is the German counterpart to Giorgione's *Madonna of Castelfranco*. The enthroned Madonna is surrounded by two saints, the Bishop Ursus and the Roman warrior Martinus, clad in contemporary knight's armour.

With a capacity for work which can only be explained with the indefatigability of youthful enthusiasm, Holbein produced an abundance of paintings and drawings, both before and after his travels, until 1526, that can hardly be ignored. Prior to his trip to England in 1526, he created the drawings for the large series of paintings. Among those are the forty-five illustrations on the Old Testament and the famous pictures from the *Dance of Death*. His basic idea in these pictures was that Death knows no class distinctions and mows down the pope, as well as the emperor, the princes, peasants, citizens and beggars with the same merciless scythe.

Hans Holbein the Younger,
Portrait of Nicolas Kratzer, 1528.
Tempera on wood, 83 x 67 cm.
Musée du Louvre, Paris.

Lucas Cranach the Elder,
Fountain of Youth, 1546.
Oil on lime panel, 122.5 x 186.5 cm.
Staatliche Museen zu Berlin, Berlin.

Lucas Cranach the Elder

The third Grand Master among the painters of the German Renaissance is Lucas Cranach the Elder (1472 to 1553), who quickly achieved a high reputation, and, as a result of his incredible amount of work produced under his name and painting symbol, the winged snake, also became rich. Among this work are large and small altarpieces, allegorical, historical and mythological portrayals, genre scenes, numerous wood cuttings and above all portraits of the Saxon princes and their families, as well as the portraits of the Reformers Luther, Melanchthon and Bugenhagen.

As a purely artistic painting, *Rest on the Flight to Egypt* from 1504 is unsurpassed among Cranach's work. It was only in his last years of life, when his best artistic work was said to be his *Self-Portrait* at seventy-seven years of age (1550), and the middle painting of the winged altar in the Weimar town church (1552/1553), that he developed a similar artistic energy. All the same, in the first twenty years of his work in Wittenberg, he created a series of oil paintings, which come quite close to the *Rest on the Flight*, and must be referred to if we want to get a genuine picture of Cranach's art. Among his wonderful depictions of the Madonna are the *Virgin and Child under an Apple Tree* (1520/1526) and the *Madonna and Child with Grapes* (1534). The intensity and depth of his devoutness can also be perceived in the depiction of *Christ on the Column*. Nevertheless, he also served the reformers with his art. At first he spread Martin Luther's wood cutting, and a little later also one of the young nobleman Jörg, working on the translation of the Bible at the Eisenach Wartburg, with the result that these wood cuttings found ever larger markets whilst the reformation was progressing, and finally ended up as mass production, carried out from his workshop.

Due to many other commitments, he was not left with much time for his artistic work, so that he was only able to monitor his workshop which was bombarded with commissions, but could no longer give out any stimuli. The numerous great altarpieces are therefore overwhelmingly performances carried out by his workshop, and he only lent a hand with work - doing his best and applying all colourful splendour - when he wanted to secure the favour of his royal patrons and satisfy them. Cranach the elder died on 16 October 1553.

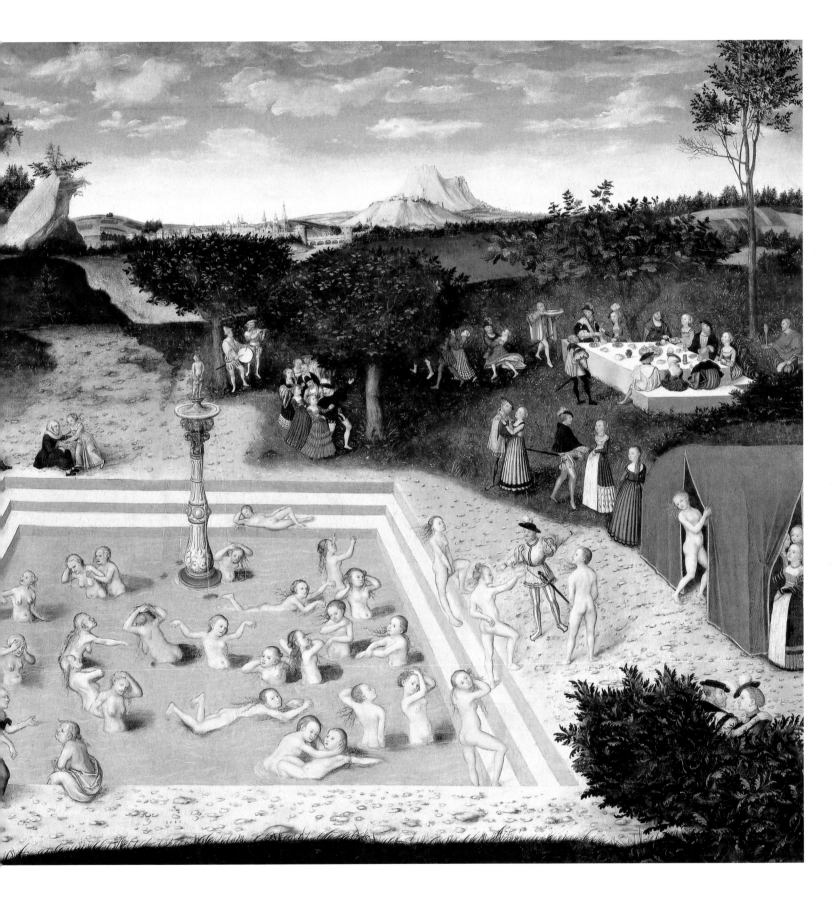

Tilman Riemenschneider

Tilman Riemenschneider (around 1460 to 1531) could compete with the Nuremberg masters regarding both the volume of his work as well as the artistic significance. Riemenschneider went to Würzburg in 1483, received his title of master craftsman there, established a workshop that in its best days employed up to eighteen apprentices, and from there supplied the churches of Würzburg and its surroundings with carved altars and stone work, as well as carrying out his engagements as the mayor of the town. Apart from some altars, his main work comprises the tomb of Emperor Henry II (973 to 1024) and his spouse Kunigunde (died in 1033) in the Bamberg Cathedral, and the stone figures of *Adam and Eve* at the portal of St Mary's Church in Würzburg. These two figures became equally important as studies on living models as the figures of the same name on the *Ghent Altar*. Riemenschneider frequently did his wood carvings without painting, preferring to take advantage of the play of light and shadows.

Tilman Riemenschneider,
Supper, Holy Blood Altar (detail),
1501-1502.
Lime.
Church of Sankt Jakob, Rothenburg.

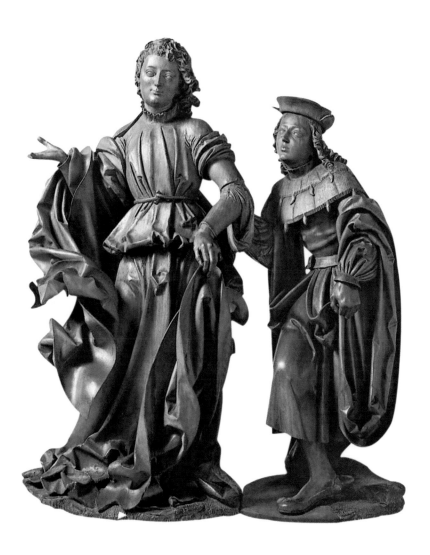

Veit Stoss

Apart from twenty years that the painter, sculptor and copper engraver Veit Stoss (c. 1450-1533) spent in Cracow, where he created the colourfully framed high altar for the church of St Mary, as well as a short stay in Breslau (1485), Stoss mainly worked in Nuremberg. The *Cracow High Altar* is the earliest work that can be attributed to him. At this time the Gothic influence is still clearly visible, especially with the figures *Death and Assumption of the Madonna* and the six reliefs from Mary's life on the altar wings. His sense of beauty was expressed in the figures of the Madonna. He probably created his best in the portrayal of the Annunciation hanging from the middle of the choir vault, the *Angelic Greeting* (in German: *Englische Gruß*, which, deceptively, has nothing to do with England), which was created, framed by a rosary almost 4 metres high and 3 metres wide and surrounded by medallions with the seven joys of Mary and by apostles and prophets. His last piece of work, the *Bamberg Altar* (1520/1523), radiates the peace and harmony that he had been lacking during a large part of his life.

Veit Stoss,
Tobias and the Angel, c. 1516.
Wood.
Germanisches Nationalmuseum, Nuremberg.

Architecture during the German Renaissance

Like the painters, the architects in the beginning of the period also only adopted the new ornamental forms from the Italian Renaissance, without departing from their acquired traditional constructive method of building. The first deviations can be found on the portals of some palaces, which had probably been carried out by immigrant Italians. In the next step they made an attempt with smaller buildings, for instance, public fountains, among which the market fountain in Mainz (1526) is perhaps one of the first structures executed in pure Renaissance forms. In the early 1630s, this "classical antique" style spread across all trading towns in Germany. The newly rich merchants decorated their medieval gable houses with new facades, providing adequate work for the native stonemasons. Although they did not achieve Italian elegance, as much was both massive and chunky, it was exactly this that gave them a national character. The newly built town houses kept the narrow gable front and they only filled the corners of the stepped and staggered gables with volutes and embellished work or trimmed them with sharply pointed spires; for public buildings, such as palaces or town halls, the medieval complex in the inner arrangement of the rooms remained the focal point. The layout of the churches, newly built or renovated during the Renaissance period, also remained untouched by the new ideas of the Italian master builders in their medieval tradition.

In spite of the destruction that many wars in Germany have left behind, already started with the Thirty Years' War, the impious destructive rage of ruthless building speculators, a mostly unjustifiable urge for modernisation, and in many cases a negligence due to a lack of financial means, so many palaces, town halls and residential buildings have been preserved that the relevant literature is almost extreme. A number of smaller towns have even preserved part of the fabric in their centres, which in the sixteenth and the first quarter of the seventeenth century people were so keen to build, have left behind, and which nowadays turns them into magnets for tourists. And the town councillors and mayors, who had emerged from the midst of the well-to-do citizens, acted just like them. They tried to gradually decorate the old town halls with the newfangled ornaments until one thing always brought something else with it, and the old building was slowly covered with all the new additions.

In the South of Germany, however, architecture in the sixteenth and seventeenth century followed the Italian requirements much more eagerly. Elias Holl erected the

"Ottheinrichsbau", the Renaissance wing of the Heidelberg Castle, built by Elector Ottheinrich, 1556-1559. Heidelberg, Germany.

armoury (1602/1607) as the town's master builder, and the town hall (1615/1620) in Augsburg, which was considered the most beautiful secular building north of the Alps.

However, the most important classical monument in Renaissance architecture is the Heidelberg Palace, although it also owes its national colouring to the Dutch sculptors, who had been trained in Italy. The *Frauenzimmerbau*, commenced under Ludwig V, of which only the ground floor has been preserved, originates from the sixteenth century. Two buildings must be pointed out in particular: on the one hand, the *Ottheinrichsbau* (1556/1559), erected by the Palatinate Elector Ottheinrich, whose courtyard front is one of the splendid specimens of architectural and creative art of the sixteenth century, the facade is owed to the Dutchman Alexander Colin. On the other hand stands the *Friedrichsbau*, named after the Elector Friedrich IV, where the facade facing the courtyard contains statues of his ancestors. Some Italians may say that the Dutchman misunderstood classical art and made everything only massive and plump, and failed to demonstrate any elegance whatsoever. But Colin was visualising the people of his time and shaped the gods and heroes of the ancient world accordingly.

Another important piece of this artist is the tomb of Maximilian I in Innsbruck. It is the reflection of art that has not been exhausted by the heritage of a rich past, but is also rampant with the treasures gained from Italy, without achieving a balance between old and new.

The Italian influence also dominated in Munich, which was conveyed by a different Dutchman trained in Italy. Pieter de Witte, better known under his Italian name Candido, rebuilt the old residence of the Bavarian princes, expanded it and equipped it with such beautiful courtyards as the *Grottenhof*.

Church building in the German Renaissance was dominated by a similar discrepancy as that which effected secular architecture, which was intensified by religious contrasts. In South Germany, where the Catholic Church maintained its dominate position, the Jesuits, for who their mother church (il Gesù) was the great model, mainly built the new churches according to Roman patterns. As a rule, however, the Roman architectural style had to make do with Gothic forms of construction, even in those countries in which the Roman Church maintained its undiminished recognition. In Cologne as well as in Würzburg, churches were built, whose Gothic foundations were only hidden outwardly by Italian ornaments. This applies to a far greater extent to two churches, which were built for the Protestant cult right from the beginning. One is St Mary's Church in Wolfenbüttel (1608) built by Paul Francke as the first large Protestant church construction, erected in Gothic construction as a hall building, with a nave and two aisles. The other one is the town church in Bückeburg (1613), for whose main front the element of gable construction and Gothic high windows could be harmonised with the Italian love for splendour.

Alexander Colin,
The Siege of Kufstein by Imperial Troops, under the Command of Emperor Maximilian I in 1504.
Marble relief from the tomb of Emperor Maximilian I.
Hofkirche, Innsbruck.

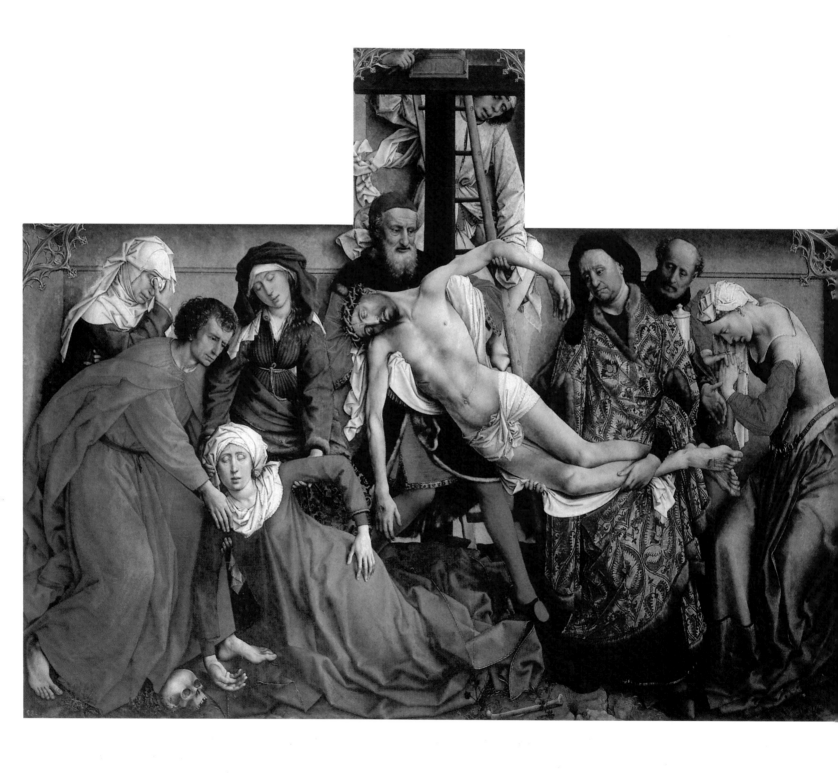

III. Art in the Netherlands, France, England and Spain

The Netherlands

In the Netherlands, painting as the leading form of art developed a similar basis and went through the same transformations as it did Germany. The difference lies in the achievement of a national direction compared to the Italian influences, which led to a heyday, unique in the history of art, making the country the focus of European art in the seventeenth century, despite her political-religious split.

The beginnings of this split go back to the end of the fifteenth century, a time during which a new generation of artists appeared on the scene, who had already found the forms applied by the founders of Dutch realism, the brothers Van Eyck and Rogiers Van der Weyden, too narrow and clumsy, and who strived for livelier reproduction.

The brothers Van Eyck, Hubert (1366-1426), and Jan (around 1390 to 1441), came from near Maastricht. Jan probably moved to the economic centre of Flanders, to Bruges, in 1432, where he lived until the end of his life. Judging on the work he left behind, he carried out a number of pieces for court officials and patricians during this time and later was even able to afford to threaten the court with terminating his work, when, due to a shortage of money, he received no payments. The *Ghent Altar*, a two-storey winged altar, consists of twelve movable panels painted on both sides, depicting the adoration of the mystic lamb, according to St John's revelation. The adoration takes up the lower half of the middle picture. In the upper half, God is enthroned between Mary and John. The holy was separated from the worldly by the arrangement of the scenes and figures on the wings. The lower half of the middle picture with the adoration of the lamb is bordered by two pairs of wings. From the left side Christ's fighters are approaching with the fair-minded judges and from the right side the holy hermits with Paul and Anthony, as well as the pilgrims, led by the gigantic Christopher, so that they can take part in the adoration of the lamb. When the wings are closed, Mary's Annunciation can be seen in the upper half in a Gothic room with arched windows through which the houses of a town are recognisable, and in the lower part four figures. In the middle are the figures of John the Baptist and John the Evangelist painted in stone colour and treated like statues, and on

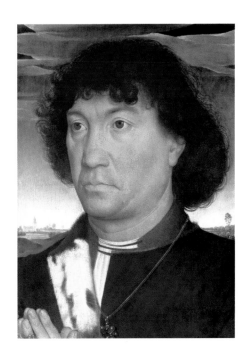

Rogier Van der Weyden,
The Decent from the Cross, c. 1435.
Oil on panel, 220 x 262 cm.
Museo del Prado, Madrid.

Hans Memling,
Portrait of a Man at Prayer before a Landscape, c. 1480.
Oil on panel, 30 x 22 cm.
Mauritshuis, The Hague.

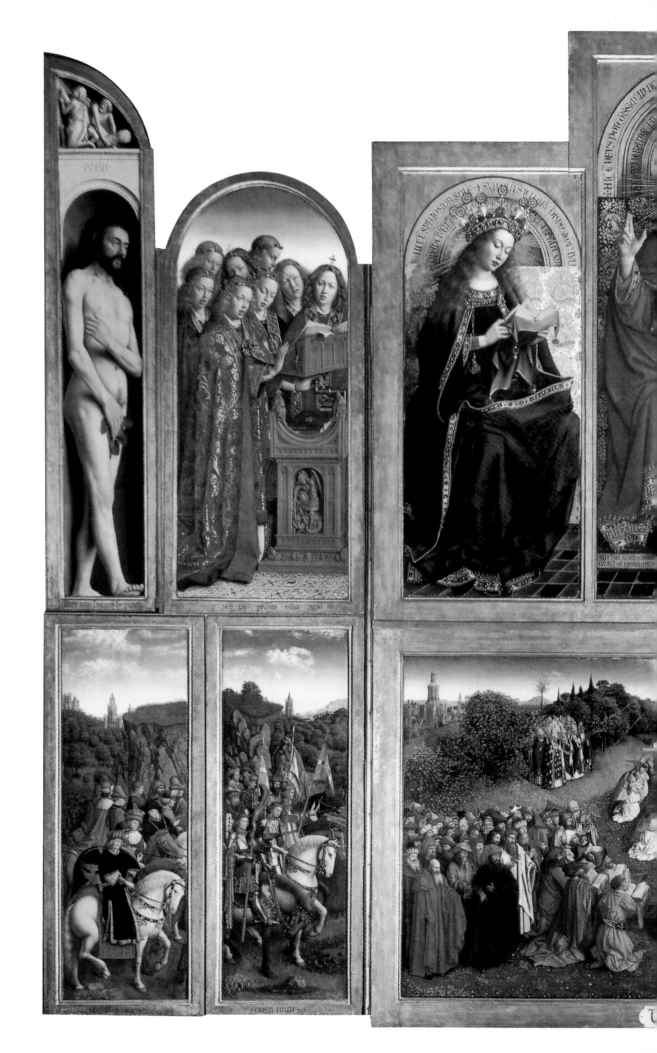

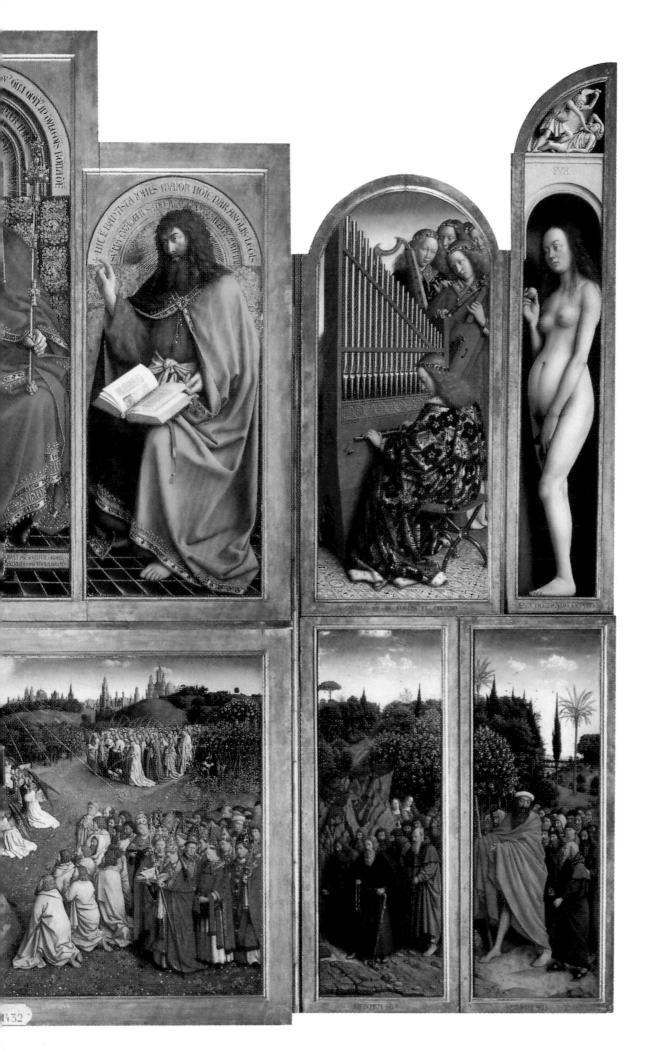

the left and right we recognise the kneeling figures of the altar donor Jodocus Vyd and his wife Isabella, who have an expression on their faces of a severe urge for reality, which is however, softened and transfigured by a reverent expression. Old Dutch art sustained itself on this masterpiece of painting for almost a century, but also developed and intensified it further. After this complex piece of work Jan Van Eyck mainly occupied himself with individual portraits in his last years of life. Among these is also the oil painting *The Virgin of Chancellor Rolin* (1435). Jan Van Eyck's devotional pictures have surely later been surpassed by other artists in their characteristic of the Madonna, but his portraits, such as *Portrait of Cardinal Albergati* (1431/1432), the *Portrait Jan de Leeuw* (around 1435) or the *Portrait of Margaretha Van Eyck* (1439) can hardly be surpassed in their energy and liveliness of their portrayal.

Dutch painting was, however, primarily developed further by Rogier Van der Weyden (around 1400 to 1464). He mainly worked in Brussels and Löwen, where he founded the Brabant School of Painting, which produced some important artists. Already in his early work, for instance, *Birth of Christ* (1435/1438) and *St Lucas Paints the Holy Virgin* (1440), the direction of his art becomes quite clear. A number of significant pieces of art are attributed to him. Around this time, and this becomes quite apparent in *St Lucas Paints the Holy Virgin*, which through a window opening allows an extensive view of a picturesque river landscape, he obviously also gained an understanding of landscape. *Deposition from the Cross* (around 1443), with its life-size figures painted in warm colours on a golden background, is totally different in comparison. Every painful sensation that could be expressed is put into these figures.

One of Van der Weyden's most important and most productive students was Hans Memling (1433/1440 to 1494), who devoted himself not as much to the soul as he did to beauty. One of his main pieces of art is the *St Ursula Shrine* (1489), a reliquary in the form of a Gothic church, showing three portrayals each on the two long sides from the life of St Ursula. Memling's other major pieces of work are the triptych *Last Judgment* (1466/1473), the triptych *The Mystic Marriage of St Catherine* of Alexandria (1479), *Cologne, Part of the Rhine from the Bayernturm to Groß-St-Martin* (1489) and the altarpiece triptych of *Lübeck St Mary's Church* (1491).

In the northern provinces of the Netherlands there existed a much more serious and austere spirit during the sixteenth century, which did not allow for the more humorous movements and a lively public feeling. The most important representative of this matter-of-fact direction was the painter, drawer and copper engraver Lucas Van Leyden (1494 to 1534), who was frequently compared to Albrecht Dürer, as he dealt with similar subjects. His realistic, down-to-earth mind dominated both his numerous copper engravings as well as his relatively few paintings, among which *Chess Players* (around 1508) or the *Healing of the Blind Man of Jericho* (1532) and some portraits

Jan Van Eyck,
Adoration of the Lamb (triptych), 1432.
Oil on panel, 350 x 461 cm (wings open);
350 x 223 cm (wings closed).
Cathedral of St Bavo, Ghent.

Lucas Van Leyden,
The Engagement, 1527.
Oil on panel, 30 x 32 cm.
Koninklijk Museum voor Schone
Kunsten, Antwerp.

Hieronymus Bosch,
Haywain (triptych), 1500-1502.
Oil on panel, 140 x 100 cm.
San Lorenzo Monastery, El Escorial.

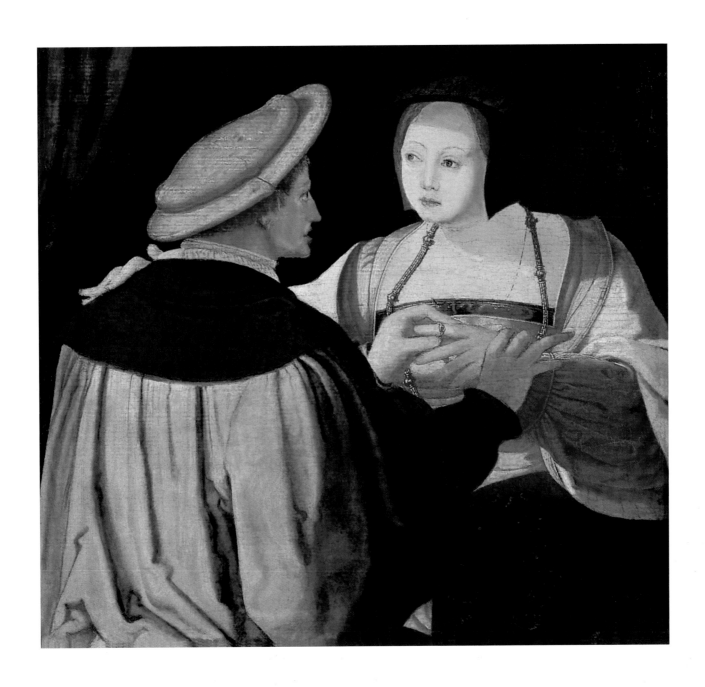

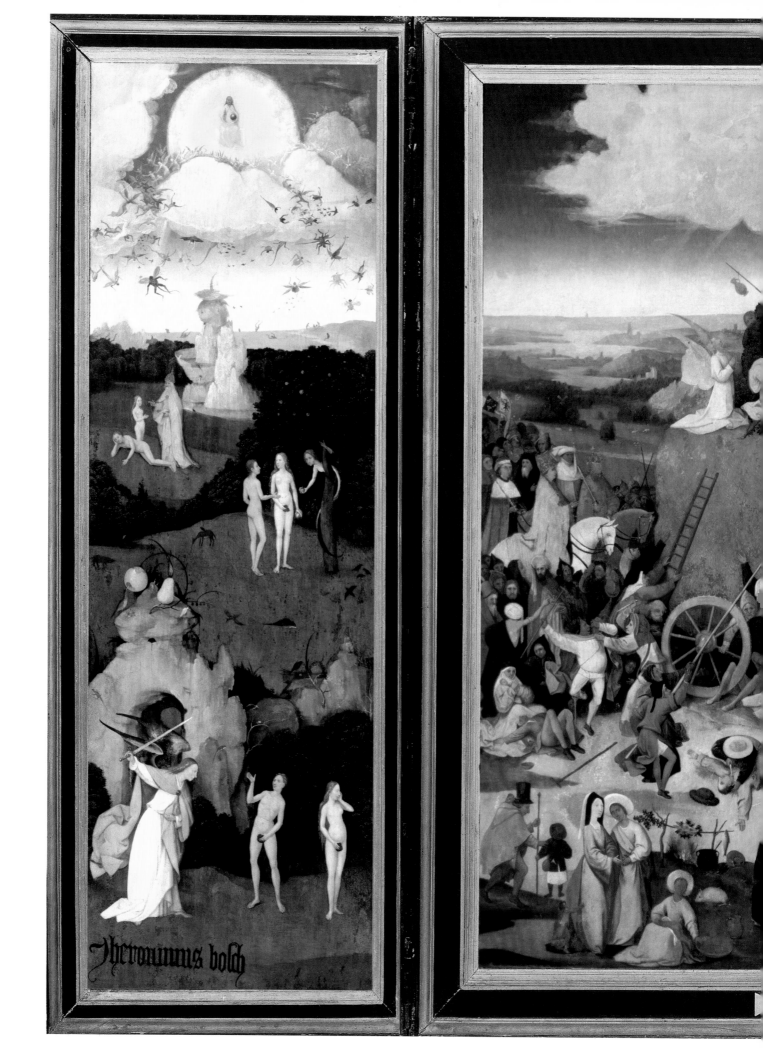

stand out in particular. He also tended to depict biblical portrayals as a reflection of the time or as a public festival or amusement of the higher social classes.

Only Hieronymus Bosch (around 1450 to 1516), who represented the burlesque element of Dutch painting with Van Leyden had equal influence. Bosch liked to portray the punishment of those rejected by the Last Judgment with exuberant imagination and brought to life horrifying ghostly and diabolical figures - he let the damned boil in cauldrons and be tormented with all kinds of red-hot instruments of torture, and converted the threats made by the repentance-preachers of that time against the spreading heresy into fantastic presentations. These interpretations were made into copper engravings and in this way quickly caught on in great numbers. One of the Bruegel sons, Pieter Brueghel the younger, had specialised in the portrayals of these torments of hell and so was given the nickname "Hell-Brueghel".

France

In contrast to the Netherlands, sculptures and architecture were the leading art forms in France, architecture having gone through a similar development than in Italy, but with a beginning in around 1500 slightly staggered in time. However, in France the individual changes in style were not named according to art historical divisions but after their kings, who, together with their aristocracy, had a greater influence on the development of architecture than the middle class.

The first half of the reign of Francis I (1494 to 1547) roughly corresponds to the time of the Italian Early Renaissance. Its love of splendour did not go beyond the building of large palaces which were decorated quite extravagantly by painters and sculptors on the inside and outside. As a transition from medieval castles, an 'in-between' type initially emerged, with a quadrangle, a court of honour, as a feature and focus point. With its three wings, it was open to the front, to ensure the entrance of the owner and his guests to be as imposing as possible. All later palaces of kings and princes were developed from these ideas. The sometimes open stair towers with a spiral staircase, in front of the facades, as well as the bay windows and balconies, and the rising total structure with the steep roofs and the great number of high chimneys are typical for France. The most beautiful and certainly most famous examples for this are the stair tower of the otherwise medieval Castle of Blois, with which Francis I began his building activities. Entirely in the style of the French Early Renaissance and the best example of this 'in-between' style is Chambord Castle (1519/1541), surrounded by a wall of more than thirty kilometres. In the centre of the castle is a double spiral staircase, designed by Leonardo da Vinci.

All Loire castles were surpassed by the palace of Fontainebleau, which, with its outer, somewhat monotonous looking facade, was also started by Francis I, with

Francesco Primaticcio,
The Room of the Duchesse d'Etampes
now known as the *Escalier du Roi*,
1541-1544.
Musée national du Château,
Fontainebleau.

Jean Clouet,
Portrait of Francis I, King of France,
c. 1530.
Oil on wood panel, 96 x 74 cm.
Musée du Louvre, Paris.

Castle of Chambord.
Loir-et-Cher, France.

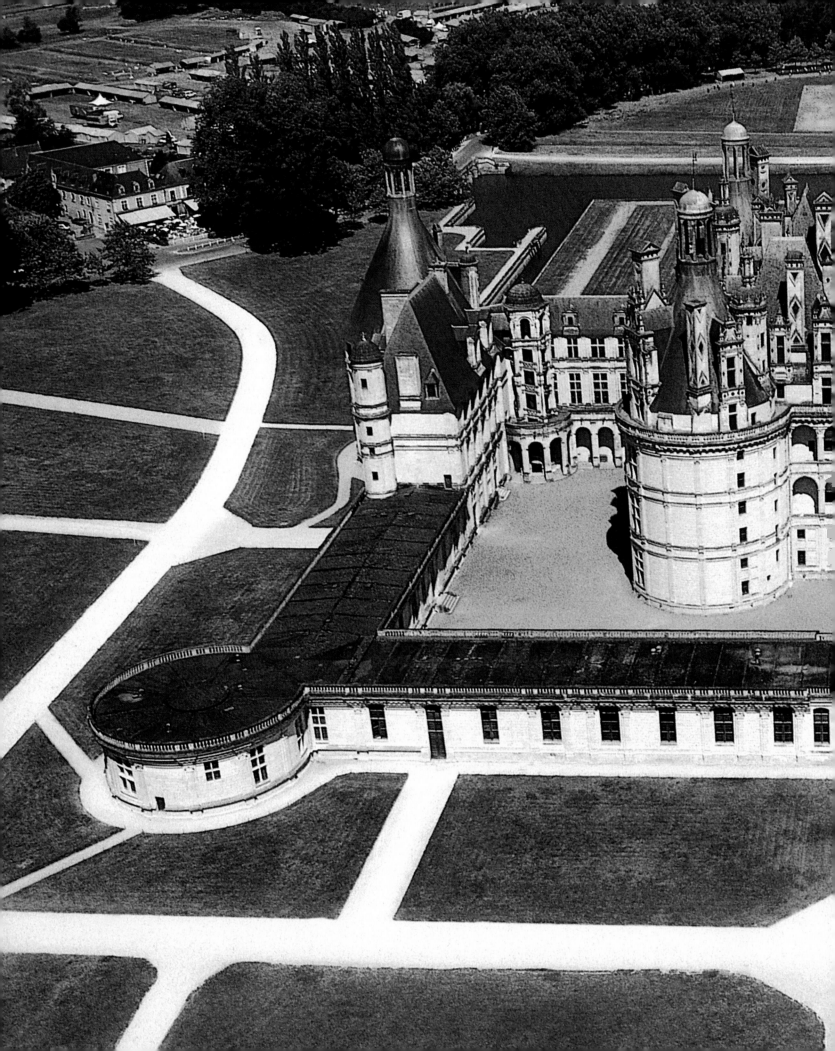

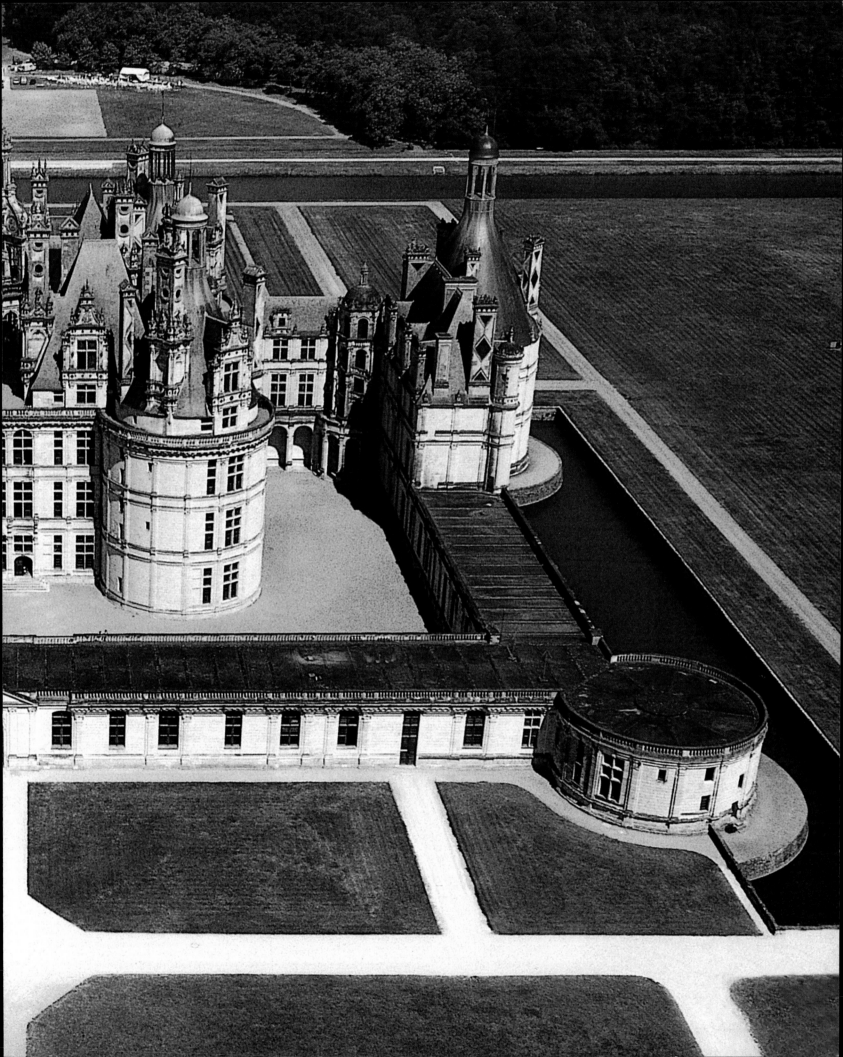

Italian artists or artists working in the Italian style. The palace has five courtyards and a chapel as well as numerous magnificent rooms. For the decorations of the numerous large and small rooms, among which the gallery Francis I with its unified artistic effect leaves the most splendid impression, Francis I and Henry II (1519 to 1559) sent for Italian painters and sculptors, who very soon developed a new style of decorating in France.

Some other buildings from the Early Renaissance are artistically more attractive than this palace, for instance, the Bishop's Palace in Sens or the town halls in Orleans and Beaugency. Approximately in the middle of the sixteenth century native architects took over not only the leadership in French architecture, but also the connection to the classics from the Italians. The most important among these architects was the master builder Pierre Lescot (active from 1540 to 1563), who was appointed to build the Louvre in 1546, the then residence of the French kings in Paris. Originally laid out as a courtyard enclosed by four wings, the building was extended by approximately four times as much during the course of the centuries. Lescot's work is about half of the present south and west wing, whose facades are among the most beautiful creations of the High Renaissance. Individually, it was probably influenced by Italian models, but in its structure, mainly of the Louvre roofs, definitely of French characteristic.

A further leading architect of that time and of approximately the same age as Lescot, was Philibert de l'Orme (around 1515 to 1570), who was born in Lyon, and had already worked for Pope Paul III in Rome. His major work in France is the Palace of Anet (1544/1555) erected by Henry II near Evreux for his mistress Diana von Poitiers (1499 to 1566), and the Palace of Catherine de' Medici (1564), which burnt down during the rule of the Paris Commune in 1871.

This Italian style probably reached its total breakthrough under the influence of the School of Fontainebleau in about the middle of the sixteenth century. However, the French sculptors only adopted the elegance of the new language of forms, without taking on the mannerism. Thus, something lively was created, which the master builder and sculptor Jean Goujon (around 1510 to 1564/1569), the major representative of pure Renaissance in French sculpture has expressed in the most beautiful way. But among his excellent pieces of art are also reliefs for the Louvre and other palaces, as well as portrayals rich in figures for churches. His slightly younger contemporary, the sculptor and medallion maker Germain Pilon (c. 1525 to 1590) was less independent. His most well-known work is that of the marble statues of the three Graces, carrying on their heads an urn that used to contain the heart of Henry II. But his most important piece of work was certainly the tomb of Henry II and his wife, Catherine de' Medici (1519 to 1589), on which the marble figures of the deceased are indeed naked but are no longer portrayed in their naturalistic earthiness.

Germain Pilon (and **Primaticcio**),
Tomb of Henri II and Catherine de' Medici,
1561-1573.
Basilique Saint-Denis, Saint-Denis.

Master from the Fontainebleau School,
Portrait of Gabrielle d'Estrées and her Sister the Duchess de Villars, c. 1594.
Oil on canvas, 96 x 125 cm.
Musée du Louvre, Paris.

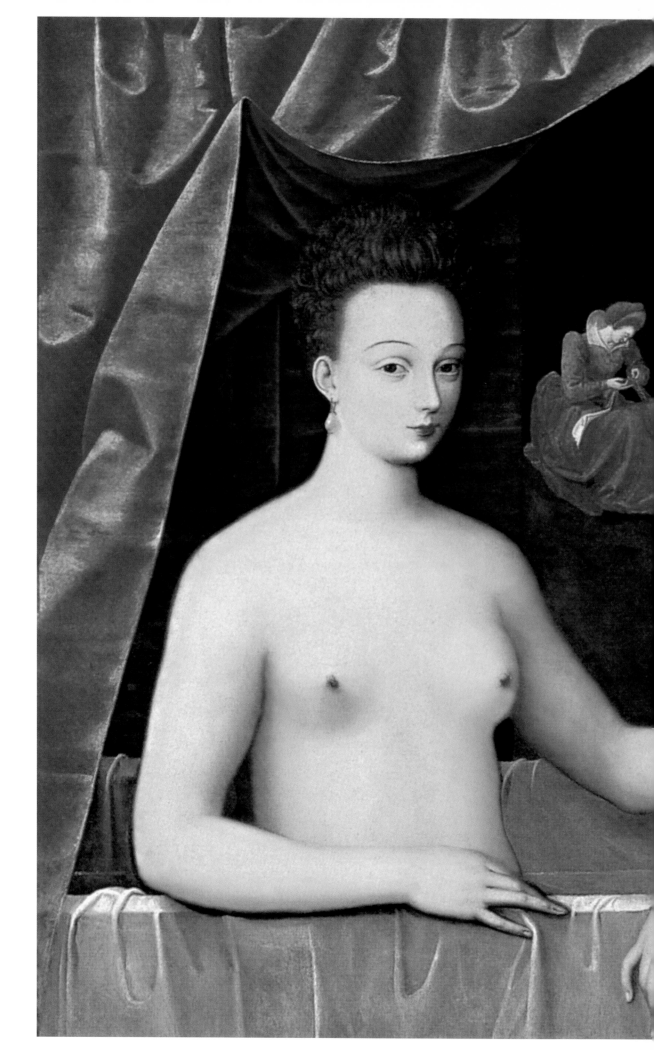

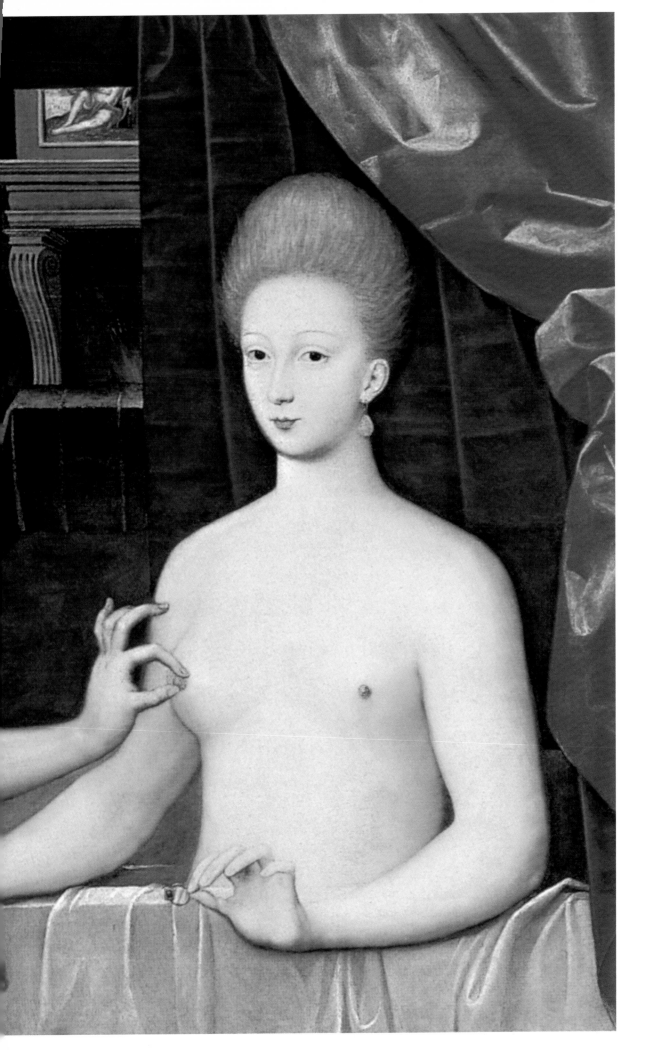

When regarding French painting that was not influenced by Italian art, only three artists need to be considered, and the eldest of these three did indeed have contact with art there during his stay in Rome. Jean Fouquet (around 1420 to 1481) met Fra Angelico around 1445 and adopted his suggestions in his miniature painting for devotional literature, as for example for his diptychon of the *Madonna and Child* (around 1450). The other two most important masters of that time are Jean Clouet (1475 to 1540), who had been working as a court painter for Francis I since 1518, and his son François Clouet (around 1505 to 1572), who later continued his father's work with the same kind of simple imitation of nature and fine detailed painting.

Owing to their attitude, which was dominated by a love of absolute truth, the portraits of French kings, queens and noblemen painted by father and son, also constitute documents of historical value, which may even have a more important position as their artistic value.

England

In England there had not been any native painters or sculptors of exceptional artistic importance who rose above technical craftsmanship. Architecture was pursued by resident architects, who held on to the Gothic style until approximately the middle of the sixteenth century. Not until the beginning of the reign of Queen Elizabeth I (1533 to 1603) did Italian influences gradually become established in English architecture as accompanying ornamental forms and without changing the medieval construction features to a great extent. This mixture of Gothic style and Renaissance, certainly artistically attractive, have become so apparent in some castles and mansions that were built between 1567 and 1591 (Longleat House, Burleigh House, Longford Castle) and university buildings (Cajus and Trinity College in Cambridge or Oxford University) that they are described in art history as Elizabethan. Following the French model, some transformations in English architecture in the seventeenth and eighteenth century were also named after the relevant ruler.

Spain

In Spain, where late Gothic art had already attracted the imagination to fully develop its energies, the Italian Renaissance had an even greater impact. As the requirements for medieval buildings had already been widely covered, the architects and sculptors had to make do with decorating courts, portals or smaller incorporations into churches, which only helped to increase their eagerness for sculptural ornamental work, so that the Spanish Early Renaissance is described as plateressque style (goldsmith style).

Robert Smythson,
Wollaton Hall (exterior view), 1580-1588.
Nottingham.

Juan Bautista de Toledo and **Juan de Herrera,**
The Escorial Monastery, 1563-1584.
Madrid.

The town hall (1527/1533) of Sevilla, created by Diego de Riaño, thought to be one of the most beautiful creations of the Spanish Early Renaissance, has a facade that is divided on the ground floor by Corinthianising half pilasters, on the upper floor by elegant half columns, which with their ornamental forms, seem slightly overcrowded. The Italian influence is perceptible in all these buildings, intensified in the courtyard and staircase of the archbishop's palace and the unfinished palace near the Alhambra, commissioned by Charles V to Pedro Machuco (until 1550). With its splendid Tuscan-Doric columns on the lower floor and the Ionic on the upper, and the round columned courtyard, it is reminiscent of Raphael's Villa Madama. The Italian High Renaissance then took over the rule under Philip II. The most excellent monument of his extraordinary devoutness and his love of art is the monastery situated north-west of Madrid in the small town of Escorial and dedicated to St Lawrence, which at the same time was a church and ruling residence. In line with Philip's II misanthropic mentality, it was built in a sad and barren waste land between 1563 and 1584, giving its appearance something cold and unapproachable, according to the design of Juan Bautista de Toledo (around 1515 to 1567) and Juan de Herrera (1530 to 1597). Since the time of Charles V, this Renaissance building, which is the largest worldwide, constructed with blocks of granite and containing more than 400 rooms, sixteen inner courtyards, fifteen cloisters, the basilica and a central building modelled on St Peter's in Rome, is the tomb of the Spanish kings, who have certainly contributed their own to the library, containing approximately 130,000 volumes and the precious collection of handwriting.

With this dark and gigantic mass of granite, the *Escorial* took an influence on art in the entire country, giving it a deprecatory, even ascetic expression, hostile to the world, which was decisive for the reign of Philip II and his successor. This architecture, in its renunciation of outward ornamentation, reflects the severe dignity of the Spanish knighthood and has nothing of the grace and charm of Roman High Renaissance. But behind the bare, five-storey walls, which surround a quadrangle marked by large angle towers, the courtyards and rooms open up and create an unforgettable impression. Through the entrance gate, a strictly gabled porch resting on columns, one reaches the Patio de los Reyes, bordered by columns, showing the church facade in the background. A wide flight of steps leads to the church, whose ground-plan resembles the one in St Peter's in Rome, and whose architectonic character has been adapted to the gravity of the facade. Nevertheless, in some parts, such as the Capilla Mayor and the Oratorios, incredible pomp and splendour was developed, even hardly found in St Peter's.

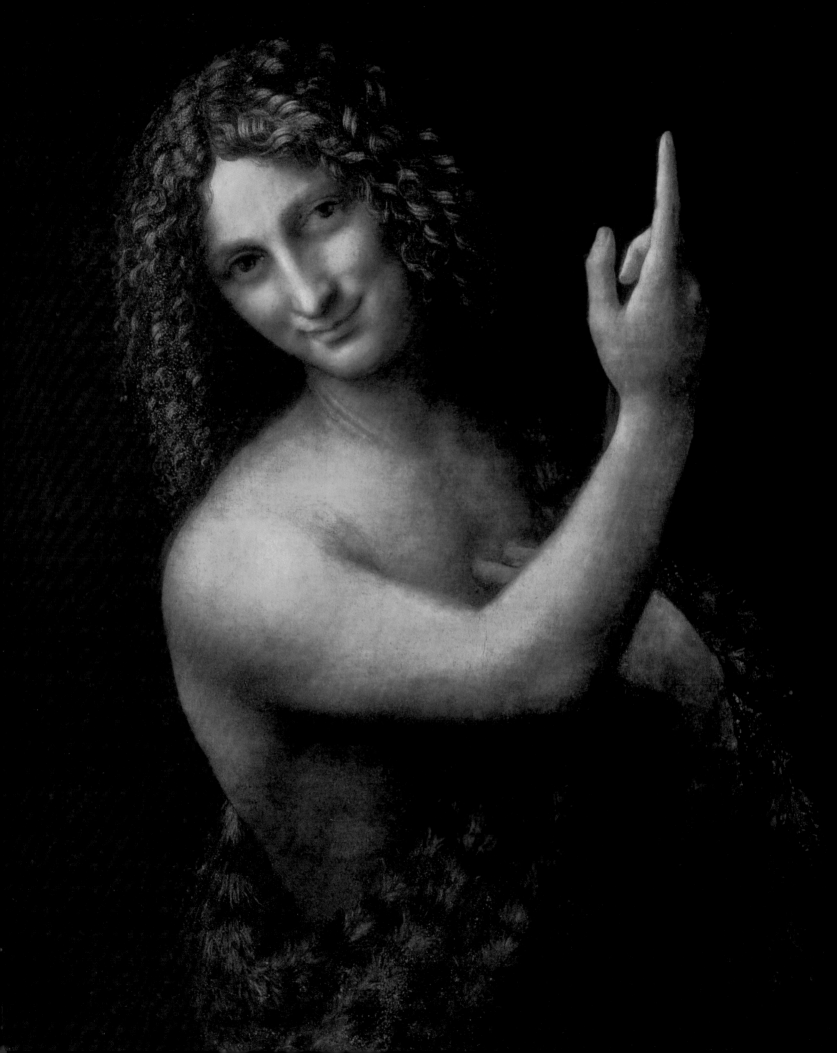

Major Artists

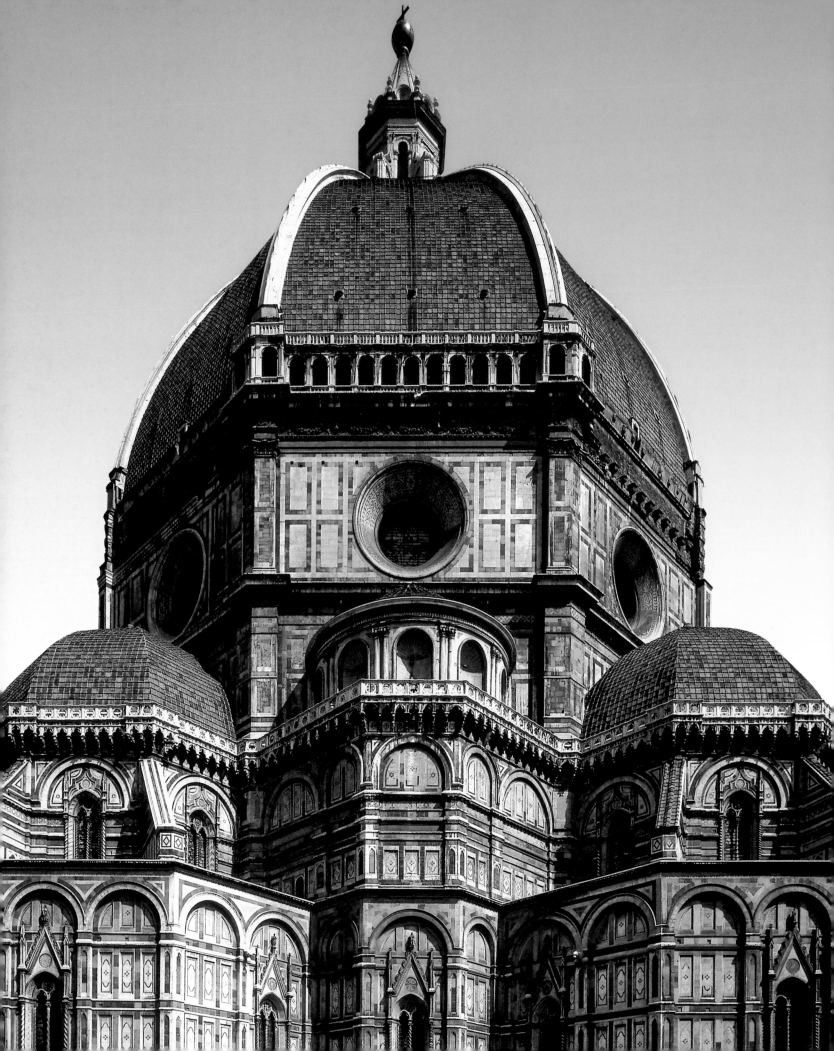

Architecture

Filippo Brunelleschi (born in Florence in 1377 – died in Florence in 1446)

Brunelleschi is regarded as the father of Renaissance architecture and one of the most famous Italian architects. Although he never worked as a painter, Brunelleschi was a pioneer in the art of perspective. In addition, he developed processes to transport building material to its required location, and constructed a self-supporting wall for domes. Filippo Brunelleschi began his career as an apprentice to a goldsmith. He passed his examination six years after his apprenticeship and was accepted into the goldsmiths' guild as a master. He started by renovating town houses and other buildings. He belonged to those artists, who in 1401/02 were defeated in the competition for the new doors of the baptistery for Florence Cathedral (his two panels from the competition are in Bargello) by another great goldsmith and sculptor, Lorenzo Ghiberti. This disappointment apparently made Brunelleschi give up sculpture and turn to architecture. An important sculpture from a different time is however attributed to him, namely a painted wooden crucifix in Santa Maria Novella (approximately 1412).

Filippo dedicated himself to architectural studies in Rome and developed the exceptional abilities, which enabled him to build one of the most important buildings of Renaissance architecture in Italy - the unfinished Gothic Cathedral in Florence (1420-36). This became one of the first examples for architectonic functionality and exhibits architectonic reliefs, circular windows and a wonderfully proportioned dome. In other buildings, such as the Church of San Lorenzo (1418-28) built by the Medici and the orphanage Ospedale degli Innocenti (1421-55), Brunelleschi employed a severe and geometrical style, inspired by the art of ancient Rome. Later Brunelleschi turned away from this linear, geometrical approach towards a more rhythmical style, more characterised by sculpture, especially in the unfinished Church Santa Maria degli Angeli (the building work started in 1434), the Basilica of Santo Spirito (started in 1436) and the Cappelli di Pazzi (started approximately 1441). This style embodied the first step towards to Baroque style. Filippo Brunelleschi died at the age of sixty-nine and was laid to rest in Florence Cathedral.

Leonardo da Vinci,
St John the Baptist, 1513-1515.
Oil on canvas, 69 x 57 cm.
Musée du Louvre, Paris.

Filippo Brunelleschi,
Duomo of Santa Maria del Fiore,
1420-1436.
Florence.

Leon Battista Alberti,
Santa Maria Novella (upper-part of the facade), 1458-1470.
Florence.

Leon Battista Alberti (born in Genua in 1404 – died in Rome in 1472)

Leon Battista Alberti was one of the outstanding personalities of the Renaissance. He employed the principles of mathematical perspective and developed a polished theory of art. Alberti came from an important Florentine family, who had, however, been banned from the town in 1387. When his family returned to Florence in 1429, Alberti, under the influence of Brunelleschi, Masaccio and Donatello, dedicated himself to the studies of architecture and art. Alberti quickly became the protégé of the Rucellai Family, for whom he created two of his most significant pieces of art in Florence, the Palazzo Rucellai in the Via della Vigna (started in 1455 and today the home of the Alinari Museum), and the elegant small Temple Santo Sepolcro (1467) in the Rucellai-Chapel near San Pancrazio (where the Marino Marini Museum is today). But the major part of his work as an architect was to take place in Rome: Alberti restored Santo Stefano Rotondo and Santa Maria Maggiore in Rimini, and built the unfinished Tempio Malatestiano (1450), the first building, which he tried to build according to his architectonic principles. Until this time, Alberti's experience as an architect had been of rather theoretical nature. Finally, towards the end of his career, he worked in Mantua, where he anticipated the typical religious architecture of the counter-reformation with the churches San Sebastiano (1460) and Sant'Andrea (1470). The facade of Santa Maria Novella (1458-71) is regarded as his most important work, as it unifies the already existing elements and the parts he added into a clear realisation of his new principles. Alberti was educated in the Latin and Greek

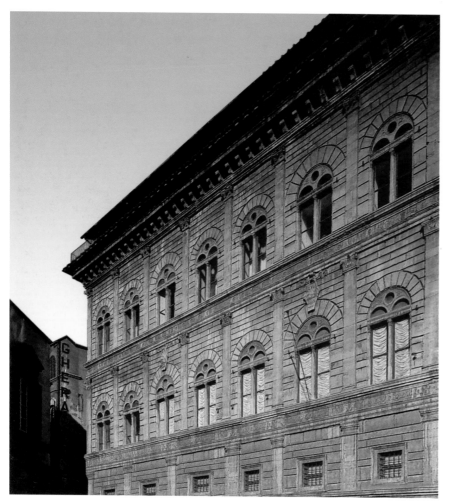

Leon Battista Alberti,
Palazzo Rucellai, 1456.
Florence.

Leon Battista Alberti,
Sant' Andrea, c. 1471.
Mantua.

languages, but never had a formal training as an architect. His architectonic ideas were therefore the result of his own studies and research. His two most important papers on architecture are *De Pictura* (1435), in which he emphatically supports the significance of painting as a foundation for architecture, as well as his theoretical masterpiece *De Re Aedificatoria* (1450). *De Re Aedificatoria* is also divided into ten books, like the ten books on architecture by Vitruvius. But unlike Vitruvius, Alberti told architects how buildings should be constructed, rather than focusing on how they had been built to date. *De Re Aedificatoria* claimed its importance as the classical treatise on architecture from the sixteenth to the eighteenth century.

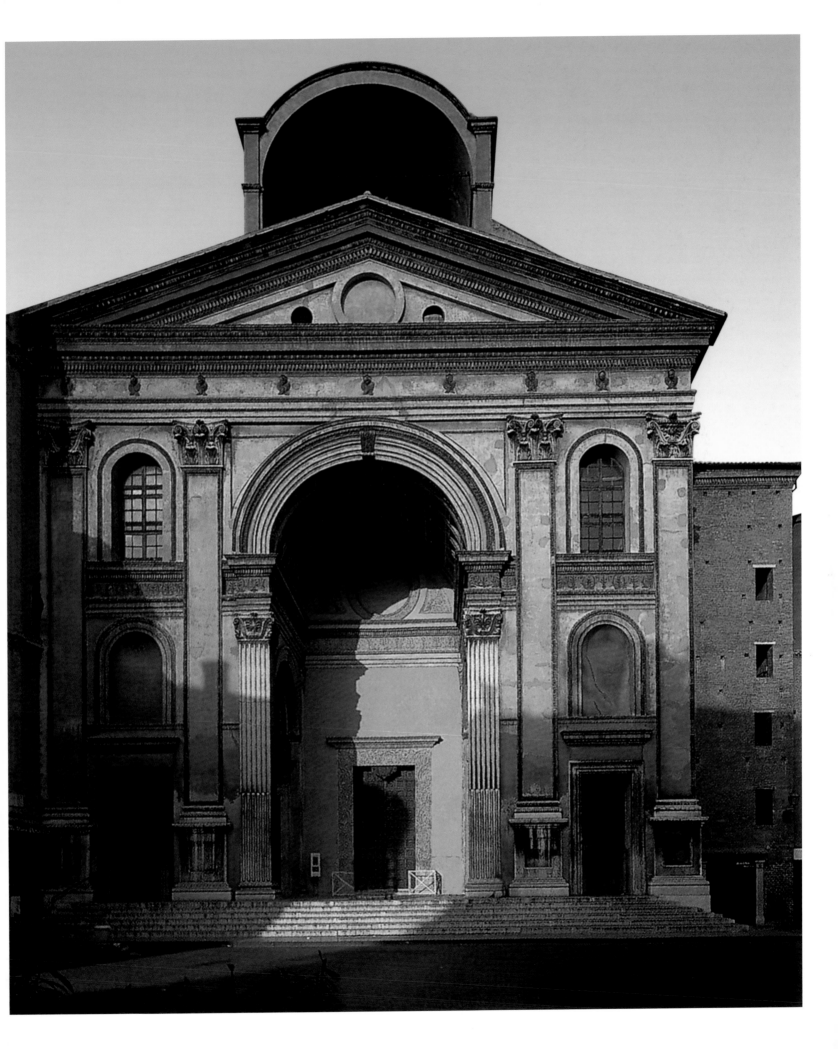

Michelozzo di Bartolomeo (with others),
Villa Medicea di Careggi, 1457.
Florence.

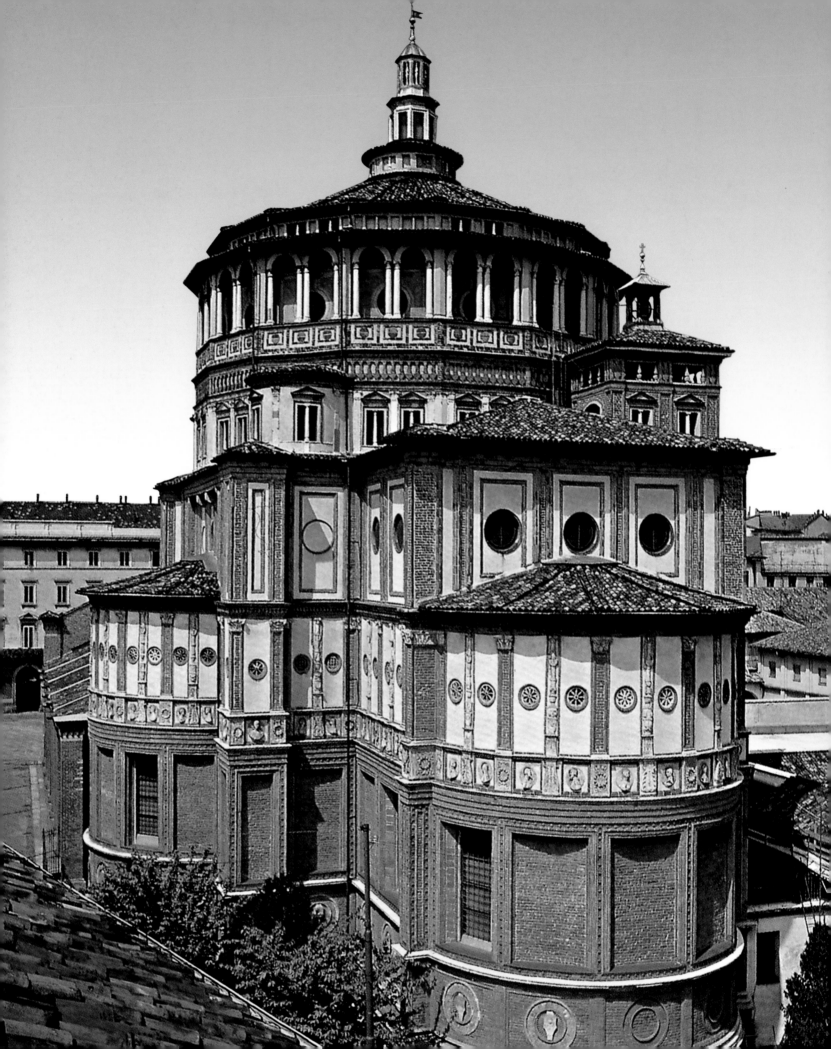

Donato Bramante (born in Urbino in 1444 – died in Rome in 1514)

Donato Bramante was born in Monte Asdruald (now Fermignano) near Urbino in 1444. We have little knowledge of his early training. He seems to have spent the largest part of his early career studying painting under Mantegna and Piero della Francesca. We hear about him for the first time in 1477, when he was working on frescoes in the Palazzo del Podesta in Bergamo. Afterwards he settled down in Milan in the 1480s. Although he created some buildings at this time (Santa Maria Presso, San Satiro, Santa Maria della Grazie, the cloisters of Sant' Ambrogio), his paintings, especially his use of the trompe l'oeil technique and the rigorous monumentality of his figures in solemn compositions, had a great influence on the Lombardic school. Bramante then moved from Milan to Rome in 1499, where he gained the favour of the future Pope Julius II. Here, Bramante began his exceptional new interpretation of the classical antiquity. In November 1503, Julius commissioned Bramante to renovate the Vatican. At first, Bramante dedicated himself to the basic new design of the Vatican palaces at the Belvedere. He worked on the new building of St Peter's from 1506 on, which was later continued by Michelangelo. Within a few years, Bramante had risen to the position of being the most important architect at the papal court. His historical significance lies not as much in his actual buildings, of which only a small part has been preserved, but rather that he constituted an important inspiration and a great influence with regard to later architects. Bramante died in 1514, a year later than his patron Pope Julius II.

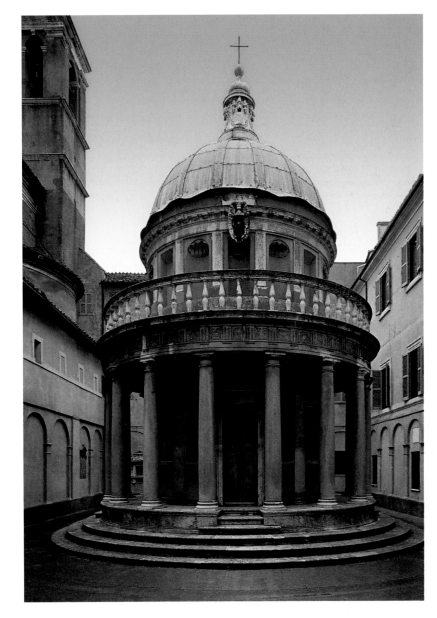

Giuliano da Sangallo (born in Florence in approximately 1445 – died in Florence in approximately 1516)

The Italian architect, military engineer, sculptor and wood carver Giuliano Giamberti, called Giuliano da Sangallo, is one of the most important figures of this epoch, on the basis of his contribution to the solution of the cultural problems of that time and as an heir and interpreter of Brunelleschi's tradition. His father, Francesco Giamberti, the founder of this famous family, worked as an architect and master builder of fortifications. His brother, Antonio da Sanagallo, the elder, and his nephew Antonio da Sanagallo, the younger, were also architects. His son, Francesco da Sangallo worked as a sculptor.

Giuliano went to Rome in 1465, were he occupied himself with the buildings and culture of classical antiquity. Fifteen years later he began his successful career there as an expert on various sectors of architecture. At the beginning of his career, Giuliano mainly worked for Lorenzo de' Medici, known as the "Magnificent", for whom he began building a beautiful palace in Poggio a Caiano between Florence and Pistoia in 1485, and strengthened the fortifications of Florence, Castellana and other places.

Giuliano also demonstrated his talent as a military engineer with the fortifications in the Val d'Elsa in Poggio Imperiale di Poggibonsi, as well as in Ostia, Nettuno, Arezzo, Sansepolcro. His designs for the sacristy of the Church Santo Spirito (Florence, 1489), the Palazzo Gondi (Florence, 1490), the Sassetti Chapel (Florence, Santa Trinita, 1485-1488), and the Villa Medici, embodying the new type of Renaissance villa (please refer to photo) in Poggio a Caiano (1480), followed Brunelleschi's tradition. Sangallo also made a major contribution to the innovative studies of the architectonic plan above the Greek cross, which led to the harmonious and elegant solution for the Church Santa Maria delle Carceri in Prato (1485). At the same time, he worked on the grand design for the Palazzo dei Tribunali in Naples (approximately 1490). Sangallo designed the same type of magnificent palace for the King of Naples, as he did for the French King. After Bramante's death in 1514 he worked together with Raphael on building St Peter's. He also took part in the building of the Church of San Lorenzo in Florence. Giuliano Sangallo died in Florence. He takes the credit for laying the foundations for the development of architectonic forms at the beginning of the sixteenth century.

Donato Bramante,
Santa Maria delle Grazie, 1492.
Milan.

Donato Bramante,
Tempietto San Pietro in Montorio, 1502.
Rome.

Giuliano da Sangallo,
Villa Medicea di Poggio a Caiano,
1480-1485.
Florence.

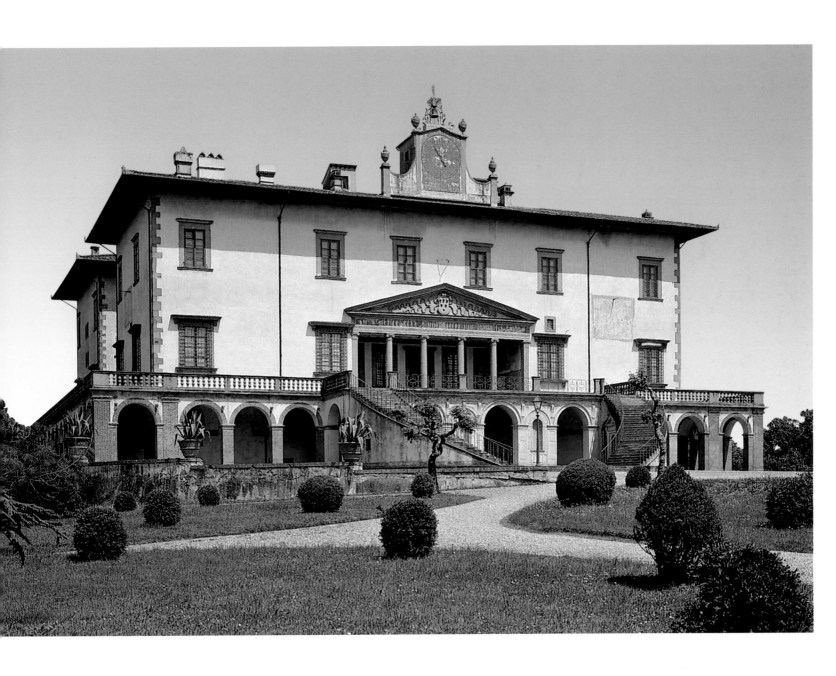

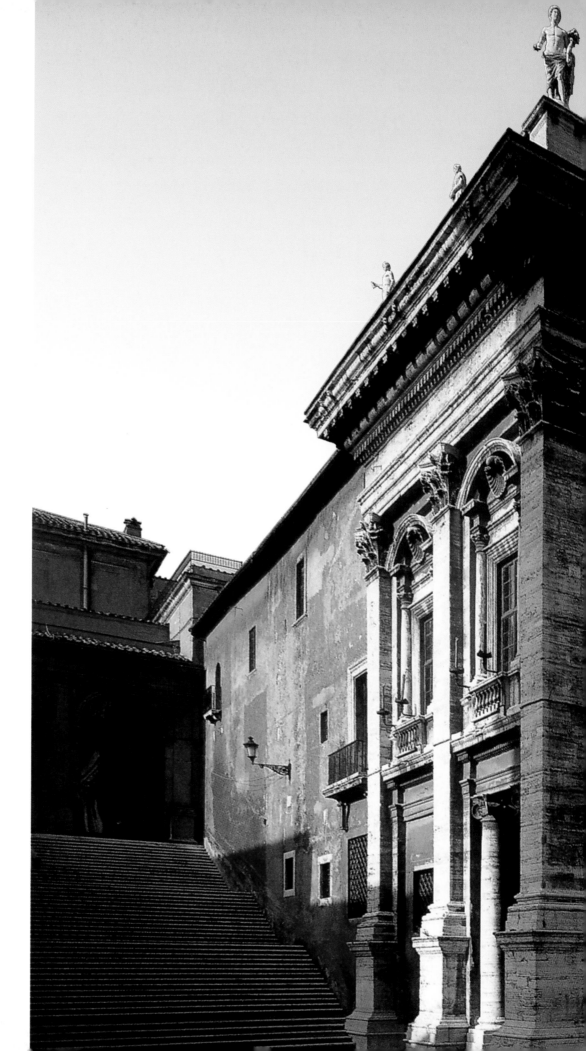

Michelangelo Buonarroti,
Frontview of the Conservative Palace,
1450-1568.
Capitol, Rome.

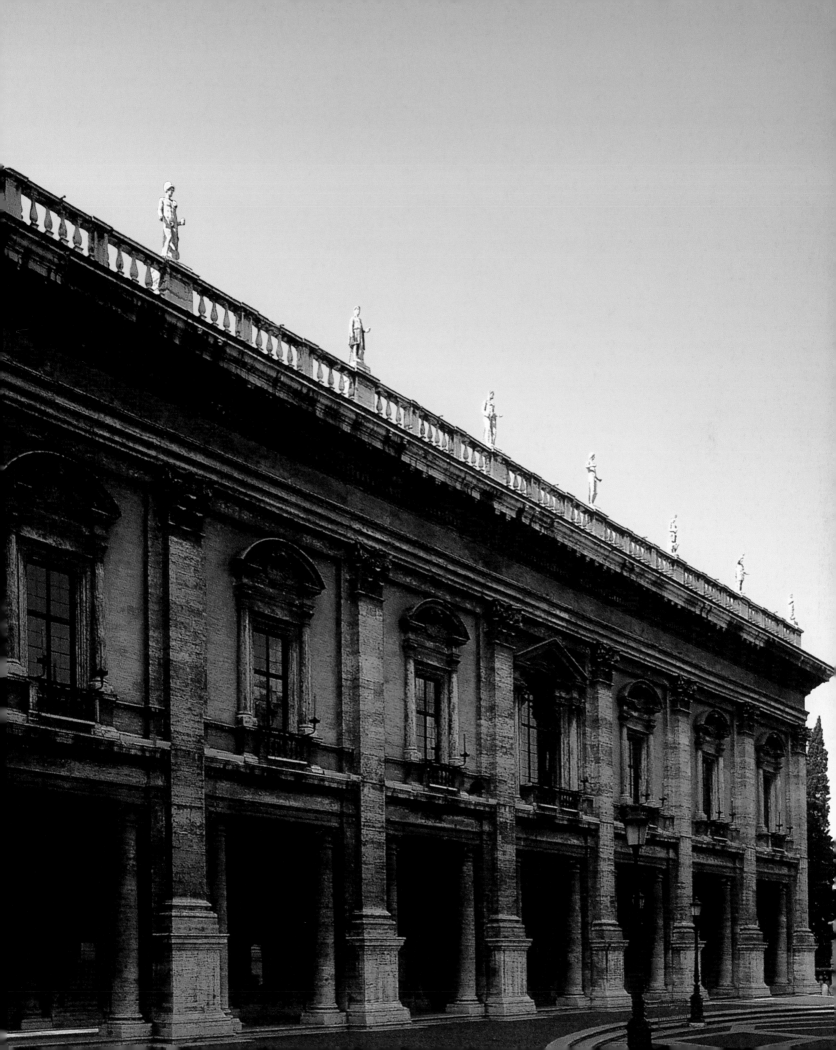

Jacopo Sansovino (born in Florence in 1486 – died in Venice in 1570)

The Italian sculptor and architect Jacopo Sansovino's original name was Jacopo Tatti. He took the surname Sansovino as a sign of respect for the Florentine sculptor Andrea Sansovino, who he was apprenticed to. He spent the years from 1506 to 1511 and from 1516 to 1527 in Rome, where he took part in theoretical and practical debates on architecture. His early sculptures were mainly influenced by classical antique art. Having dedicated himself to sculpture in his early years, he then designed several buildings in Rome as an architect and went to Venice in 1527, introducing the classical style of Roman architecture of the High Renaissance there. In 1529 he was appointed the highest master builder in the town, designing palaces, churches and public buildings. The style of these buildings was characterised by the merging of the classical tradition of the Florentine masters Bramante with the more decorative Venetian approach. His building work in Venice began with four notable buildings: the high altar of the Scuola Grande di San Marco (approximately 1533), the new Scuola Grande di Misericordia (building started 1533), the church of San Francesco della Vigna (started 1534) and the Palazzo Corner a San Maurizio (designed in 1532).

Jacopo Sansovino,
Villa Garzoni, 1547-1550.
Ponte Casale.

In addition to these masterpieces, he built the Palazzo Corner della Ca' Grande, the mint, the hall at the foot of the great campanile and several churches. When the Venetian town government made the decision to renew the town centre (the Piazza San Marco), in order to express municipal liberty symbolically, Sansovino was entrusted with the construction of the most important buildings of the new urban complex. Libreria Marciana, Zecca, Loggetta del campanile. Sansovino achieved a wonderful balance between classicism and Venetian tradition as a result of the successful studies of the urban complex. Another one of his masterpieces was the Villa Garzoni, laid out like a small factory, in Pontecasale (building started approximately 1540). Sansovino deserves the artistic importance of being the most significant figure in Venetian art of the sixteenth century. His designs became the fundamental model of Venetian palaces in the entire century. His outstanding masterpiece, the Libreria Vecchia (1536-88) at the Piazzetta San Marco follows the antique Roman theatre of Marcellus: Doric columns frame the arcade on the ground floor and Ionic columns the one on the first floor, so that there is a long majestic facade. As with all his buildings, the architecture is richly decorated with impressive free standing sculptures and friezes. Sansovino had a great influence on future Venetian architects Andrea Palladio and Baldassare Longhena.

Pietro Lombardo,
Santa Maria dei Miracoli, 1481-1489.
Venice.

Jacopo Sansovino,
Palazzo Corner de la Ca'Granda, 1537.
Venice.

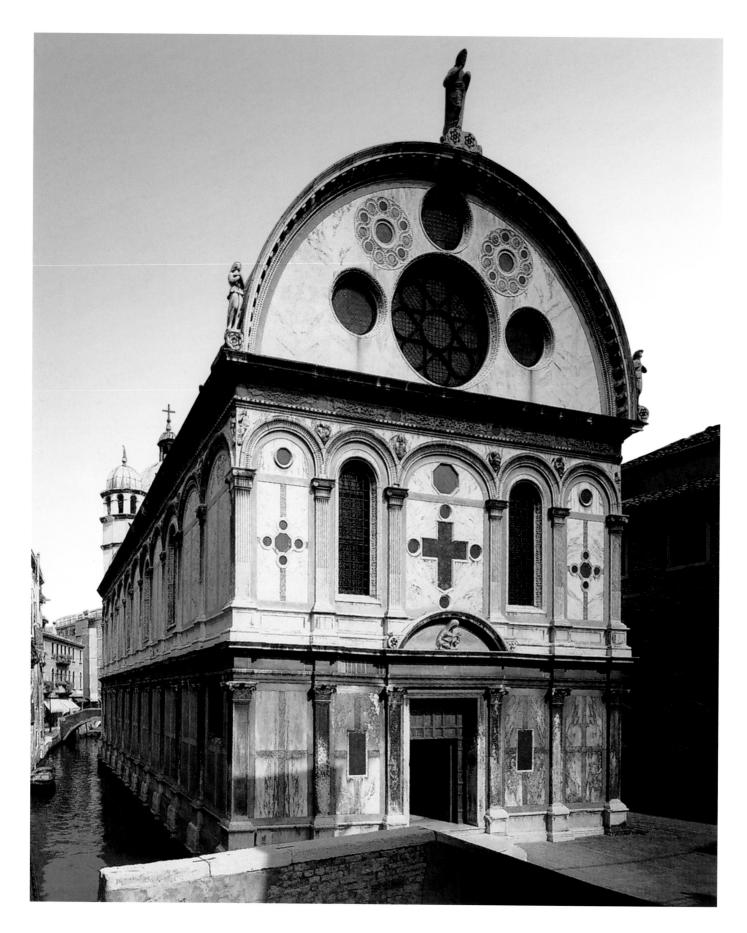

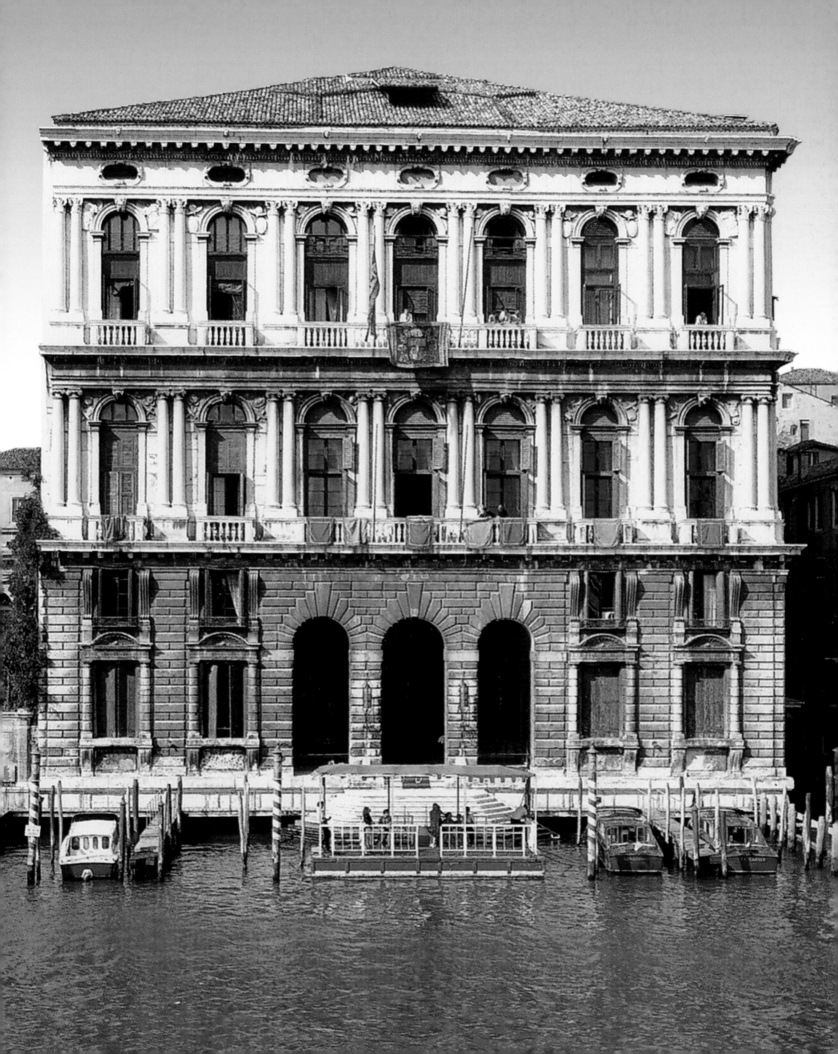

Andrea Palladio (born in Padua in 1508 – died in Vicenza in 1580)

Andrea Palladio was an important artist, architect and author for the entire development of Western architecture and beyond that a stonemason. His original name was Andrea di Pietro. Palladio, the name he adopted, refers to the Greek goddess of wisdom Pallas Athena. At the age of thirteen years we find him in the stonemasons' guild of Vicenza as an assistant. Then he met the amateur architect Giangiorgio Trissino, who looked after him and changed his name to Andrea Palladio. After a number of commissions in the classical tradition, he dedicated himself primarily to the construction of palaces and villas for the aristocracy. In the 1560s he took up the design for religious buildings. He completed the refectory of the Benedictine monastery San Giorgio Maggiore, the cloister of the monastery Santa Maria della Carita (now the Galleria dell'Accademia), and the facade of the church of San Francesco della Vigna. His Venetian work culminated in three magnificent churches, which have been preserved until this day: San Giorgio Maggiore, Il Redentore and "Le Zitelle" (Santa Maria della Presentazione). Surprisingly, in spite of numerous attempts, Palladio never managed to get commissions for worldly buildings in Venice. In 1570 he published his theoretical paper *I Quattro Libri dell'Architettura*. In the same year he was appointed architectonic consultant of the Venetian Republic. Although he was influenced by a number of thinkers and architects of the Renaissance, he developed his conceptions quite independently from most contemporary ideas. Palladio's work slightly lacks the splendour of other Renaissance architects, but instead he established a successful method, which survived the times, of invoking the architecture of classical antiquity as a source of inspiration. His loggias, equipped with colonnades, constituted an innovation, which was later taken up in the whole of Europe.

Palladio died in Vicenza in 1580.

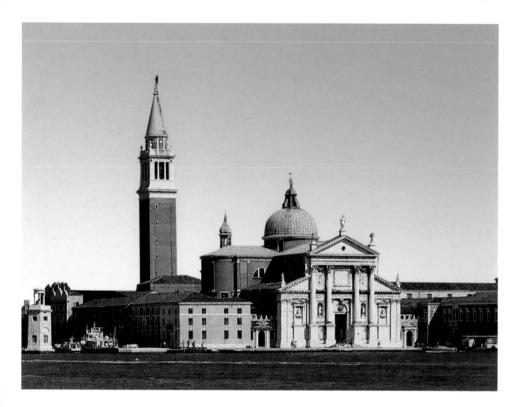

Andrea Palladio,
San Giorgio Maggiore, begun in 1566
(completed in 1610 by Simone Sorella).
Venice.

Andrea Palladio,
Il Redentore, 1577-1592.
Venice.

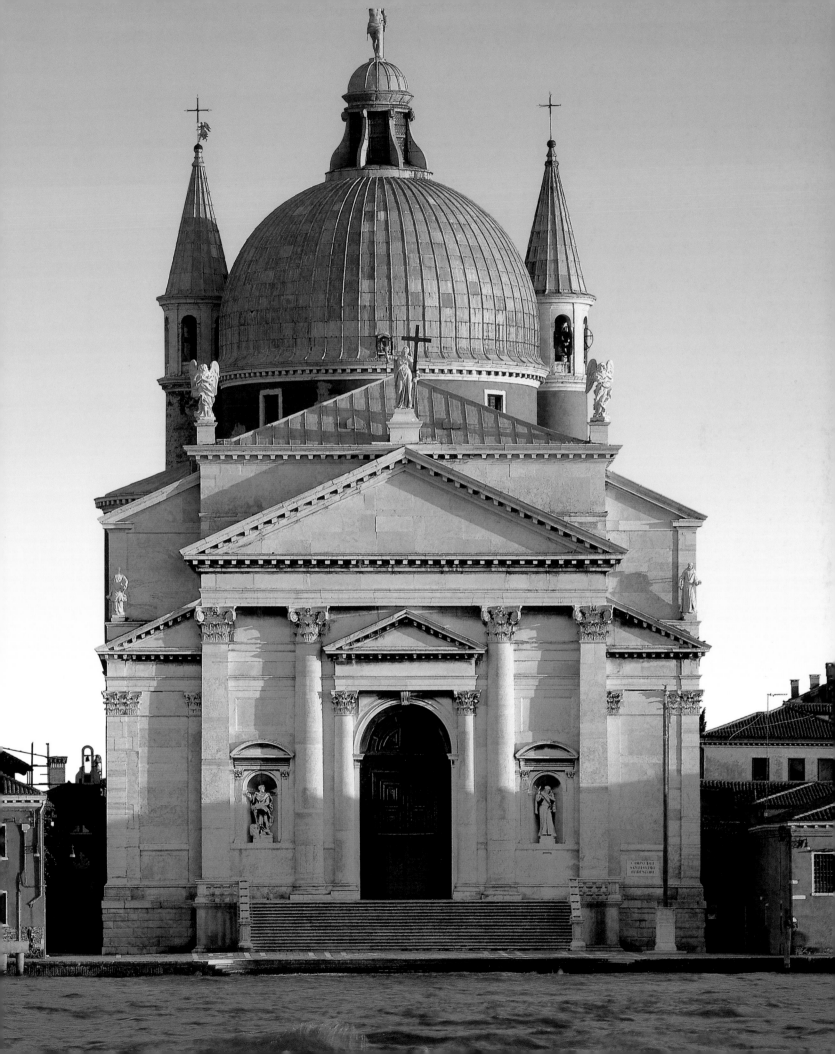

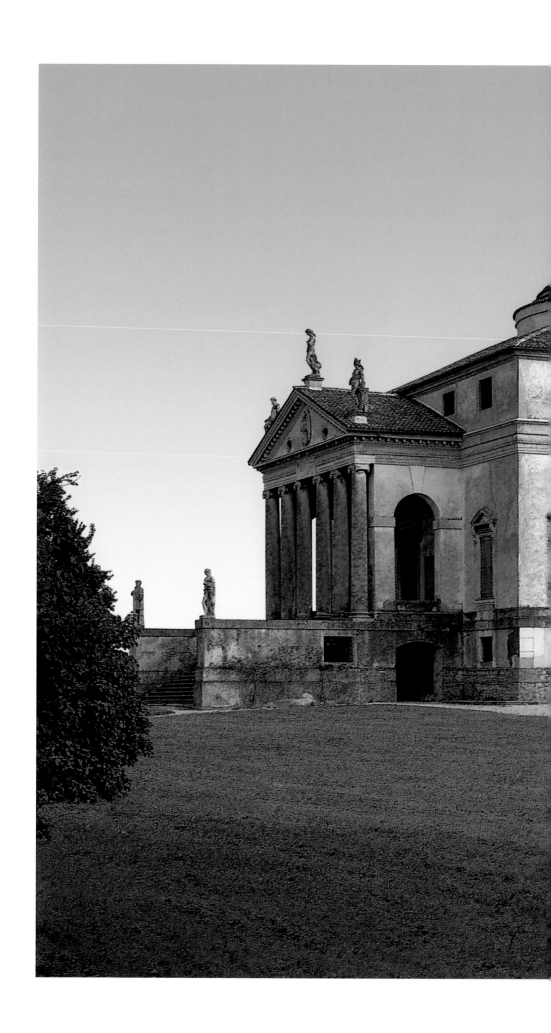

Andrea Palladio,
Villa Rotonda, begun in 1550 (and
completed by Vincenzo Scamozzi).
Vicenza.

Painting

Fra Angelico (Fra Giovanni da Fiesole) (born in Vicchio in 1387 – died in Rome in 1455)

Secluded within cloister walls, a painter and a monk, and brother of the order of the Dominicans, Angelico devoted his life to religious paintings.

Little is known of his early life except that he was born at Vicchio, in the broad fertile valley of the Mugello, not far from Florence, that his name was Guido de Pietro and that he passed his youth in Florence, probably in some bottegha, for at twenty he was recognised as a painter. In 1418 he entered in a Dominican convent in Fiesole with his brother. They were welcomed by the monks and, after a year's novitiate, admitted to the brotherhood, Guido taking the name by which he was known for the rest of his life, Fra Giovanni da Fiesole; for the title of *Angelico*, the "Angel," or *Il Beato*, "The Blessed," was conferred on him after his death.

Henceforth he became an example of two personalities in one man: he was all in all a painter, but also a devout brother; his subjects were always religious ones and represented in a deeply religious spirit, yet his devotion as a brother was no greater than his absorption as an artist. Consequently, though his life was secluded within the walls of the convent, he kept in touch with the art movements of his time and continually developed as a painter. His early work shows that he had learned of the illuminators who inherited the Byzantine traditions, and had been affected by the simple religious feeling of Giotto's work. Also influenced by Lorenzo Monaco and the Sienese School, he painted under the patronage of Cosimo de' Medici. Then he began to learn of that brilliant band of sculptors and architects who were enriching Florence by their genius. Ghiberti was executing his pictures in bronze upon the doors of the Baptistery; Donatello, his famous statue of *St George* and the dancing children around the organ-gallery in the Cathedral; and Luca della Robbia was at work upon his frieze of children, singing, dancing and playing upon instruments. Moreover, Masaccio had revealed the dignity of form in painting. Through these artists the beauty of the human form and of its life and movement was being manifested to the Florentines and to the other cities. Angelico caught the enthusiasm and gave increasing reality of life and movement to his figures.

Fra Angelico (Fra Giovanni da Fiesole),
The Annunciation (across from the top of the staircase to the second floor), 1450.
Fresco, 230 x 321 cm.
Convento di San Marco, Florence.

Lorenzo Monaco,
Adoration of the Magi, 1421-1422.
Tempera on panel, 115 x 170 cm.
Galleria degli Uffizi, Florence.

Gentile da Fabriano,
Adoration of the Magi, 1423.
Tempera on panel, 303 x 282 cm.
Galleria degli Uffizi, Florence.

128

OPVS·GENTILIS·DE·FABRIANO ·M·CCCC·XXIII·MENSIS·MAII·

129

Lorenzo Monaco,
Coronation of the Virgin, 1413.
Tempera on canvas, 450 x 350 cm.
Galleria degli Uffizi, Florence.

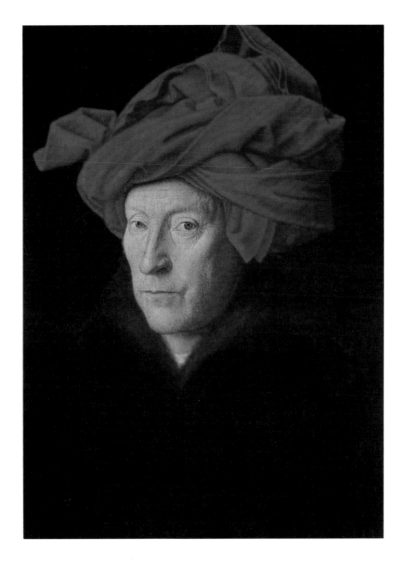

Jan and Hubert Van Eyck (born near Maastricht circa 1390 – died in Bruges in 1441) (born in Bruges circa 1366 – died in Bruges in 1426)

Little is known of these two brothers; even the dates of their births being uncertain. Their most famous work, begun by Hubert and finished by Jan, is the altarpiece, *The Adoration of the Lamb*. Jan, as perhaps also Hubert, was for a time in the service of Philip the Good, Duke of Burgundy. He was entered in the household as "varlet and painter", but acted at the same time as a confidential friend, and for his services received an annual salary of two horses for his use, and a "varlet in livery" to attend on him. The greater part of his life was spent in Bruges.

Their wonderful use of colour is another reason for the fame of the Van Eycks. Artists came from Italy to study their pictures, to discover what they themselves must do in order to paint so well, with such brilliance, such full and firm effect, as these two brothers. For the latter had found out the secret of working successfully with oil colours. Before their time, attempts had been made to mix colours in the medium of oil, but the oil was slow in drying, and the varnish added to remedy this had blackened the colours. The Van Eycks, however, had hit upon a transparent varnish which dried quickly, without injury to the tints. Though they guarded the secret jealously, it was discovered by the Italian Antonello da Messina, who was working in Bruges, and through him published to the world. The invention made possible the enormous development in the art of painting which ensued.

In these two brothers the grand art of Flanders was born. Like "the sudden flowering of the aloe, after sleeping through a century of suns," this art, rooted in the native soil, nurtured by the smaller arts of craftsmanship, reached its full ripeness and expanded into blossom. Such further development as it experienced came from Italian influence; but the distinctly Flemish art, born out of local conditions in Flanders, was already fully-grown.

Jan Van Eyck,
Portrait of a Man (Self-Portrait?), 1433.
Oil on wood, 26 x 19 cm.
The National Gallery, London.

Jan Van Eyck,
The Arnolfini Portrait, Giovanni Arnolfini and his Wife, 1434.
Oil on oak panel, 82.2 x 60 cm.
The National Gallery, London.

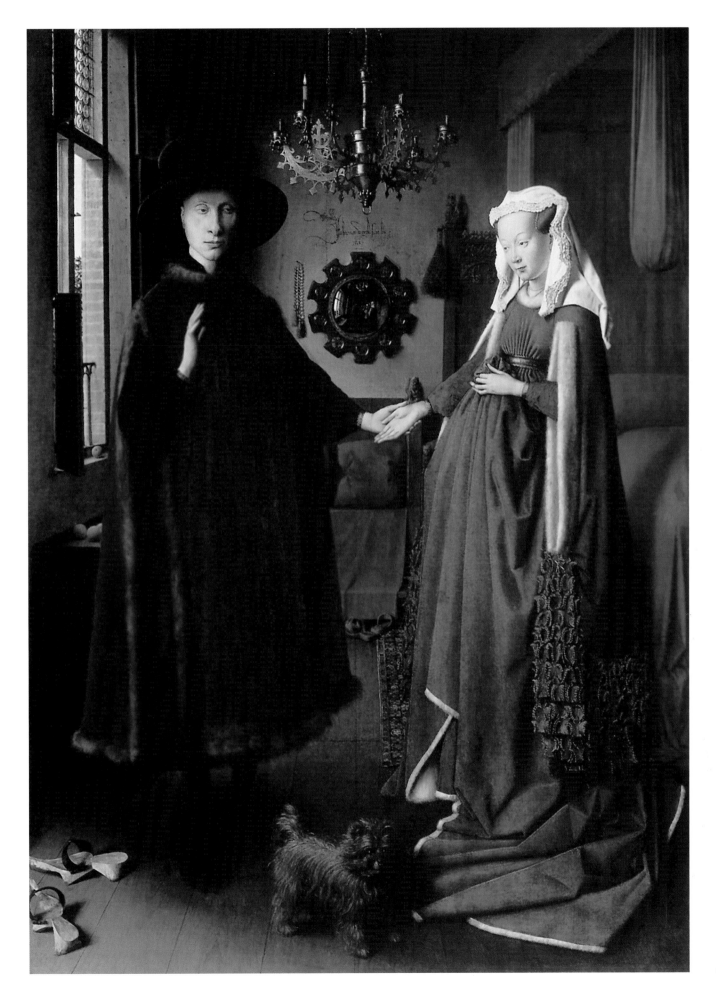

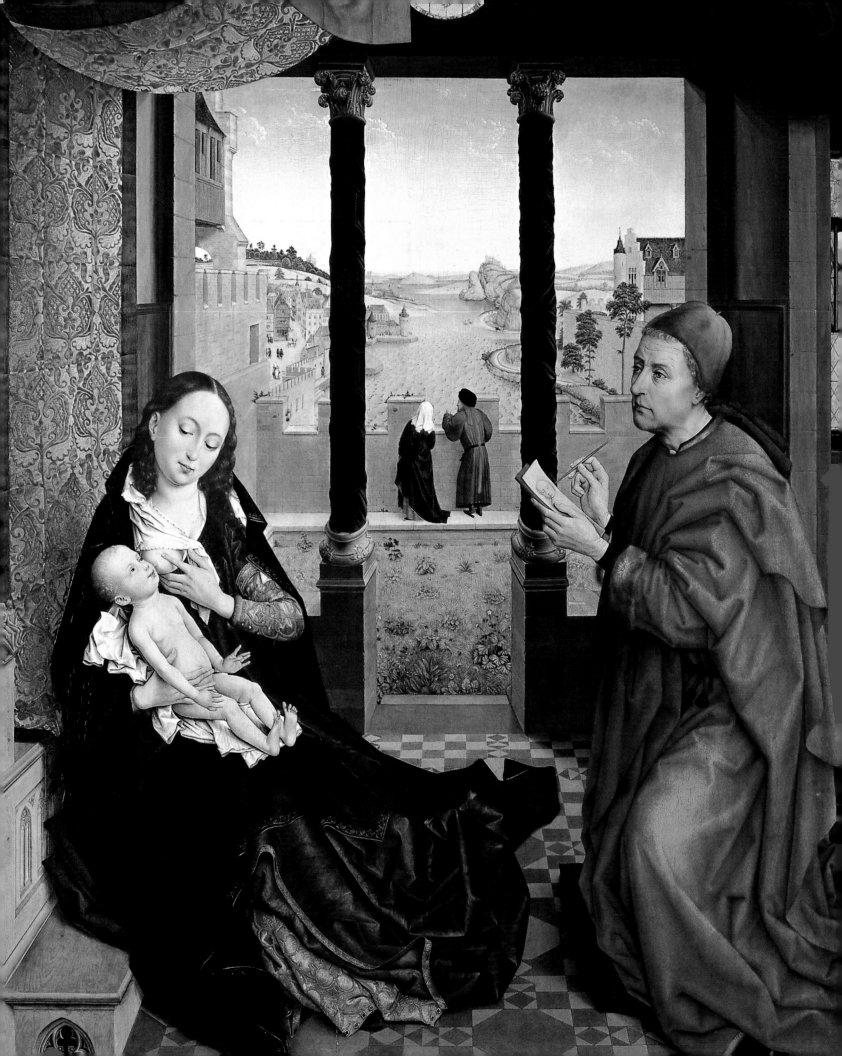

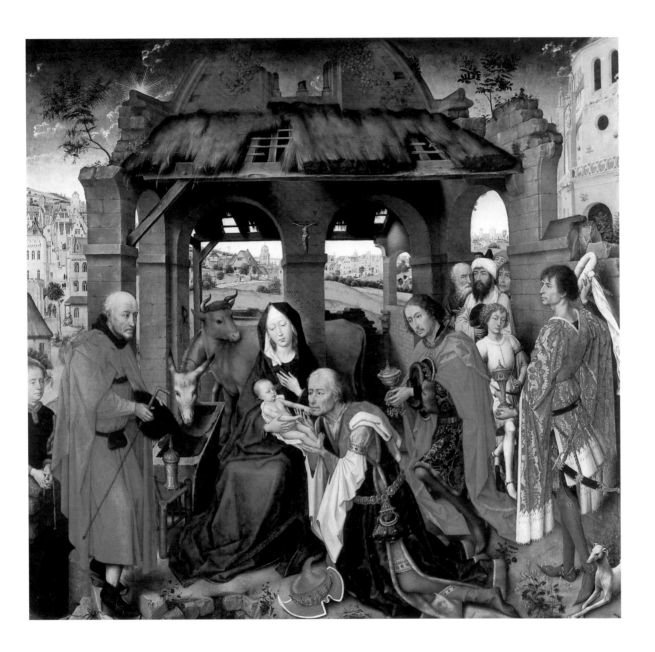

Rogier Van der Weyden (born in Tournai in 1399 – died in Brussels in 1464)

He lived in Brussels where he was the city's official painter (from 1436), but his influence was felt throughout Europe. One sponsor was Philip the Good, an avid collector. Van der Weyden is the only Fleming who truly carried on Van Eyck's great conception of art. He added to it a pathos of which there is no other example in his country except, though with less power and nobility, that of Hugo Van der Goes, who worked towards the end of the century. He had a considerable influence on the art of Flanders and Germany. Hans Memling was his most renowned pupil. Van der Weyden was the last inheritor of the Giottesque tradition and the last of the painters whose work is thoroughly religious.

Rogier Van der Weyden,
St Luke Drawing the Virgin, c. 1435-1440.
Oil on canvas, 102.5 x 108.5 cm.
The State Hermitage Museum,
St Petersburg.

Rogier Van der Weyden,
Adoration of the Magi (triptych, central panel), c. 1455.
Tempera on wood, 138 x 153 cm.
Alte Pinakothek, Munich.

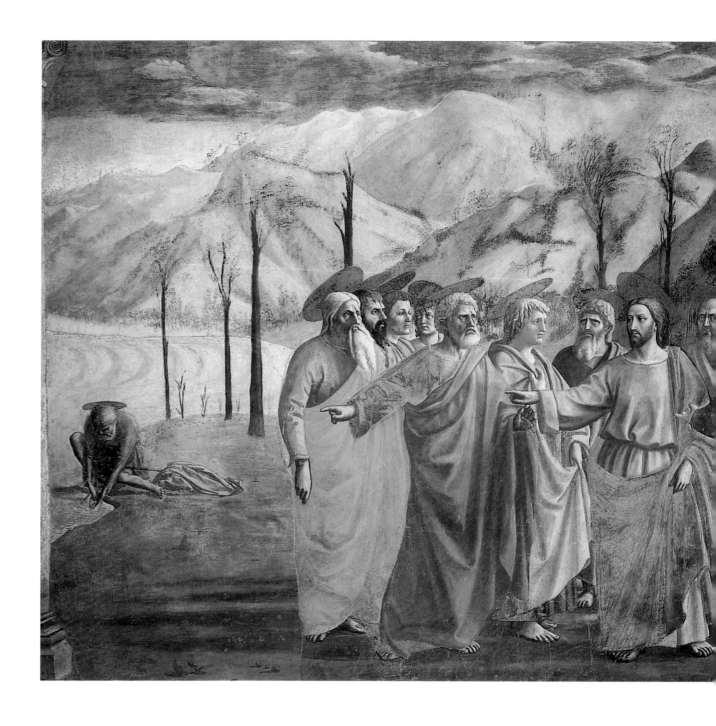

Masaccio (Tommaso Cassai),
The Tribute Money, c. 1428.
Fresco, 255 x 598 cm.
Brancacci Chapel of Santa Maria della
Carmine, Florence.

Masaccio (Tommaso Cassai) (born in San Giovanni Valdarno in 1401 – died in Rome in 1427)

He was the first great painter of the Italian Renaissance, innovatively using the scientific perspective. Masaccio, originally named Tommaso Cassai, was born in San Giovanni Valdarno, near Florence. He joined the painters' guild in Florence in 1422.

His influences came from the work of his contemporaries, the architect Brunelleschi and sculptor Donatello, from whom he acquired the knowledge of mathematical

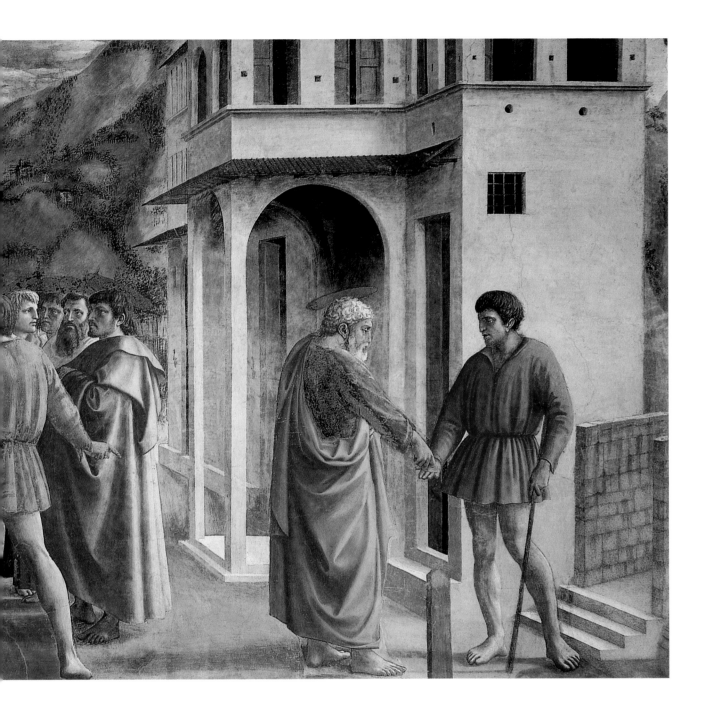

proportion that he used for scientific perspective, and the knowledge of classical art that led him away from the prevailing Gothic style.

He inaugurated a new naturalistic approach to painting that was concerned less with details and ornamentation than with simplicity and unity, less with flat surfaces than with the illusion of three-dimensionality.

Together with Brunelleschi and Donatello, he was a founder of the Renaissance. Masaccio's work exerted a strong influence on the course of later Florentine art and particularly on the work of Michelangelo.

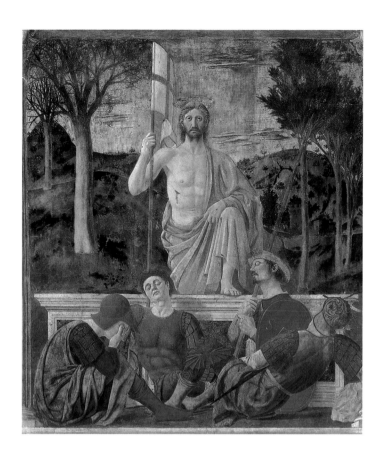

Piero della Francesca (born in Borgo San Sepulcro in 1416 – died in Borgo San Sepulcro in 1492)

Forgotten for centuries after his death, Francesca has been regarded, since his rediscovery in the early twentieth century, as one of the supreme artists of the *Quattrocento*. Born in Borgo San Sepolcro (now Sansepolcro) in Umbria, he spent much of his life there. His major work is a series of frescoes on the *Legend of the True Cross* in the choir of San Francesco at Arezzo (c. 1452-c. 1465).

While influenced at the beginning of his life by all the great masters of the generation before, his work represents a synthesis of all the discoveries these artists had made in the previous twenty years. He created a style in which monumental, meditative grandeur and almost mathematical lucidity are combined with limpid beauty of colour and light. He was a slow and thoughtful worker and often applied wet cloths to the plaster at night so that - contrary to normal fresco practice – he could work for more than one day on the same section. Piero's later career was spent working at the humanist court of Federico da Montefeltro at Urbino. Vasari said Piero was blind when he died, and failing eyesight may have been his reason for giving up painting. He had considerable influence, notably on Signorelli (in the weighty solemnity of his figures) and Perugino (in the spatial clarity of his compositions). Both are said to have been Piero's pupils.

Piero della Francesca,
Resurrection, 1463.
Fresco, 225 x 200 cm.
Museo Civico, Sansepolcro.

Masaccio (Tommaso Cassai),
Holy Trinity, c. 1428.
Fresco, 667 x 317 cm.
Santa Maria Novella, Florence

Piero della Francesca,
*The Duke (Federico da Montefeltro) and
Duchess of Urbino (Battista Sforza)*
(*diptych: left panel*), c. 1472.
Tempera on wood, 47 x 33 cm each panel.
Galleria degli Uffizi, Florence.

Piero della Francesca,
*The Duke (Federico da Montefeltro) and
Duchess of Urbino (Battista Sforza)*
(*diptych: right panel*), c. 1472.
Tempera on wood, 47 x 33 cm each panel.
Galleria degli Uffizi, Florence.

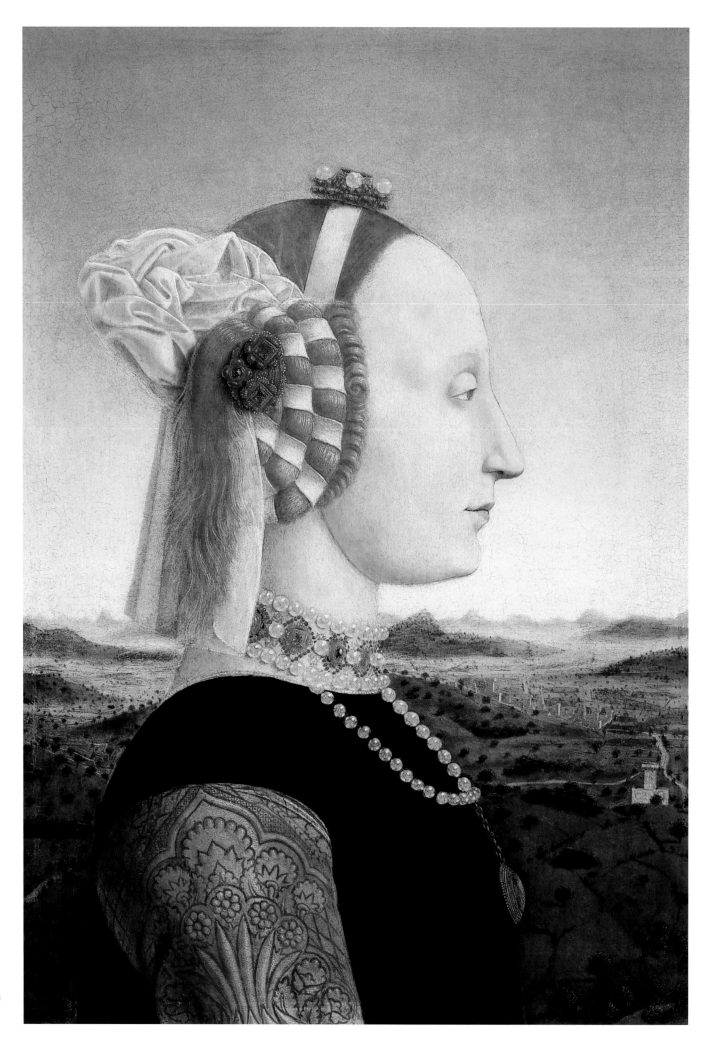

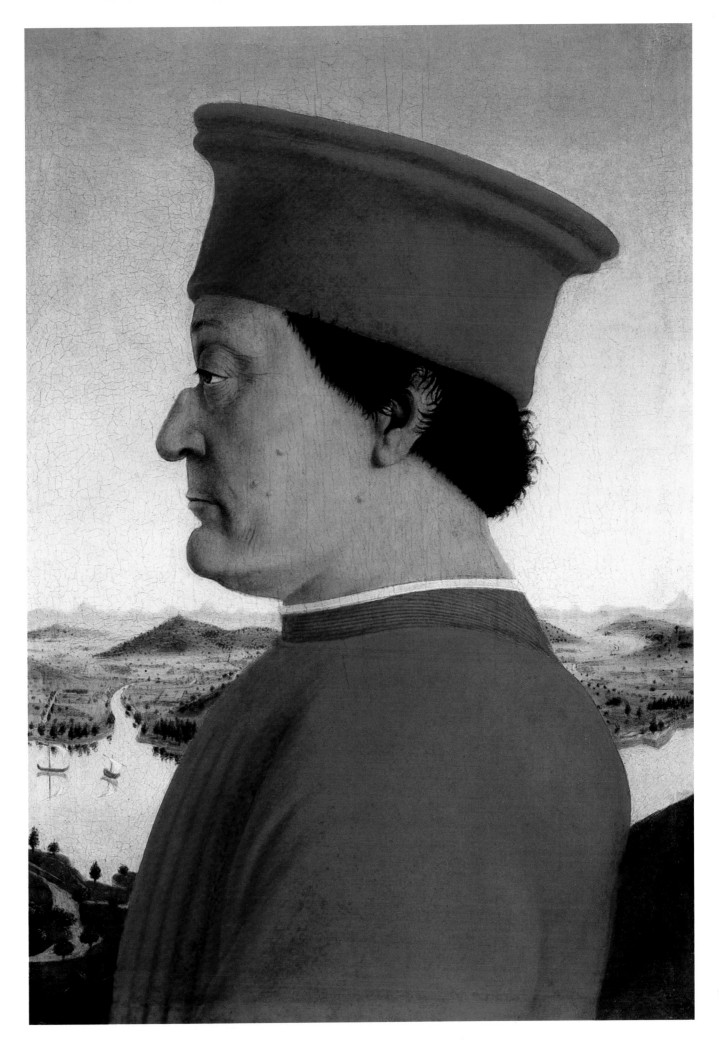

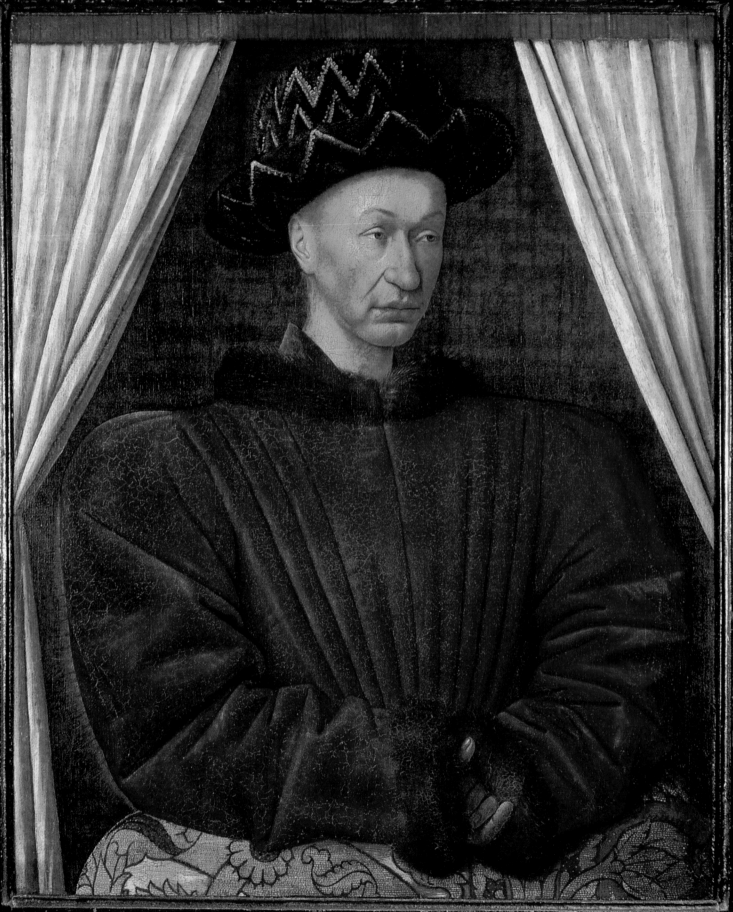

LE TRESVICTORIEVX ROY DE FRANCE

CHARLES SEPTIESME DE CE NOM

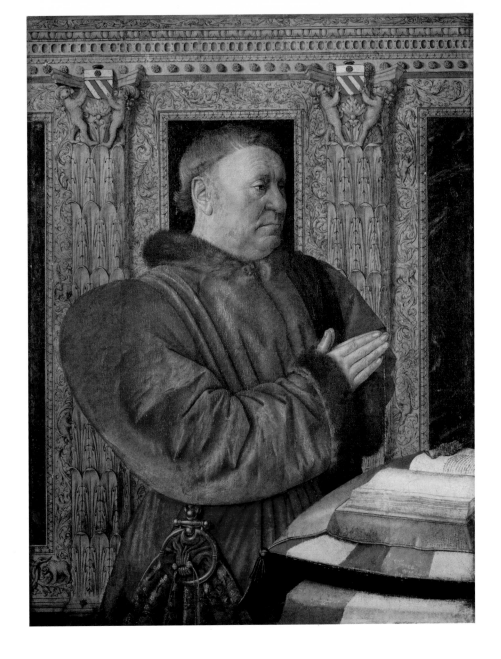

Jean Fouquet (born in Tours in 1420 – died in Tours in 1481)

A painter and illuminator, Jean Fouquet is regarded as the most important French painter of the fifteenth century. Little is known about his life but it is quite sure that he executed, in Italy, the portrait of Pope Eugenius IV. Upon his return to France, he introduced Italian Renaissance elements into French painting. He was the court painter to Louis XI. Whether he worked on miniatures rendering the finest detail, or on larger scale in panel paintings, Fouquet's art had the same monumental character. His figures are modelled in broad planes defined by lines of magnificent purity.

Jean Fouquet,
Portrait of Charles VII, c. 1450-1455.
Oil on panel, 85 x 70 cm.
Musée du Louvre, Paris.

Jean Fouquet,
Guillaume Jouvenel des Ursins,
Chancellor of France, c. 1465.
Oil on wood, 93 x 73 cm.
Musée du Louvre, Paris.

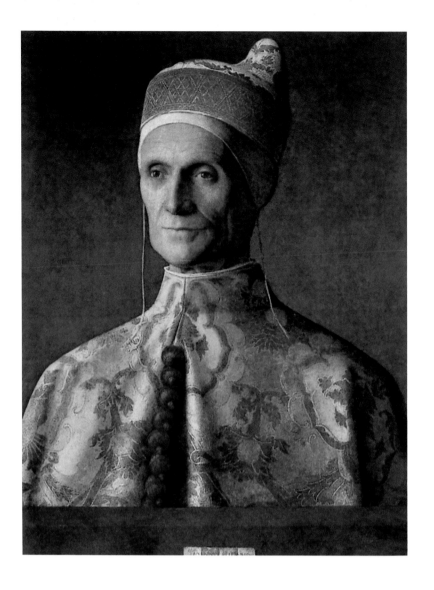

Giovanni Bellini (born in Venice in 1430 – died in Venice in 1516)

Giovanni Bellini was the son of Jacopo Bellini, a Venetian painter who was settled in Padua at the time Giovanni and his elder brother, Gentile, were in their period of studentship. Here they came under the influence of Mantegna, who was also bound to them by the ties of relationship, since he married their sister. To his brother-in-law, Bellini owed much of his knowledge of classical architecture and perspective, and his broad and sculptural treatment of draperies. Sculpture and the love of the antique played a large part in Giovanni's early impressions, and left their mark in the stately dignity of his later style. This developed slowly during his long life. Bellini died of old age, indeed in his eighty-eighth year, and was buried near his brother, Gentile, in the Church of Ss. Giovanni e Paulo. Outside, under the spacious vault of heaven, stands the Bartolommeo Colleoni, Verrocchio's monumental statue, which had been among the elevating influences of Bellini's life and art. After filling the whole of the north of Italy with his influence, he prepared the way for the giant colourists of the Venetian School, Giorgione, Titian, and Veronese.

Giovanni Bellini,
The Doge Leonardo Loredan,
c. 1501-1505.
Oil on poplar, 61 x 45 cm.
The National Gallery, London.

Giovanni Bellini,
St Zaccaria Altarpiece, 1505.
Oil and tempera on wood, transferred
to canvas, 402 x 273 cm.
San Zaccaria, Venice.

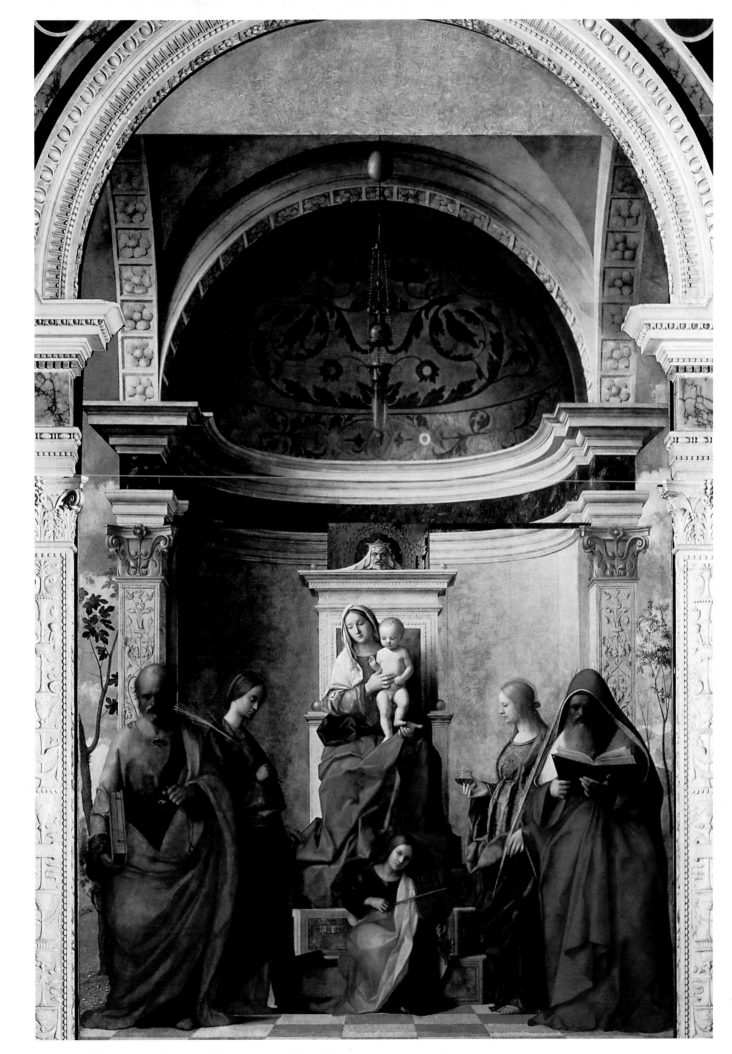

Andrea Mantegna (born in Isola di Carturo in 1431 – died in Mantova in 1506)

Humanist, geometrist and archaeologist, of great scholastic and imaginative intelligence, Mantegna dominated the whole of northern Italy by virtue of his imperious personality. Aiming at optical illusion, he mastered perspective. He trained in painting at the Padua School where Donatello and Paolo Uccello had previously attended. Even at a young age, commissions for Andrea's work flooded in, for example the frescoes of the Ovetari Chapel of Padua.

In a short space of time Mantegna found his niche as a modernist due to his highly original ideas and the use of perspective in his works. His marriage with Nicolosia Bellini, the sister of Giovanni, paved the way for his entrance into Venice.

Mantegna reached an artistic maturity with his *Pala San Zeno*. He remained in Mantova and became the artist for one of the most prestigious courts in Italy – the Court of Gonzaga. Classical art was born.

Despite his links with Bellini and Leonardo da Vinci, Mantegna refused to adopt their innovative use of colour or leave behind his own technique of engraving.

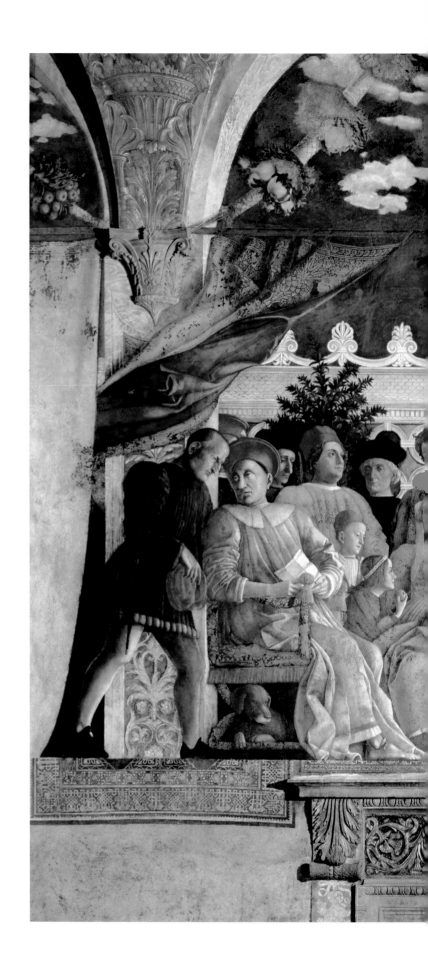

Andrea Mantegna,
North Wall, called the *Fireplace Wall*,
Camera Picta, 1465-1474.
Fresco, 99 x 71 cm.
Palazzo Ducale, Mantova.

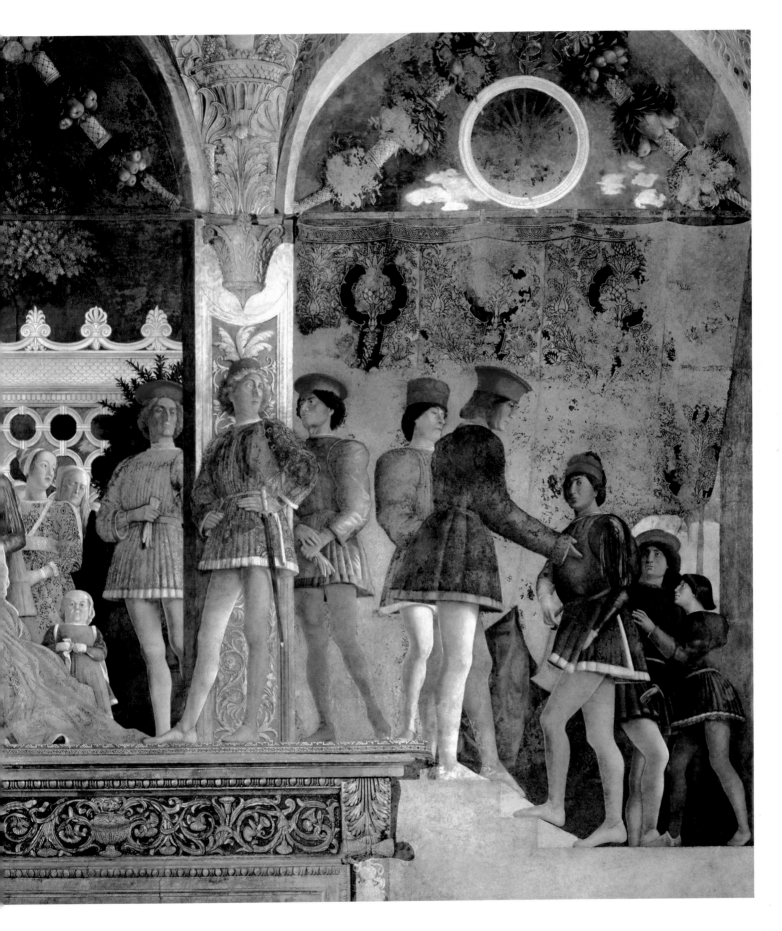

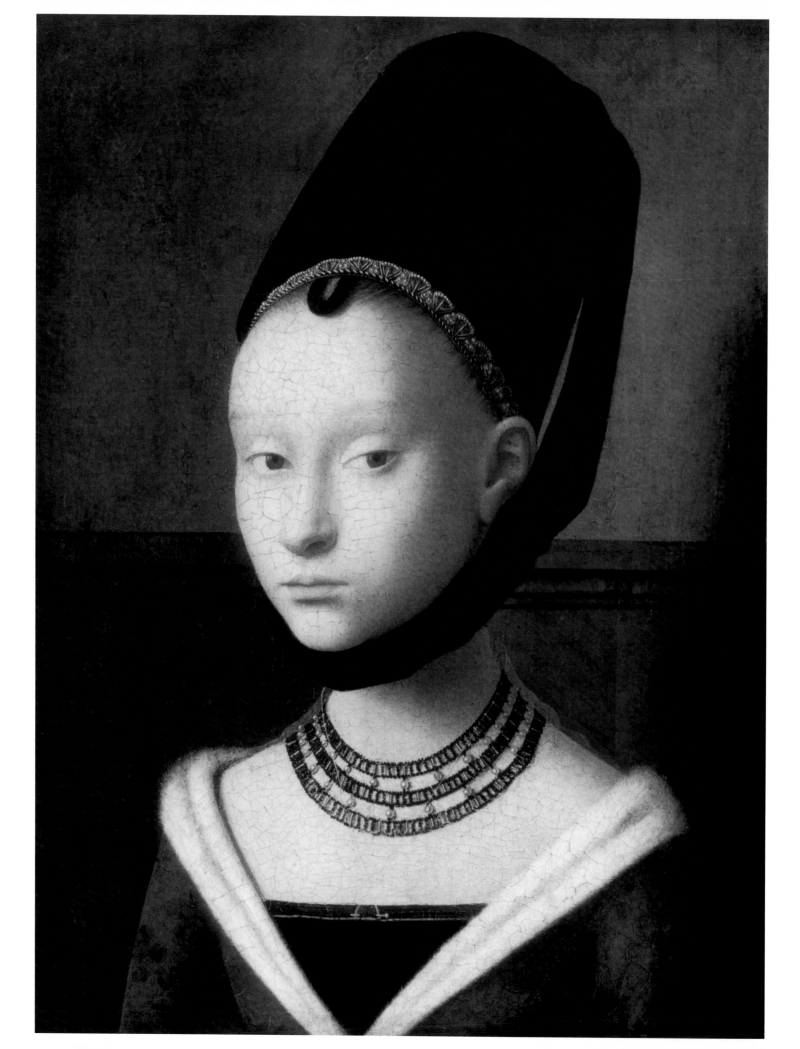

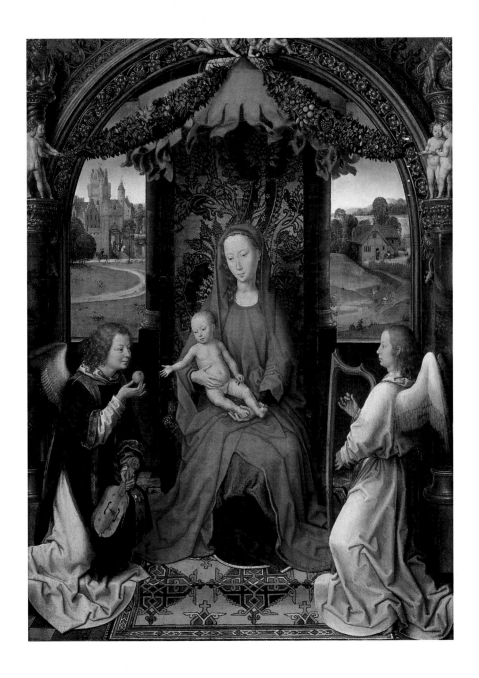

Hans Memling (born in Seligenstadt in 1433 – died in Bruges in 1494)

Little is known of Memling's life. It is surmised that he was a German by descent but the definite fact of his life is that he painted at Bruges, sharing with the Van Eycks, who had also worked in that city, the honour of being the leading artists of the so-called 'School of Bruges'. He carried on their method of painting, and added to it a quality of gentle sentiment. In his case, as in theirs, Flemish art, founded upon local conditions and embodying purely local ideals, reached its fullest expression.

Petrus Christus,
Portrait of a Young Lady, c. 1450.
Oil on wood panel, 17.5 x 12.5 cm.
Gemäldegalerie, Berlin.

Hans Memling,
Madonna Enthroned with Child and Two Angels, c. 1480.
Oil on panel, 57 x 42 cm.
Galleria degli Uffizi, Florence.

Sandro Botticelli (Alessandro di Mariano Filipepi) (born in Florence in 1445 – died in Florence in 1510)

He was the son of a citizen in comfortable circumstances, and had been, in Vasari's words, "instructed in all such things as children are usually taught before they choose a calling." However, he refused to give his attention to reading, writing and accounts, continues Vasari, so that his father, despairing of his ever becoming a scholar, apprenticed him to the goldsmith Botticello: whence came the name by which the world remembers him. However, Sandro, a stubborn-featured youth with large, quietly searching eyes and a shock of yellow hair – he has left a portrait of himself on the right-hand side of his picture of the *Adoration of the Magi* – would also become a painter, and to that end was placed with the Carmelite monk Fra Filippo Lippi. But he was a realist, as the artists of his day had become, satisfied with the joy and skill of painting, and with the study of the beauty and character of the human subject instead of religious themes. Botticelli made rapid progress, loved his master, and later on extended his love to his master's son, Filippino Lippi, and taught him to paint, but the master's realism scarcely touched Lippi, for Botticelli was a dreamer and a poet.

Botticelli is a painter not of facts, but of ideas, and his pictures are not so much a representation of certain objects as a pattern of forms. Nor is his colouring rich and lifelike; it is subordinated to form, and often more of a tint than actual colour. In fact, he was interested in the abstract possibilities of his art rather than in the concrete. For example, his compositions, as has just been said, are a pattern of forms; his figures do not actually occupy well-defined places in a well-defined area of space; they do not attract us by their suggestion of bulk, but as shapes of form, suggesting rather a flat pattern of decoration. Accordingly, the lines which enclose the figures are chosen with the primary intention of being decorative.

It has been said that Botticelli, "though one of the worst anatomists, was one of the greatest draughtsmen of the Renaissance." As an example of false anatomy we may notice the impossible way in which the Madonna's head is attached to the neck, and other instances of faulty articulation and incorrect formation of limbs may be found in Botticelli's pictures. Yet he is recognised as one of the greatest draughtsmen: he gave to 'line' not only intrinsic beauty, but also significance. In mathematical language, he resolved the movement of the figure into its factors, its simplest forms of expression, and then combined these various forms into a pattern which, by its rhythmical and harmonious lines, produces an effect upon our imagination, corresponding to the sentiments of grave and tender poetry that filled the artist himself.

This power of making every line count in both significance and beauty distinguishes the great master- draughtsmen from the vast majority of artists who used line mainly as a necessary means of representing concrete objects.

Sandro Botticelli (Alessandro di Mariano Filipepi),
Virgin with Child with Five Angels
(*Magnificat Madonna*), c. 1482-1485.
Tondo, diameter: 118 cm.
Galleria degli Uffizi, Florence.

Sandro Botticelli (Alessandro di Mariano Filipepi),
The Birth of Venus, c. 1485.
Tempera on canvas, 173 x 279 cm.
Galleria degli Uffizi, Florence.

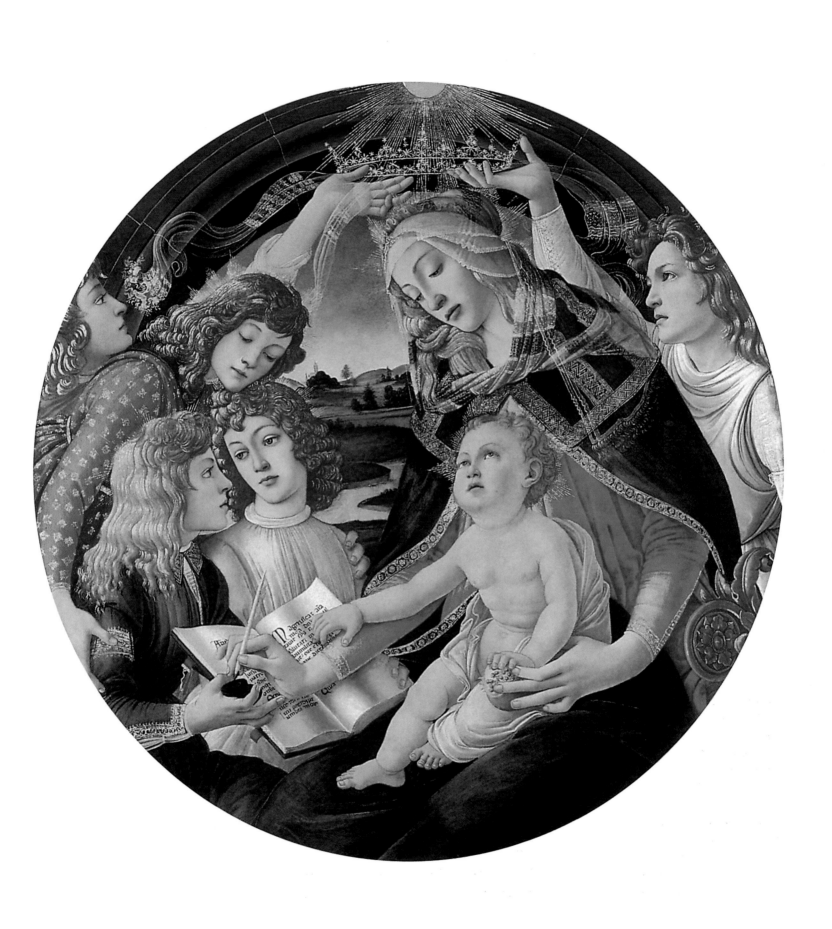

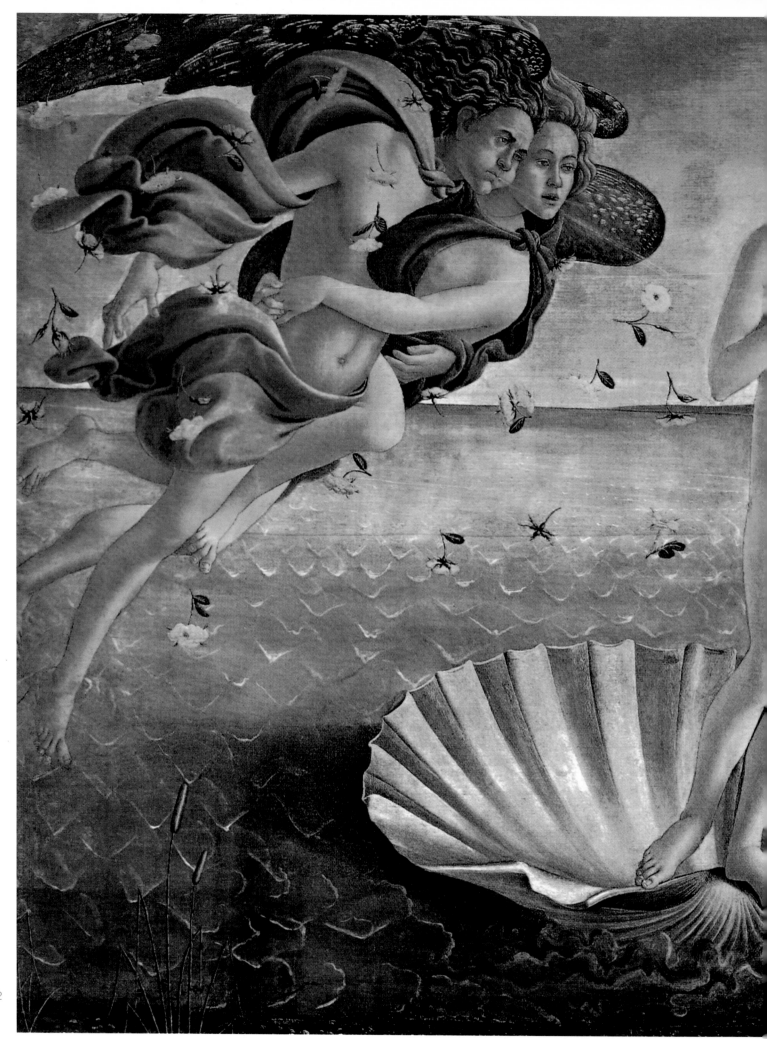

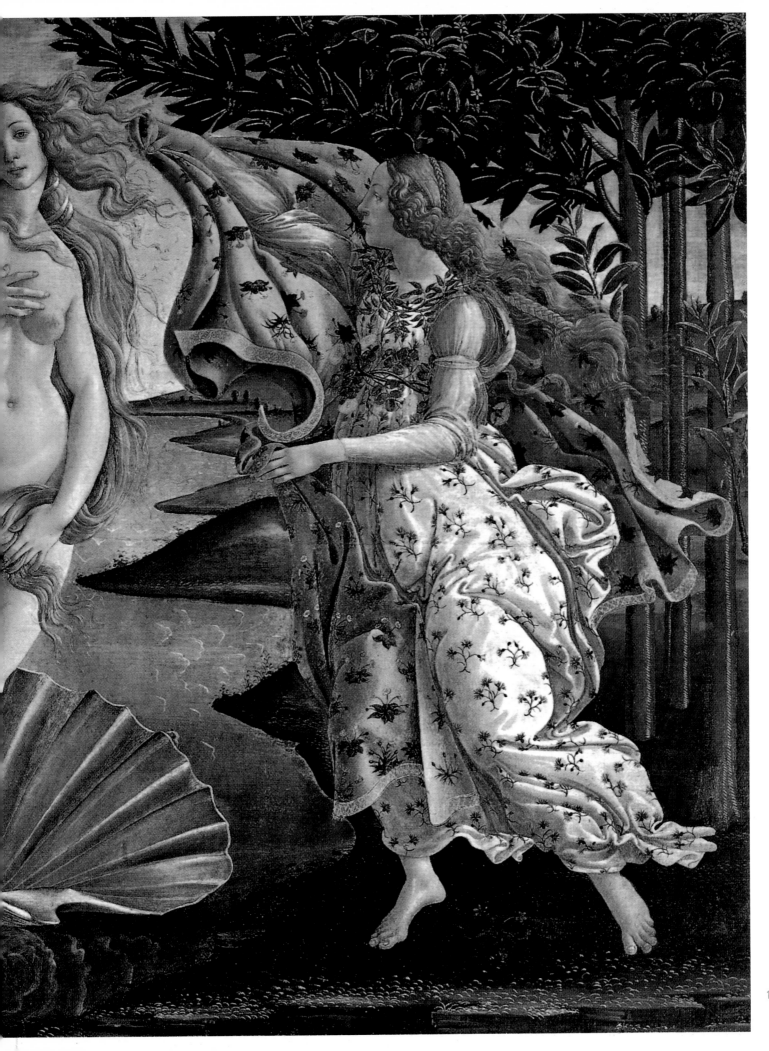

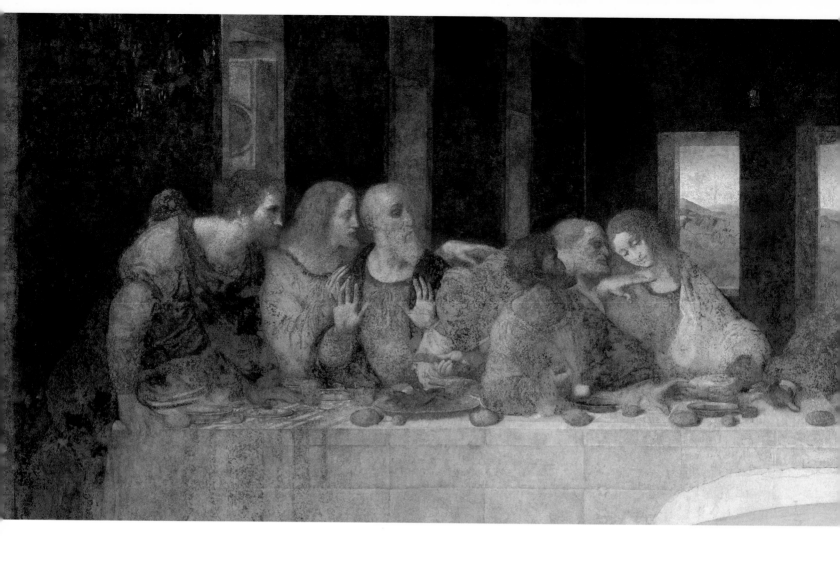

Leonardo da Vinci (born in Vinci in 1452 – died in Le Clos-Lucé in 1519)

Leonardo's early life was spent in Florence, his maturity in Milan, and the last three years of his life in France. Leonardo's teacher was Verrocchio. First he was a goldsmith, then a painter and sculptor: as a painter, representative of the very scientific school of draughtsmanship; more famous as a sculptor, being the creator of the Colleoni statue at Venice, Leonardo was a man of striking physical attractiveness, great charm of manner and conversation, and mental accomplishment. He was well grounded in the sciences and mathematics of the day, as well as a gifted musician. His skill in draughtsmanship was extraordinary; shown by his numerous drawings as well as by his comparatively few paintings. His skills are at the service of most minute observation and analytical research into the character and structure of form.

Leonardo is the first a series of great men who had the desire to create in a picture a kind of mystic unity brought about by the fusion of matter and spirit. Now that the Primitives had concluded their experiments, ceaselessly pursued during two centuries, by the conquest of the methods of painting, he was able to pronounce the words which served as a password to all later artists worthy of the name: painting is a spiritual thing, *cosa mentale*.

Leonardo da Vinci,
The Last Supper, 1495-1497.
Oil and tempera on stone, 460 x 880 cm.
Convent of Santa Maria delle Grazie,
refectory, Milan.

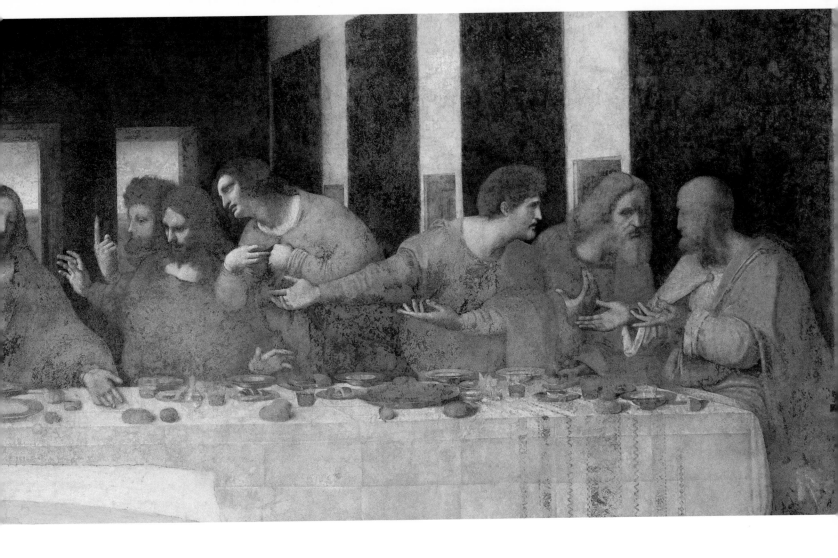

He completed Florentine draughtsmanship in applying to modelling by light and shade, a sharp subtlety which his predecessors had used only to give greater precision to their contours. This technique is called *sfumato*. This marvellous draughtsmanship, this modelling and chiaroscuro he used not solely to paint the exterior appearance of the body but, as no one before him had done, to cast over it a reflection of the mystery of the inner life. In the *Mona Lisa* and his other masterpieces he even used landscape not merely as a picturesque decoration, but as a sort of echo of that interior life and an element of a perfect harmony.

Relying on the still novel laws of perspective this doctor of scholastic wisdom, who was at the same time an initiator of modern thought, substituted for the discursive manner of the Primitives the principle of concentration which is the basis of classical art. The picture is no longer presented to us as an almost fortuitous aggregate of details and episodes. It is an organism in which all the elements, lines and colours, shadows and lights, compose a subtle tracery converging on a spiritual, a sensuous centre. It was not with the external significance of objects, but with their inward and spiritual significance, that Leonardo was occupied.

Leonardo da Vinci,
Portrait of Cecilia Gallerani, also called
The Lady with an Ermine, 1483-1490.
Oil on panel, 54 x 39 cm.
Czartoryski Museum, Cracow.

Leonardo da Vinci,
Mona Lisa, also called *La Gioconda,*
c. 1503-1506.
Oil on poplar panel, 77 x 53 cm.
Musée du Louvre, Paris.

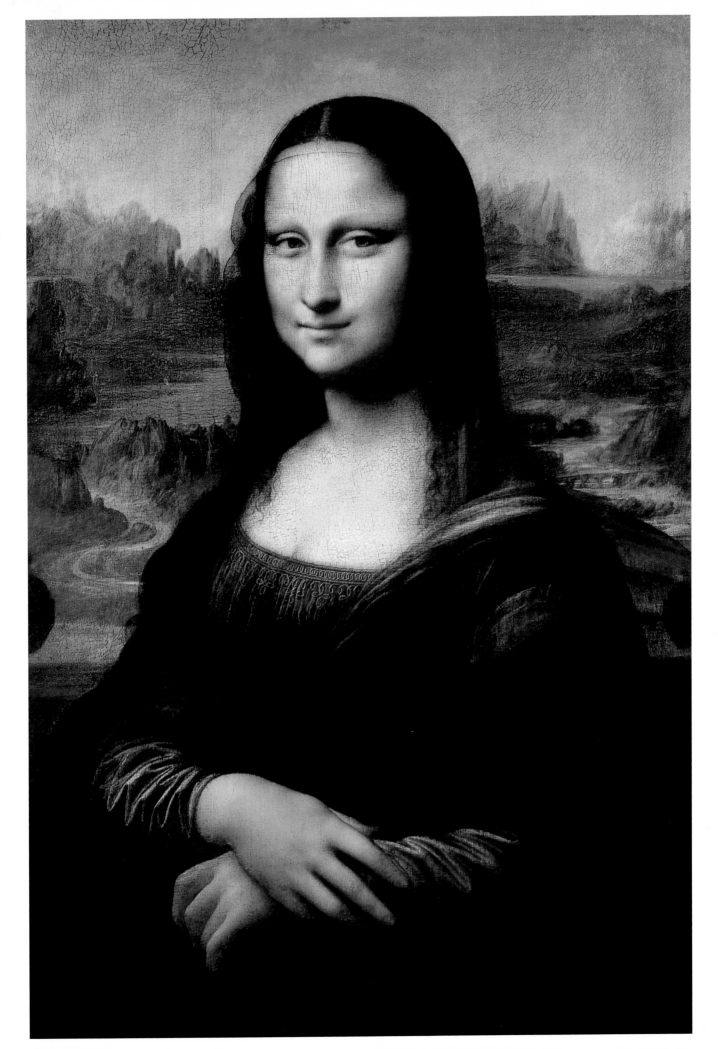

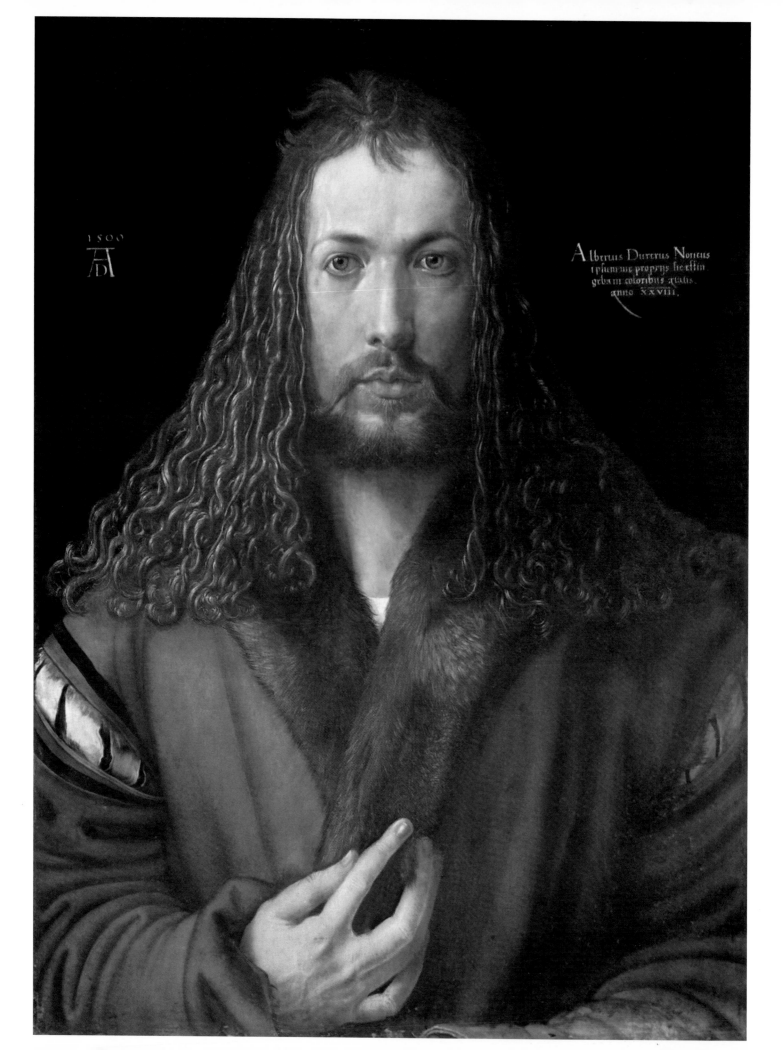

Albrecht Dürer (born in Nuremberg in 1471 – died in Nuremberg in 1528)

Dürer is the greatest of German artists and most representative of the German mind. His skill in draughtsmanship was extraordinary. Dürer is even more celebrated for his engravings on wood and copper than for his paintings. With both, the skill of his hand was at the service of the most minute observation and analytical research into the character and structure of form. He was a great admirer of Luther; and in his own work is the equivalent of what was mighty in the Reformer.

The Renaissance in Germany was more a moral and intellectual, than an artistic movement, partly due to northern conditions. The feelings of ideal grace and beauty are fostered by the study of the human form, and this flourished, predominantly in southern Europe. But Albrecht Dürer had a genius too powerful to be conquered. He remained profoundly Germanic in his penchant for drama, as was his contemporary Mathias Grünewald, a fantastic visionary and rebel against all Italian seductions. Dürer, in spite of all his tense energy, dominated conflicting passions by a sovereign and speculative intelligence comparable with that of Leonardo. He, too, was on the border of two worlds, that of the Gothic age and that of the modern age, and on the border of two arts, being an engraver and draughtsman rather than a painter.

Raphael (Raffaello Sanzio) (born in Urbino in 1483 – died in Rome in 1520)

Raphael was the artist who most closely resembled Pheidias. The Greeks said that the latter invented nothing; rather, he carried every kind of art invented by his forerunners to such a pitch of perfection that he achieved pure and perfect harmony. Those words, "pure and perfect harmony," express, in fact, better than any others what Raphael brought to Italian art. From Perugino, he gathered all the weak grace and gentility of the Umbrian School, he acquired strength and certainty in Florence, and he created a style based on the fusion of Leonardo's and Michelangelo's lessons under the light of his own noble spirit.

His compositions on the traditional theme of the Virgin and Child seemed intensely novel to his contemporaries, and only their time-honoured glory prevents us now from perceiving their originality. He manifests an even greater in the composition and realisation of those frescoes with which, from 1509, he adorned the Stanze and the Loggia at the Vatican. The sublime, which Michelangelo attained though his ardour and passion, Raphael attained by the sovereign balance of intelligence and sensibility. One of his masterpieces, *The School of Athens*, was created by genius: the multiple detail, the portrait heads, the suppleness of gesture, the ease of composition, the identifiable life circulating everywhere within the light are his most admirable and traits.

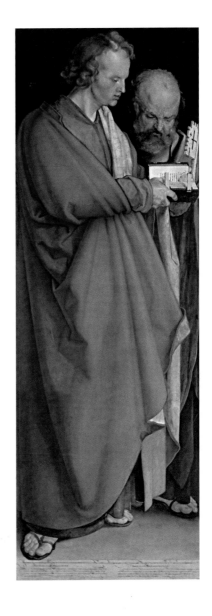

Albrecht Dürer,
Self-Portrait in a Fur-Collared Robe, 1500.
Oil on limewood panel, 67.1 x 48.9 cm.
Alte Pinakothek, Munich.

Albrecht Dürer,
The Four Holy Men (diptych, left pannel), 1526.
Oil on linenwood panels, 215 x 76 cm.
Alte Pinakothek, Munich.

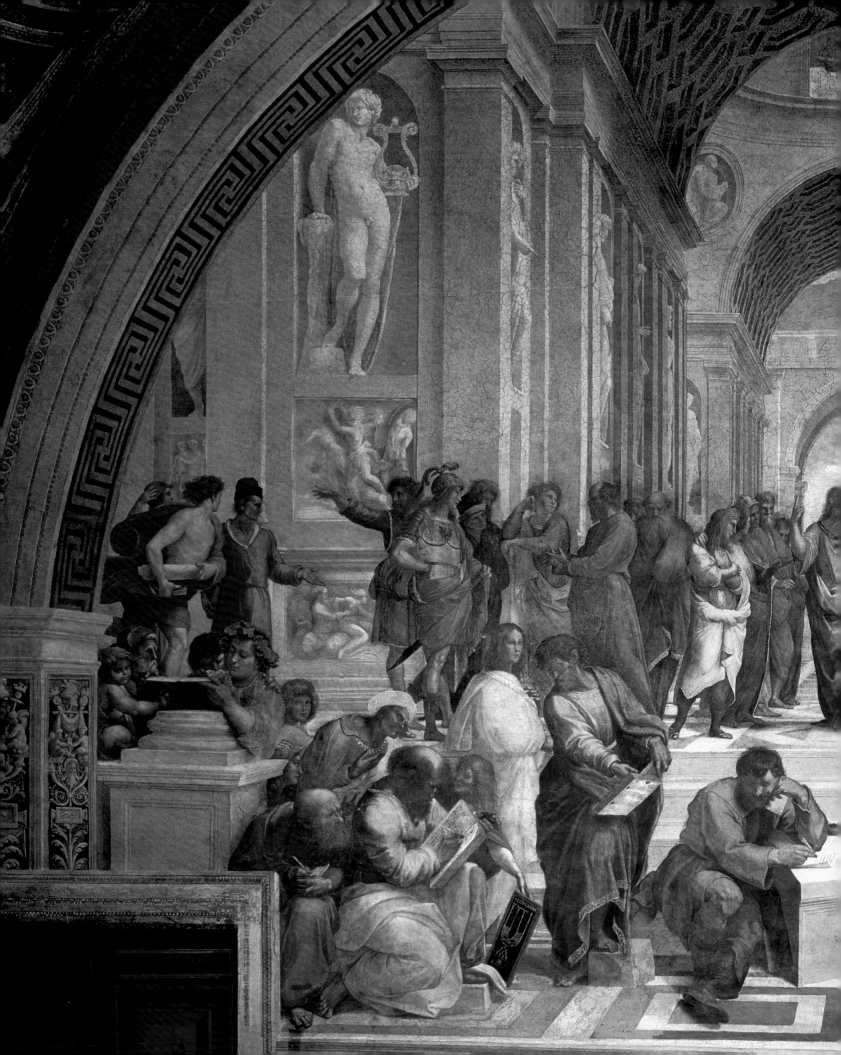

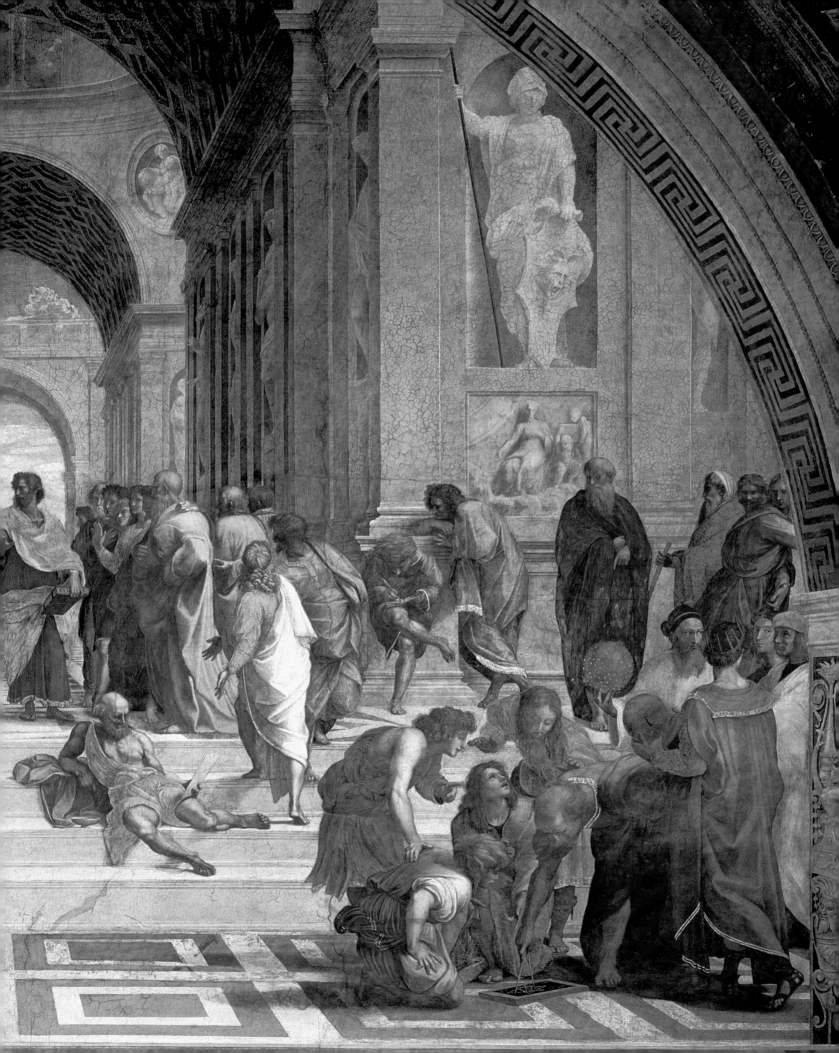

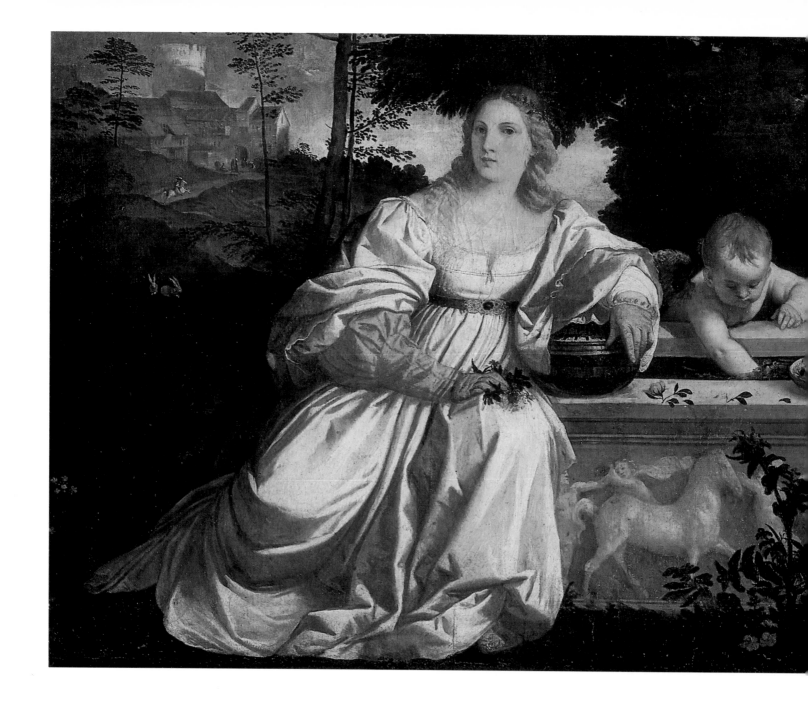

Titian (Vecellio Tiziano) (born in Pieve di Cadore in 1488 – died in Venice in 1576)

Titian was at once a genius and a favourite of fortune; he moved through his long life of pomp and splendour serene and self-contained. The details of his early life are not certain. He was of an old family, born at Pieve in the mountain district of Cadore. By the time that he was eleven years old he was sent to Venice, where he became the pupil, first of Gentile Bellini, and later of Gentile's brother, Giovanni. He then worked with the great artist Giorgione. He worked on major frescoes in Venice and Padua, as well as commissions in France and Spain. His equestrian portrait of Charles V (1549) symbolises

Raphael (Raffaello Sanzio),
The School of Athens, 1510-1511.
Fresco, width at the base: 770 cm.
Stanza della Segnatura, Vatican.

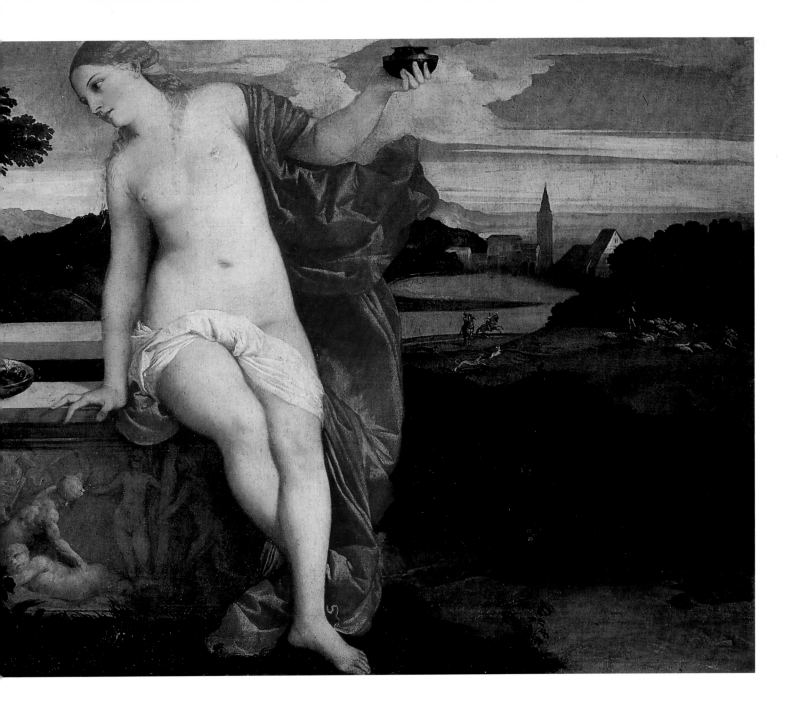

a military victory over Protestant princes in 1547. Titian then went to Rome for commissions by Pope Paul III, then in Spain to work exclusively for Philip II.

No artist's life was so completely and consistently superb; and such, too, is the character of his work. He was great in portraiture, in landscape, in the painting of religious and mythological subjects. Titian's beautiful reclining women are among the most original of the creations of the Venetian school and particularly of its great masters, to which he and Giorgione belonged. His works differ greatly from the Florentine nude, which is generally standing, resembling sometimes, in the fine precision of its contours, the precious work of a goldsmith and sometimes the great marble of a sculptor.

Titian (Vecellio Tiziano),
Sacred and Profane Love, c. 1514.
Oil on canvas, 118 x 279 cm.
Galleria Borghese, Rome.

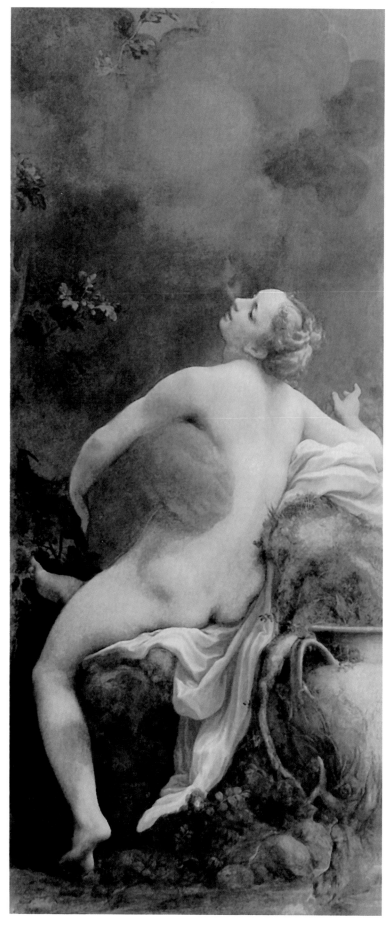

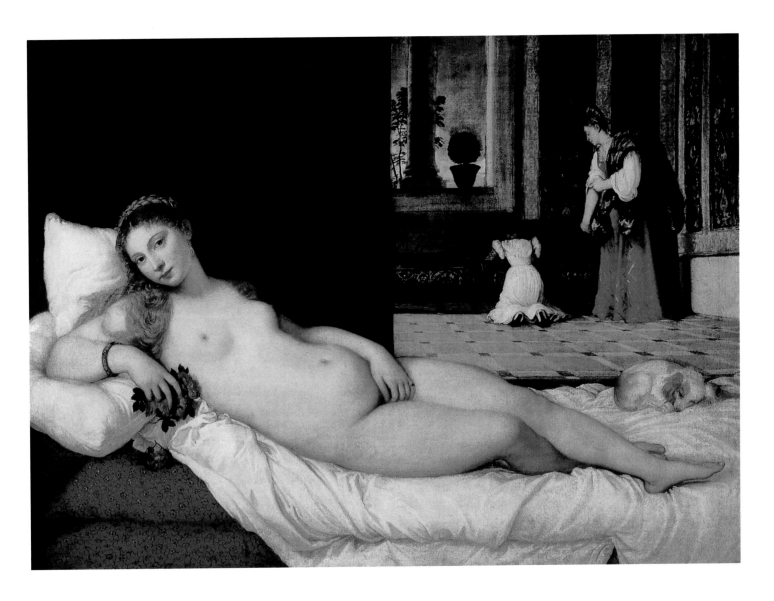

Correggio (Antonio Allegri) (born in Corregio in 1490 – died in Corregio in 1534)

Correggio founded the Renaissance school in Parma, but little is known of his life. He was born and educated in the little town of Correggio near Parma. In his seventeenth year an outbreak of the plague drove his family to Mantova, where the young painter had an opportunity of studying the pictures of Mantegna and the collection of works of art accumulated originally by the Gonzaga family and later by Isabella d'Este. In 1514 he went back to Parma, where his talents found ample recognition; and for some years the story of his life is the record of his work, culminating in his wonderful recreation of light and shade.

It was not, however, a record of undisturbed quiet, for the decoration which he made for the dome of the cathedral was severely criticised. At the age of thirty-six, he retired to the comparative obscurity of his birth place, where for four years he devoted himself to the painting of mythological subjects. His work prefigures mannerism and baroque style.

Correggio (Antonio Allegri),
Jupiter and Io, 1530.
Oil on canvas, 163.5 x 74 cm.
Kunsthistorisches Museum, Vienna.

Correggio (Antonio Allegri),
Abduction of Ganymede, 1531.
Oil on canvas, 163.5 x 70 cm.
Galleria Nazionale, Parma.

Titian (Vecellio Tiziano),
Venus of Urbino, 1538.
Oil on canvas, 119 x 165 cm.
Galleria degli Uffizi, Florence.

Hans Holbein the Younger (born in Augsburg in 1497 – died in London in 1543)

The genius of Holbein blossomed early. His father, Hans Holbein the Elder, was himself a painter of merit, and took his son into his studio. In 1515, when he was eighteen years old, he moved to Basle, the centre of learning, whose boast was that every house in it contained at least one learned man. He set out for London with a letter of introduction to Sir Thomas Moore, the King's Chancellor, "Master Haunce," as the English called him, arriving towards the close of 1526. Here Holbein was welcomed, and made his home during this first visit to England. He painted portraits of many of the leading men of the day, and executed drawings for a picture of the family of his patron. He soon became a renowned Northern Renaissance portrait painter of major contemporary figures. His work typically includes amazing details showing natural reflections through glass or the intricate weave of elegant tapestry.

By 1537 Holbein had come to the notice of Henry VIII, and was established as court painter, a position he held until his death.

Hans Holbein the Younger,
The Ambassadors (Jean de Dinteville and Georges de Selve), 1533.
Oil on oak, 207 x 209.5 cm.
The National Gallery, London.

Hans Holbein the Younger,
Portrait of Henri VIII, 1539-1540.
Galleria Nazionale, Rome.

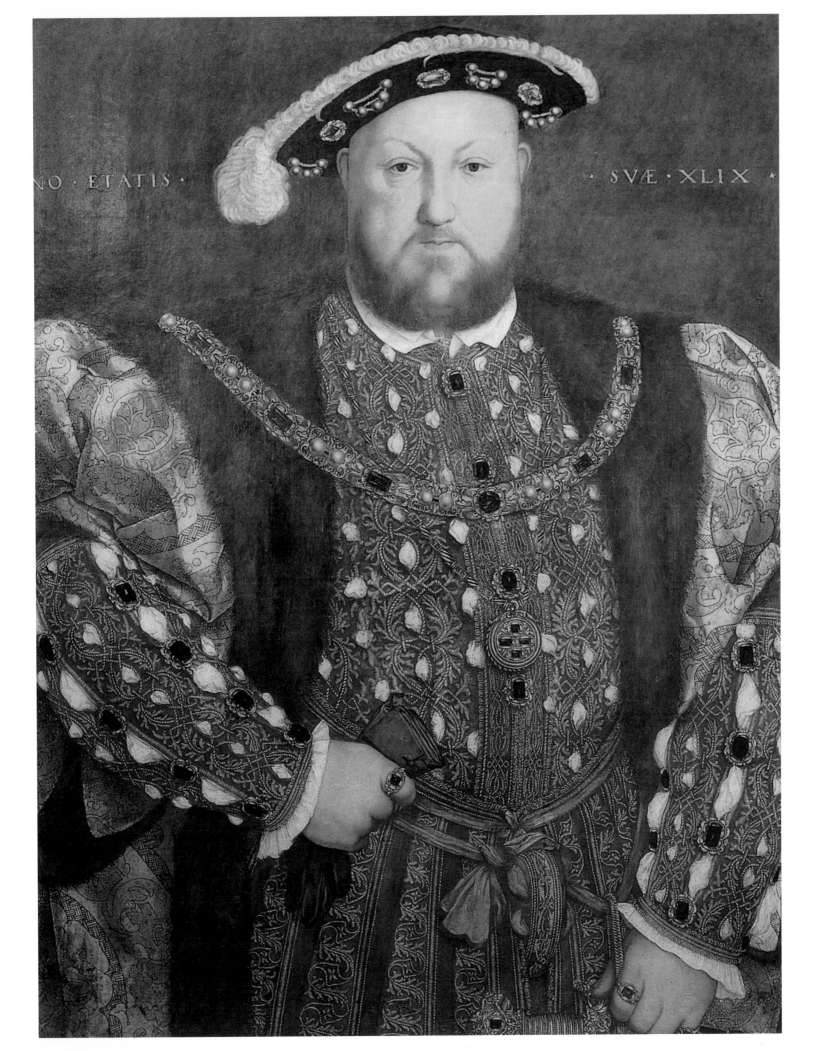

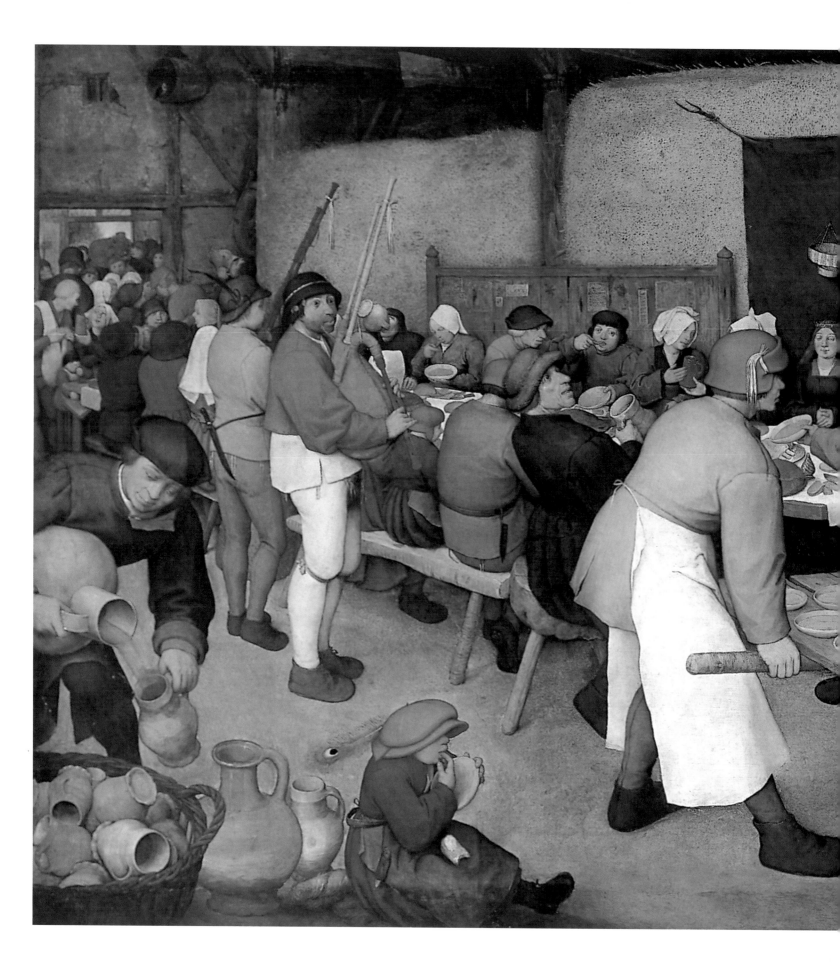

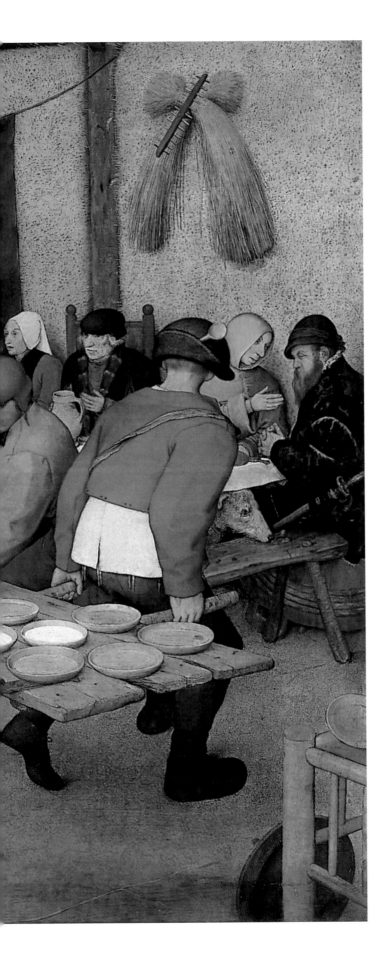

Pieter Bruegel the Elder (born in Breda in 1525 – died in Brussels in 1569)

Pieter Bruegel was the first important member of a family of artists who were active for four generations. A drawer before becoming a painter later, he painted religious themes, such as the Tower of Babel, with very bright colours. Influenced by Hieronymus Bosch, he painted large, complex scenes of peasant life and scripture or spiritual allegories, often with crowds of subjects performing a variety of acts, yet his scenes are unified with an informal integrity and often with wit. In his work, he brought a new humanising spirit. Befriending the Humanists, Bruegel composed true philosophical landscapes in the heart of which man accepts passively his fate, caught in the track of time.

Pieter Bruegel the Elder,
Peasant Wedding, c. 1568.
Oil on wood, 114 x 164 cm.
Kunsthistorisches Museum, Vienne.

Veronese (Paolo Caliari) (born in Verona in 1528 – died in Venice in 1588)

Paolo Veronese was one of the great masters of the late Renaissance in Venice. Originally named Paolo Caliari, he was called Veronese from his native city of Verona. He is known for his works of supreme colouring and for his decorations in both fresco and oil. His large paintings of biblical feasts executed for the refectories of monasteries in Venice and Verona are especially celebrated (like *The Wedding Feast at Cana*). He also painted many portraits, altarpieces and historical and mythological paintings. He headed a family workshop that remained active after his death. Although highly successful, he had little immediate influence. To the Flemish baroque master Peter Paul Rubens and to the eighteenth-century Venetian painters, especially Giovanni Battista Tiepolo, however, Veronese's handling of colour and perspective supplied an indispensable point of departure.

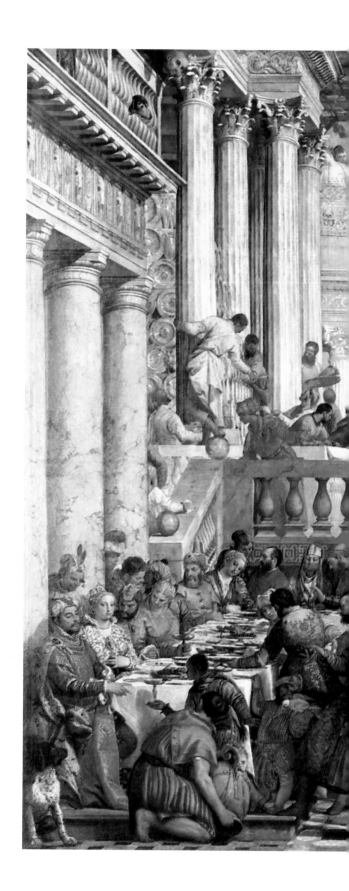

Veronese (Caliari Paolo),
The Wedding Feast at Cana, c. 1562-1563.
Oil on canvas, 677 x 994 cm.
Musée du Louvre, Paris.

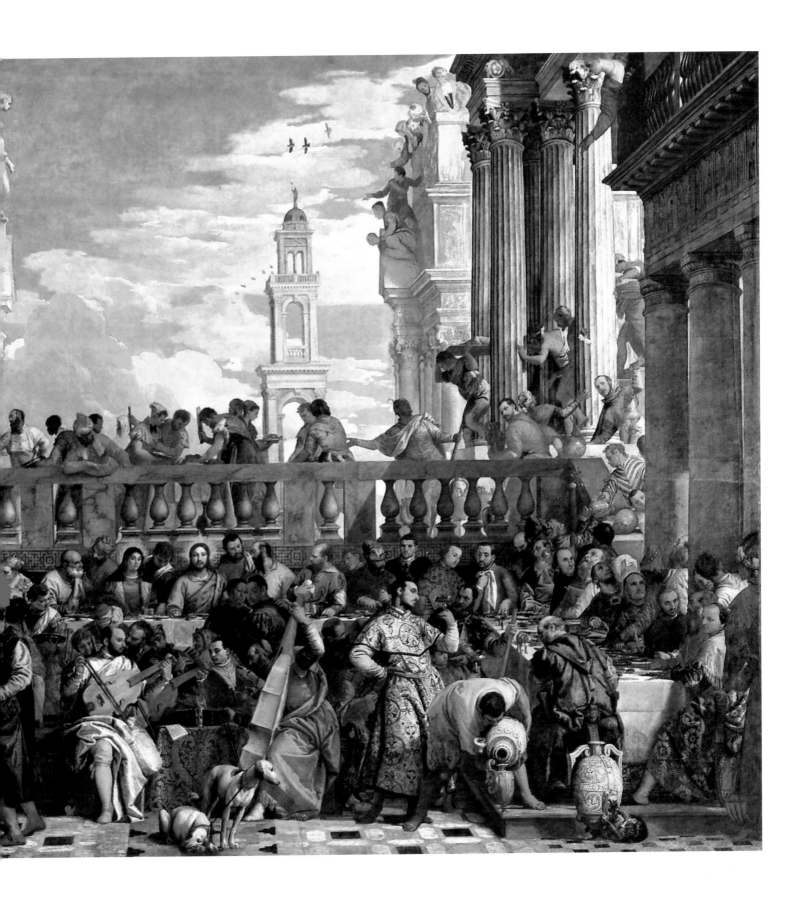

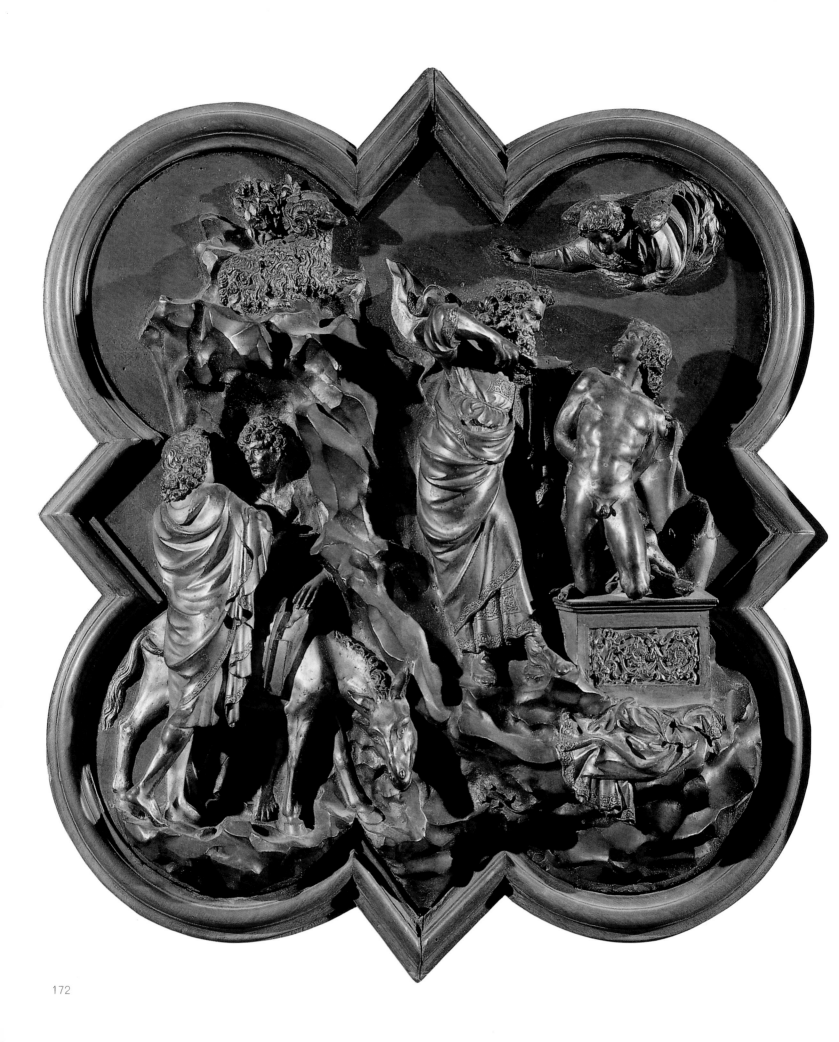

Sculpture

Lorenzo Ghiberti (born in Florence circa 1378 – died in Florence in 1455)

The Italian sculptor Lorenzo Ghiberti learned the craft of gold work under his father Ugoccione and his stepfather Bartoluccio. During the first stage of his artistic career, Ghiberti was mainly known as a mural painter. He created a highly regarded fresco, for instance, in the palace of the local prince Pandolfo Malatesta.

When he learned that there was a competition for the designs of a second bronze portal for the baptistery, Ghiberti returned to Florence. The already decided subject was Isaac's sacrifice, and the artists had to hand in designs at the same time, which matched the first bronze gate of the baptistery, created approximately 100 years before by Andrea Pisano. Six Italian artists submitted contributions to the competition, and Ghiberti's was announced the best. Subsequently, Ghiberti was occupied for twenty years with the first of his two bronze portals for the baptistery.

Ghiberti tackled his task with a deep religious fervour, striving for a great poetic ideal, such as we do not find in Donatello's work, for instance. The unlimited admiration, aroused by his first bronze door, induced the Florentine guilds to entrust him with a further portal, whose themes were also taken from the Old Testament. The Florentines were very proud of these magnificent works of art, which must have still been shining with all the brilliance of their original gold paint, when Michelangelo declared them worthy of serving as the gate to Paradise. Next to the doors of the baptistery are the three statues of John the Baptist, St Matthew and St Stephen in the church of Or San Michele, Ghiberti's outstanding works of art, preserved until this day. He died at the age of seventy-seven.

We know more about Ghiberti's theoretical ideas on art than about most of his contemporaries. He left us a commentary, which, apart from his thoughts on art, also told us a lot about his character and his personal convictions. Every page illustrates his deep religiosity, which characterised his life and work. He not only strives to proclaim the truth of his Christian belief in his work, but also sees a relationship to the classical Greek statues, which, according to him, express the highest intellectual and moral characteristics of human nature.

Lorenzo Ghiberti,
Sacrifice of Isaac, 1401-1402.
Bronze, 45 x 38 cm.
Museo Nazionale del Bargello, Florence.

Lorenzo Ghiberti,
St John the Baptist, 1412-1416.
Bronze, h: 254 cm.
Orsanmichele, Florence.

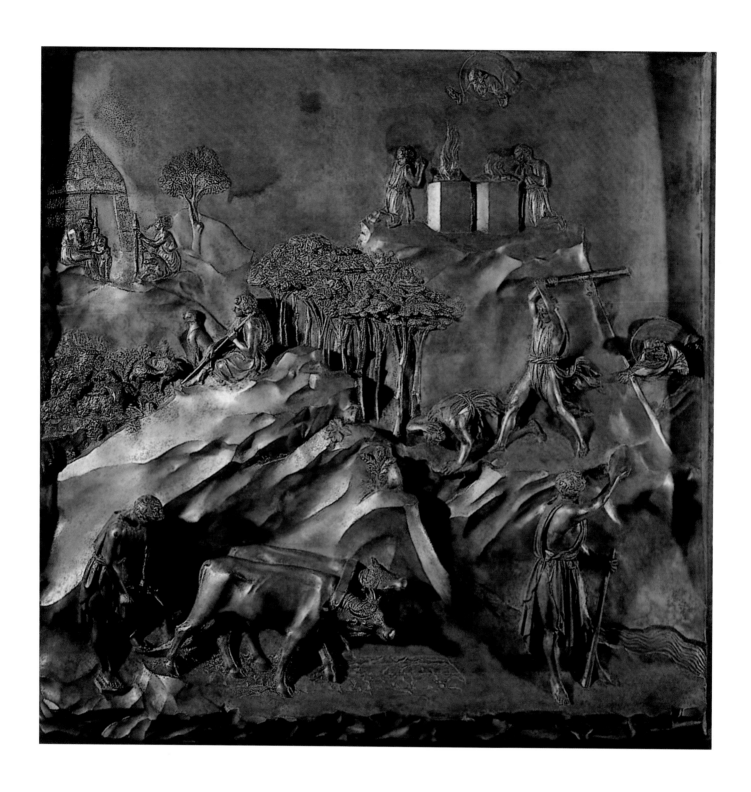

Lorenzo Ghiberti,
Story of Abel and Cain (original panel
of the eastern *Door of Eden*, baptistery
of Florence), 1425-1437.
Gilded bronze, 79.5 x 79.5 cm.
Museo dell'Opera del Duomo, Florence.

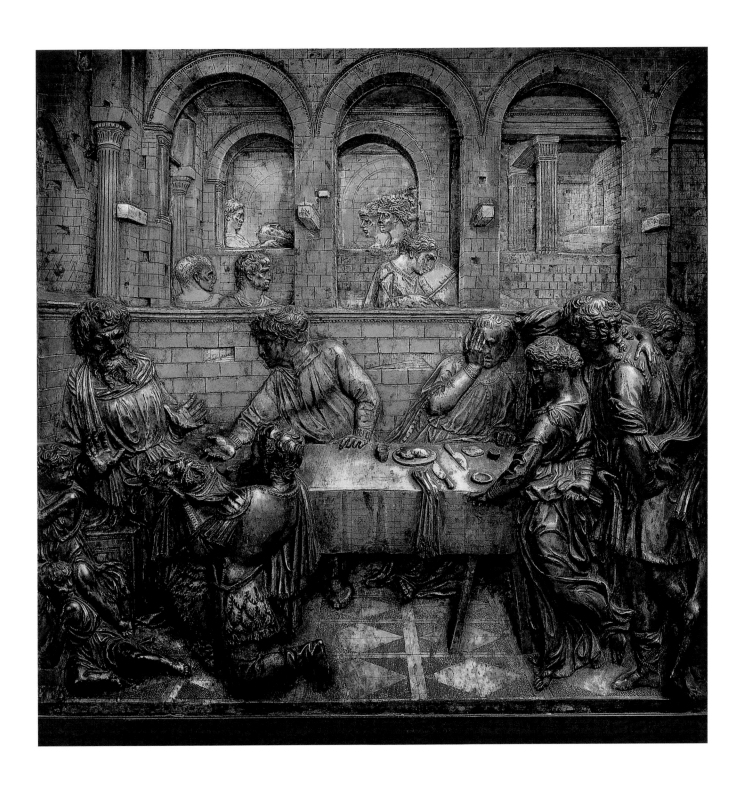

Donatello,
Herod's Feast (baptismal fonts), c. 1425.
Gilded bronze, 60 x 60 cm.
Baptistery, Sienna.

Donatello (born in Florence circa 1386 – died in Florence in 1466)

The Italian sculptor Donatello was born in Florence. He was first apprenticed to the workshop of a goldsmith, and worked in Ghiberti's studio for a short while. He was too young to take part in the competition for the gates to the baptistery in 1402. But when the defeated and disappointed Brunelleschi left Florence and went to Rome in order to study the remains of antique art, he was accompanied by the young Donatello. Brunelleschi was at this time measuring the dome of the Pantheon, which enabled him to build the awe-inspiring dome of Santa Maria del Fiore in Florence, whilst Donatello acquired his knowledge about classical forms and ornaments. The two masters, each in their own field, were to become the leading minds of fifteenth century art.

Donatello was back in Florence in about 1405, and was entrusted with the important commissions for the marble *David* and the colossal sitting figure of *John the Evangelist*. Later, he worked on the church Or San Michele. Between 1412 and 1415 Donatello completed *St Peter*, *St George* and *St Mark*.

During the period between the completion of the niches for Or San Michele and his second trip to Rome, in 1433, Donatello mainly worked in Florence on the statues for the campanile and the Cathedral. Among the marble statues for the campanile are *John the Evangelist*, the so-called *"Zuccone"* (Prophet *Habakkuk)*, as well as the *Prophet Jeremiah*.

During this time Donatello also carried out some work on the font in the church of San Giovanni in Siena, which Jacopo della Quercia and his assistants had begun in 1416. The relief *Feast of Herod* already shows a great strength of dramatic narrative and his ability to express depth of space, using the variation between sculptural roundness and the finest stiacciato.

In May 1434, Donatello was back in Florence. There he immediately signed the contract for the marble pulpit at the facade of the Prato-Cathedral, an almost Bacchanalian dance of half-naked puttoes, the forerunner of the cupid *Attis* for the Cathedral in Florence, on which he worked between 1433 and 1440.

Donatello's greatest achievement of his "classical stage" is, however, the bronze *David*, the first naked statue of the Renaissance, well-proportioned, magnificently balanced, its simplification of form referring to Greek art as well as being highly realistic as a result of not striving for ideal proportions.

In 1443, Donatello was invited to Padua to take over the embellishment of the high altar of Sant' Antonio. In this year the famous Condottiere Erasmo de' Narni, called Gattamelata had died earlier on, and it was decided to commemorate him with an equestrian statue. Owing to this commission and the reliefs and figures for the high altar, Donatello spent ten years in Padua. The finished equestrian statue, a work of art, which was both majestic and powerful, was erected in 1453.

Donatello spent the rest of his life in Florence.

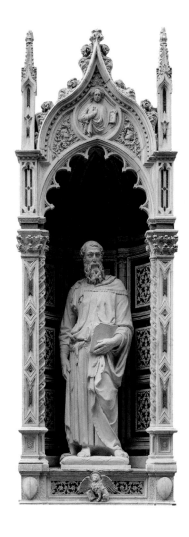

Donatello,
St Mark, 1411.
Marble, h: 236 cm.
Orsanmichele, Florence.

Donatello,
St Mary Magdalene, c. 1455.
Wood, h: 188 cm.
Museo Nazionale del Bargello, Florence.

Donatello,
Habakkuk (*Il Zuccone*), 1425-1427.
Marble, h: 195 cm.
Museo dell'Opera del Duomo, Florence.

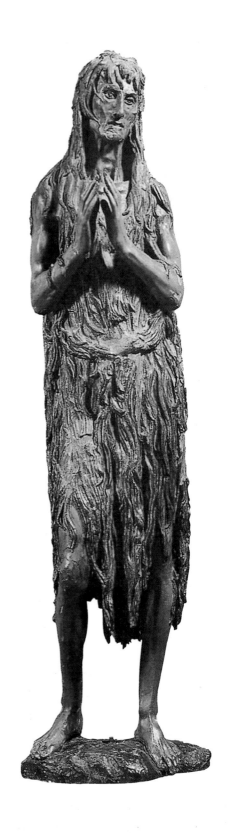
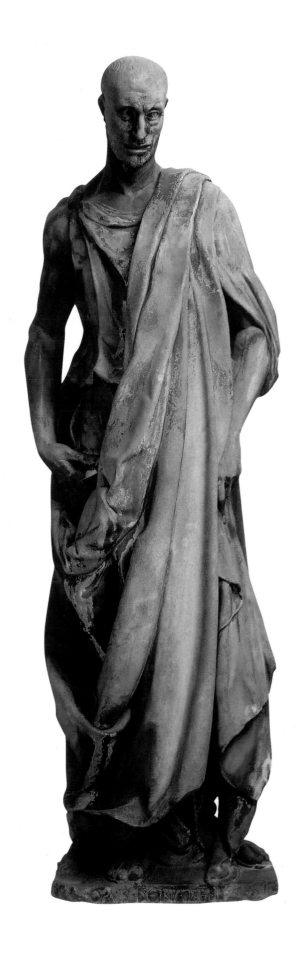

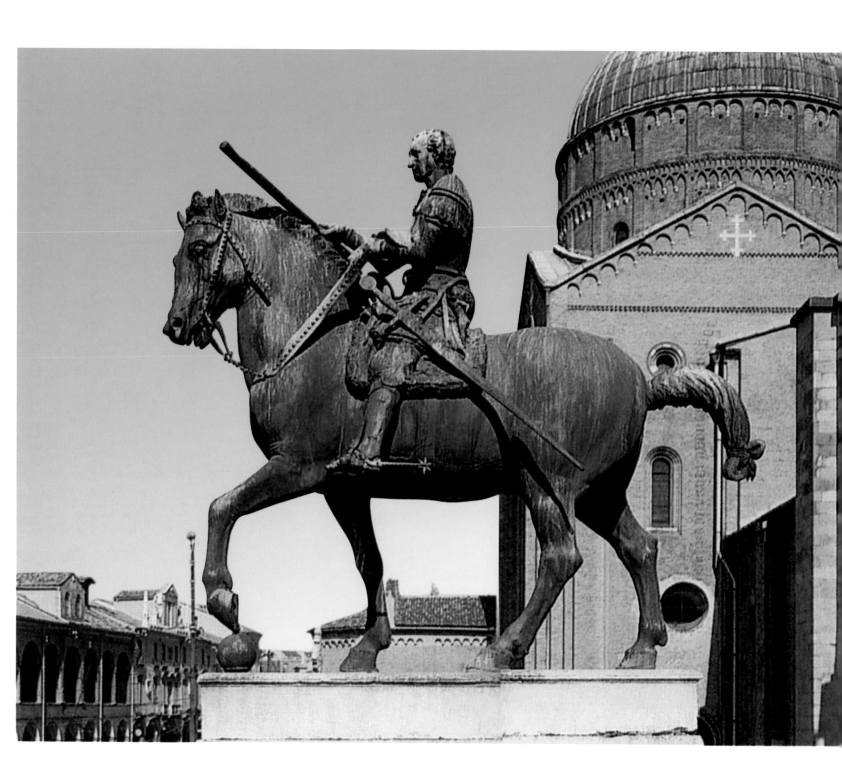

Andrea del Verrocchio (Andrea di Francesco de Cioni) (born in Florence circa 1435 – died in Venice in 1488)

The Italian goldsmith, sculptor and painter Andrea del Verrocchio took over his name from his master, the goldsmith Giuliano Verrocchio. Apart from his work, only little is known about Verrocchio's life. His significance as a painter is mainly based on the fact that Leonardo da Vinci and Lorenzo di Credi worked for many years as students and assistants in his bottega. Only one preserved painting can definitely be attributed to Verrocchio, the famous *Baptism of Christ*.

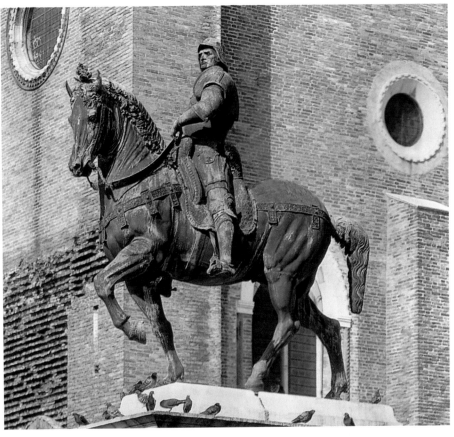

One of his earliest sculptures was the beautiful marble medallion of the Madonna over the tomb of Leonardo Bruni from Arezzo in the church of Santa Croce in Florence. In 1476 Verrocchio modelled and cast the beautiful but too realistic bronze statue of *David*. In the following year he finished one of the reliefs of the magnificent altar ceiling in the Florentine baptistery, which is the one showing the beheading of John the Baptist. He spent the years between 1478 and 1483 working on the bronze group for the *Doubting Thomas*, which stands in one of the outer niches in Or San Michele. Verrocchio's outstanding masterpiece was the colossal equestrian bronze statue of the Venetian general Bartollomeo Colleoni, which stands on the Campo die Santi Giovanni e Paolo. Verrocchio was commissioned to do this statue in 1479, but was only able to finish the model in 1488, the year he died. In spite of his wish to entrust his student Lorenzo di Credi with the casting, the Venetian Senate commissioned Alessandro Loepardi. The statue was finally unveiled in 1506. It is perhaps the most sublime equestrian statue in the world, in a certain respect it is superior to the antique bronze statue of Marc Aurel in Rome and equals Donatello's Gattamelata in Padua. The horse is characterised by a wonderful nobility and great vigour, and the relaxed pose of the great general that combines perfect balance with absolute ease and confidence in the saddle, is a miracle of the sculptor's art.

According to Vasari, Verrocchio was one of the first artists to work with casts of dead and living beings. He is regarded today as the most important sculptor between Donatello and Michelangelo.

Donatello,
Equestrian Statue of the Gattamelata
(*Condottiere Erasmo da Nami*), 1446-1451.
Bronze, 340 x 390 cm.
Piazza del Santo, Padua.

Andrea del Verrocchio (**Andrea di Francesco de Cioni**),
Equestrian Statue of Bartolomeo Colleoni,
also called the *Colleone*, 1480-1495.
Gilded bronze, h: 396 cm.
Campo di Santi Giovanni e Paolo, Venice.

Veit Stoss (born in Horb circa 1450 – died in Nuremberg in 1533)

The German sculptor and wood carver Veit Stoss is, apart from Tilman Riemenschneider, the greatest wood carver of his time. Stoss went to Cracow in 1477, where he worked until the end of the century. Between 1477 and 1489, he carved the high altar for St Mary's Church here. After the death of King Casimir IV in 1492, Stoss created his tomb in red marble for Cracow Cathedral. In general, this is also the year he is said to have created the marble tombstone of Archbishop Zbigniew Ollsnicki in Gnesen Cathedral. Stoss returned to Nuremberg in 1496, where he worked primarily on altars. His most well-known sculpture is *Assumption of the Virgin Mary* for the church St Lorenz in Nuremberg dating from 1518. This free figure, carved in a heroic size, hangs from the vaulted ceiling in the church.

Tilman Riemenschneider (born in Heiligenstadt circa 1460 – died in Wurzburg in 1531)

In spite of the fact that he lived and worked during the time of the Italian High Renaissance, the German sculptor Tilman Riemenschneider remained fundamentally a medieval artist who worked in a Late Gothic style and was unimpressed by the innovations coming from south of the Alps.

Riemenschneider's earliest work was made of the relatively soft material alabaster. Later he used stone as well as wood. He is primarily admired for his wood carvings and especially for his filigreed depiction of surface details and textures. Riemenschneider was always more interested in superficial realism than in the anatomical precision of his Italian contemporaries. The complex and angular folds in his cloths have a life of their own, covering the body rather than revealing it.

Riemenschneider was a successful and productive sculptor, who employed up to forty assistants in his workshop. Due to changes in taste, fire and wars, a major part of his work has been lost, damaged and altered. His abilities are perhaps best expressed in the altar-piece, created between 1501 and 1505 in Jacob's Church in Rothenburg ob der Tauber.

After completing his apprenticeship with Michael Erhart in Ulm, Riemenschneider went to the wealthy town of Wurzburg, where he lived until his death. Riemenschneider was a successful and respected citizen and became a member of the town council and the chapter of the Cathedral. In 1505 he belonged to the delegation of the town council, which welcomed Emperor Maximilian I at the town gates of Wurzburg. All this changed, when, during the Peasants' War in the 1520s, Riemenschneider and the peasants opposed the Bishop of Wurzburg, who was also the town master. After the rebellion had been suppressed, Riemenschneider was arrested and punished with a significant fine and, additionally, was probably also tortured. Although there is no evidence for the legend that his right hand was chopped off, he seems to have finished very few pieces of work during his last six years of life.

Michelangelo Buonarroti, called Michelangelo (born in Caprese in 1475 – died in Rome in 1565)

The name "Michelangelo" is nowadays almost synonymous with "genius". On the one hand, he was an outstanding sculptor, painter, architect, military engineer and even poet. On the other hand, humanism experienced its full expression through his work.

Michelangelo was the son of a Florentine civil servant from the lower aristocracy. He was sent to Francesco d'Urbino as an apprentice, who opened his eyes to the beauty of Renaissance art. Afterwards, he joined Ghirlandaio's workshop as an "apprentice or servant".

Through Ghirlandaio, Michelangelo became acquainted with Lorenzo de' Medici, the "Magnificent". This patron of the arts and literature founded a school of art in his own palace, which was run by Bertoldo, one of Donatello's students. Through this, Michelangelo strengthened his acquaintance with the Medici Family, whose splendid collection of sculptures deeply impressed him.

At the age of sixteen, Michelangelo had already produced numerous pieces of art, among them the *Battle of the Centaurs*, an allusion to the sarcophagus of the antique and the *Madonna of the Stairs*. In around 1495, Cardinal Lorenzo di Pierfrancesco de' Medici invited him to Rome. Thus, Michelangelo stayed in Rome for the first time. This time enabled him to study the splendour of the antiquity more intensively, with which he had first become acquainted in the gardens of the Medici. Here, he created *Bacchus* and in 1497 completed *La Pietà*, one of his most beautiful creations. This was a commission by the French ambassador to the Vatican for the tomb of his King Charles VIII. Today, this sculpture is in the Basilica of St Peter's and constitutes a perfect reproduction of God's sacrifice and inner beauty. Michelangelo was twenty-two years old at the time, and was soon to be one of the most influential artists of his time and receive the nickname "The Divine". His genius stimulated art by his obtaining inspiration from classical antiquity, using it, however, to glorify mankind. The 4.34 metre tall marble *David*, now in the Accademia in Florence, constitutes the highlight of Michelangelo's early work. The first drafts for this work of art, finished in 1504, originate from the year 1501. Michelangelo broke with tradition by depicting David without Goliath's head in his hand.

Pope Pius III died in 1503, and was followed by Julius II. His Holiness persuaded Michelangelo to return to Rome, and commissioned him with a majestic tomb for himself as well as other monuments. This tomb, influenced by a classical style, is among the splendid pieces of work, with which Michelangelo wanted to express all the power and sensuality that render marble the most noble of all stones. The tomb for Julius II, finally completed in 1547, reflects the Pope's love for classical antiquity.

Michelangelo Buonarroti,
Tomb of Lorenzo de' Medici, 1525-1527.
Marble.
Medici Chapel, San Lorenzo, Florence.

Michelangelo Buonarroti,
Pietà, 1498-1499.
Marble, h: 174 cm.
St Peter's Basilica, Vatican.

Michelangelo Buonarroti,
Pietà, 1547-1555.
Marble, h: 226 cm.
Museo dell'Opera del Duomo, Florence.

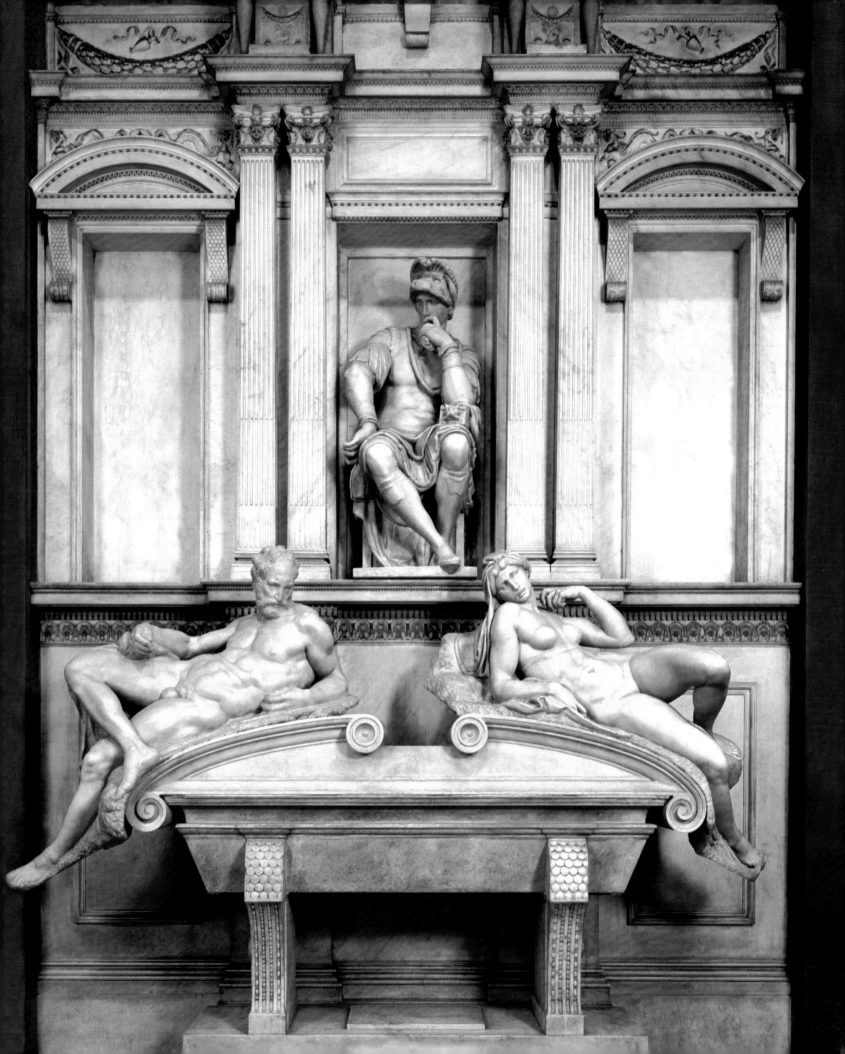

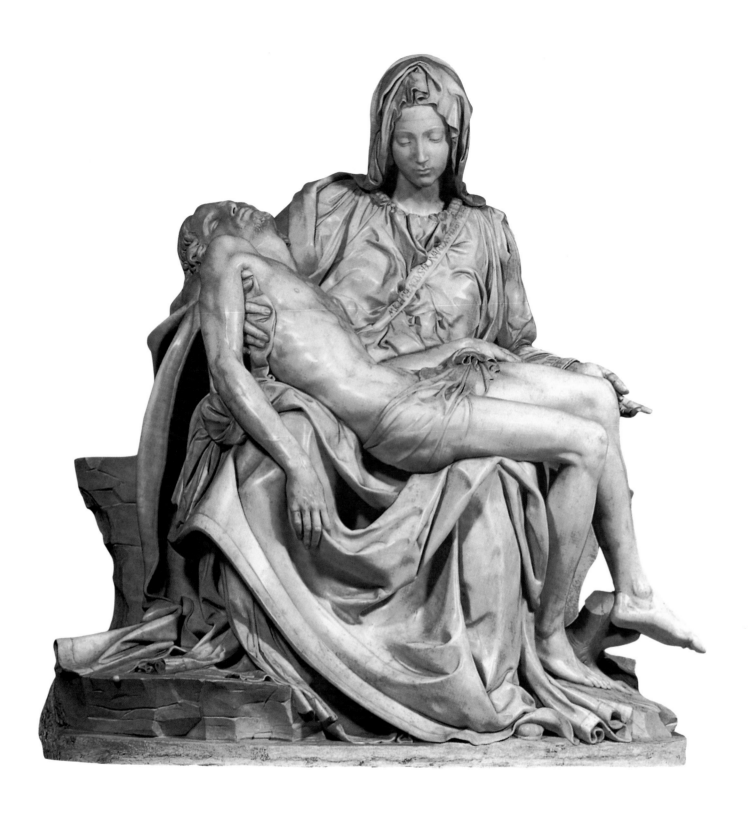

In 1520 Michelangelo was commissioned to design the burial chapel of the Medici. This architectonic gem contains the mortal remains of Giuliano de' Medici, Duke of Nemours and Lorenzo, Duke of Urbino. Altogether, it seems more like an informal scene from daily life, and less like a reflection of rigorous piety, thus demonstrating

Michelangelo's ability to overcome his rebellious temperament and achieve the true freedom of the artistic gift of expressing oneself.

Throughout his whole life, Michelangelo was tortured by his striving for excellence, driven by his enormous ego and his exceptional persistence.

Benvenutto Cellini (born in Florence in 1500 – died in Florence in 1571)

The Italian artist, medallion-maker and sculptor Benvenuto Cellini was the third child of Giovanni Cellini, a musician and instrument maker. When he was fifteen, his father reluctantly consented to let him do an apprenticeship with a goldsmith. When Cellini was banned to Siena for six months as a result of being involved in fights, he had already, to a certain extent, made a name for himself in his hometown. He also worked for a goldsmith in Siena. From there he went to Bologna, where he made further progress as a goldsmith. After a stay in Pisa and two interludes in Florence, he went to Rome at the age of nineteen. His first independent attempt at his art in this town was a silver casket, which was followed by silver candle-holders, and later by a vase for the Bishop of Salamanca, who introduced him to Pope Clemens VII. During the Sacco die Roma in 1527, Cellini rendered outstanding services to the Pope through his bravery. This made reconciliation with the Florentine Magistrate possible, and soon after he returned to his hometown. Here he dedicated himself with great eagerness to producing medallions. Among the most important are his *Hercules and the Nemean Lion*, made of embossed gold and *Atlas carrying the Celestial Sphere*, made of chased gold. From Florence he went to the court of the Duke of Mantua, then back to Florence and then to Rome, where he not only made jewellery, but also casts for private medallions, and created the papal mint.

Cellini worked at the court of King Francis I in Fontainebleau and Paris from 1540 to 1545, where he created his famous salt-cellar made of gold and enamel. However, the intrigues of the King's favourites made him move back to Florence after five busy and fulfilled years, where he dedicated himself to works of art, and fought out numerous quarrels with the unpleasant sculptor Vaccio Bandinelli. Due to the war with Siena, Cellini was entrusted with strengthening the fortifications in his hometown, and whilst he was treated relatively miserably by the ducal court, his magnificent work gained him an ever increasing high standing among his fellow citizens. He died in Florence in 1571, unmarried and without any descendants. His funeral in the Church of Annunziata took place with great extravagance.

Apart from the gold and silver work attributed to him, Cellini created several sculptures of major dimensions. The outstanding one among these pieces of art is the bronze group *Perseus with the Head of Medusa*. This piece of art following a suggestion by Duke Cosimo de' Medici is today in the Loggia dei Lanzi in Florence. With its fantastic portrayal of the power of genius and the splendour of a terrible beauty it is one of the most typical and unforgettable monuments of the Italian Renaissance. The cast of this large sculpture caused Cellini major difficulties, and its completion was welcomed with enthusiasm throughout Italy.

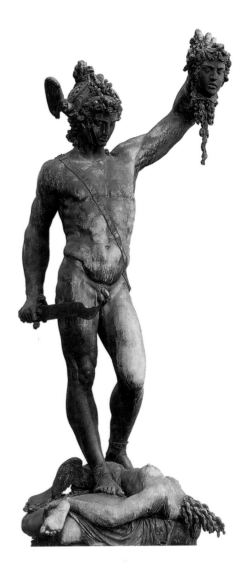

Benvenuto Cellini,
The Salt Cellar of Francis I, 1540-1543.
Ebony, gold partly enameld, 26 x 33.5 cm.
Kunsthistorisches Museum, Vienna.

Benvenuto Cellini,
Perseus, 1545-1554.
Bronze, h: 32 cm.
Loggia dei Lanzi, Florence.

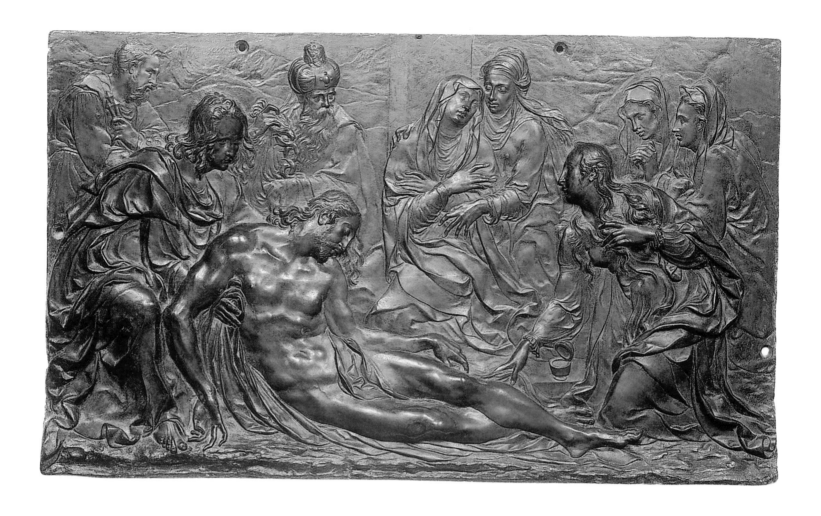

Germain Pilon,
Lamentation over Christ, 1580-1585.
Bronze, 47 x 82 cm.
Musée du Louvre, Paris.

Germain Pilon,
Mater Dolorosa, 1585.
Terracotta, 159 x 119 x 81 cm.
Musée du Louvre, Paris.

Germain Pilon (born in Paris circa 1525 – died in Paris in 1590)

Germain Pilon was a French sculptor. He worked together with his father, also a sculptor, on the Solesmus Abbey, and returned to Paris in approximately 1550. Charles IX soon appointed him warden of the mints. He produced numerous pieces of work of an awe-inspiring style. His oldest known work of art is the tomb of Francis I and Catherina of Medici in St Denis Abbey, finished in 1558. Here, one can also see the magnificent tomb of Henry II, which took Pilon from 1564 to 1583 to complete. He also created the well-known group of the *Three Graces*, now in the Louvre, who used to carry an urn on their heads with the heart of Henry II. Much of his work has been lost. Even so – numerous authors class him as belonging to the great French School of Renaissance, although his work differs from the work of Jean Goujon in that it shows a sluggish gracefulness, which already anticipates a certain decadence.

189

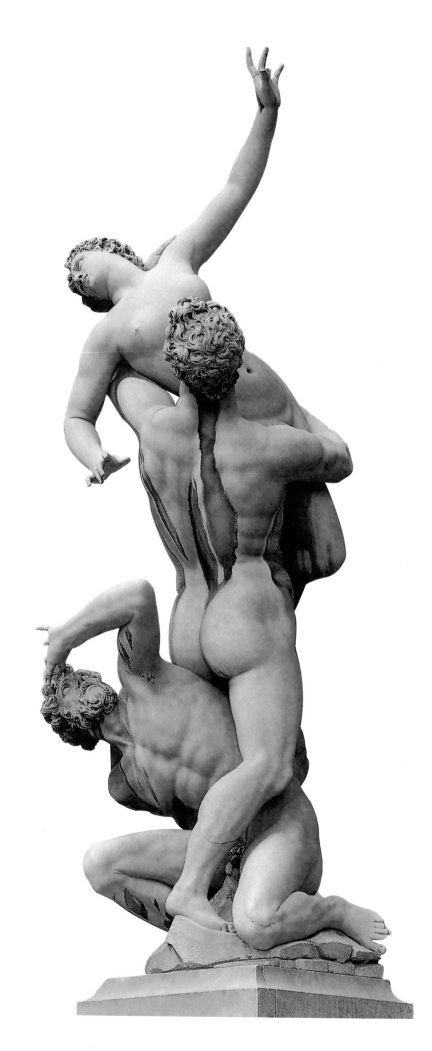

Giambologna (Jean Bologne or Boulogne),
The Rape of the Sabine Women,
1581-1583.
Marble, h: 410 cm.
Loggia dei Lanzi, place della Signora,
Florence.

Giambologna (Jean Bologne or Boulogne),
Mercury, 1564-1580.
Bronze, h: 180 cm.
Museo Nazionale del Bargello, Florence.

Jean Goujon,
Caryatid, 1550-1551.
Stone.
Musée du Louvre, Paris.

Anonymous,
Diana with Stag (also called the *Diana of Anet*), middle of 16th century.
Marble, 211 x 258 x 134 cm.
Musée du Louvre, Paris.

Giambologna (Jean Bologne or Boulogne) (born in Douai in 1529 – died in Florence in 1608)

Giambologna was the most celebrated and most successful Italian sculptor during the period between Michelangelo and Bernini. We hardly find any kind of expression pointing to his northern roots in his work. He is probably the most typical sculptor of the School of Mannerism in Italy. Giambologna was an apprentice of the Flemish sculptor Jacques Du Brœucq, who had visited Italy and shown himself open to Italian influences. He also travelled to Rome and spent two years there studying the work and intellectual world of the High Renaissance. Here, he could also study the originals of the newly discovered sculptors of classical antiquity. During his trip back to Flanders in 1552, Giambologna stopped off in Florence. He was persuaded to stay, and finally became the court sculptor of the Dukes of Tuscany from the Medici Family. Their court was an important art centre, and on the basis of his position, Giambologna's reputation spread across the courts in the whole of Europe.

Giambologna's figure *Rape of the Sabines*, dated 1582, in the Loggia dei Lanzi can be regarded as a representative example of mannerism by sculptor with its complex ballet-like poses, the composition winding itself like a spiral upwards, and the virtuoso treatment of the marble.

Among Giambologna's other important works of art are the graceful bronze statue of the flying *Mercury* (in different versions), the larger than life-size marble statue of a Philistine striking dead Samson (1560-62, Victoria and Albert Museum, London), the large, but fanciful *Neptune Fountain* in Bologna (finished in 1566), and numerous exquisite small bronze statues from his workshop, which were now and again given as presents by diplomats during their visits.

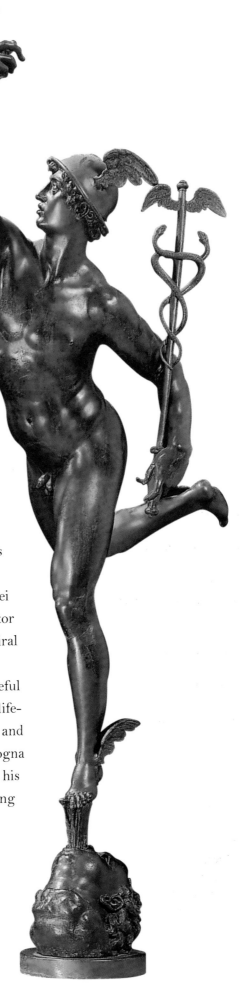

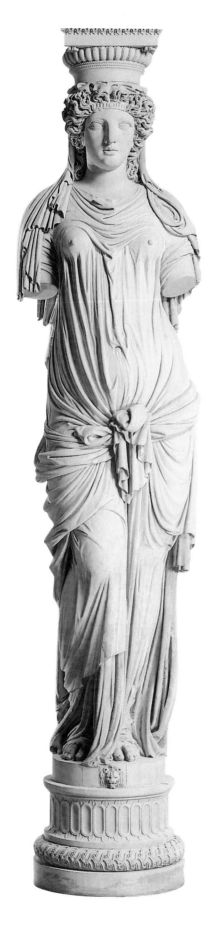

Jean Goujon (active 1540 – 1563)

Jean Goujon was a French sculptor of the sixteenth century. We read his name for the first time in the records of the church St Maclou in Rouen for the year 1540. Subsequently, Goujon was in the employ of Pierre Lescot, the celebrated architect of the Louvre, whom he helped with the restoration of St Germain l'Auxerrois. In 1547 Martin's French translation of Vitruvius was published, whose illustrations are from Goujon, "naguères architecte de Monseigneur le Connétable, et maintenant un des vôtres", as the translator tells us in his "Dedication to the King". We not only learn from this statement that Goujon had been taken into royal employment by Henry II, but also that he had helped Bullant during his work at the Castle of Ecouen earlier. Between 1547 and 1549 he worked on the embellishment of the Loggia, commissioned by Lescot, for the entry of Henry II into Paris, which finally took place on 16 June 1549. Lescot's building was erected again by Bernard Poyet in a modified form in the *Fontaine des Innocents* towards the end of the eighteenth century. In the Louvre, Goujon took over the sculptural work on the south-western corner of the court, the reliefs of the Escalier Henry II and the Tribune des Caryatides, according to the instructions from Lescot. In the years between 1548 and 1554 the Château d'Anet was built, whose embellishment Goujon carried out together with Philibert Delorme under the commission of Diana of Poitiers. Unfortunately, the building records for Anet have disappeared, but Goujon carried out a series of work of similar importance, which were lost or destroyed during the French Revolution. From 1555 we find his name back in the records of the Louvre, and that is until 1562, when every trace of him is lost. In this year an attempt was made to remove all those from royal service who were suspected of Huguenot tendencies. Goujon had always been regarded as a reformer. Therefore it is absolutely possible that he was among the victims of this measure.

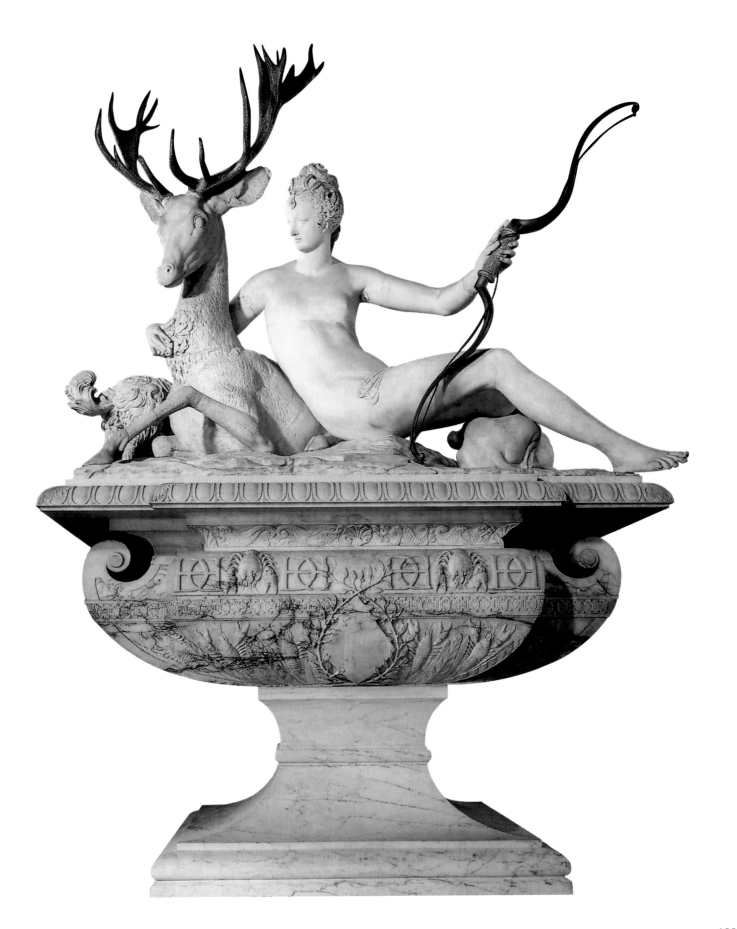

Bibliography

BEGUIN, Sylvie, *L'Ecole de Fontainebleau. Le Maniérisme à la cour de France*, Paris, 1960.

CREIGHTON, Gilbert, *Renaissance Art*, New York, Harper Torchbooks, 1970.

DELUMEAU, Jean, *La Civilisation de la Renaissance*, Paris, Flammarion, 1984.

GOMBRICH, Ernst Hans, *Histoire de l'art*, Paris, Phaidon Press, 2006.

LETTS, Rosa Maria, *The Renaissance*, Cambridge, Cambridge University Press, 1981.

MANCA, Joseph, *Andrea Mantegna et la Renaissance italienne*, New York, Parkstone, 2006.

MIGNOT, Claude, BAJARD, Sophie and RABREAU, Daniel, *Histoire de l'art Flammarion. Temps modernes : XV^e-XVIII^e siècles*, Paris, Flammarion, 1996.

MOREL, Philippe, *L'Art de la Renaissance*, Paris, Somogy, 2006.

MUNTZ, Eugène, *Histoire de l'art de la Renaissance*, Paris, Hachette et Cie, 1891.
– *Michelangelo*, New York, Parkstone, 2005.

PANOFSKY, Erwin, *Albrecht Dürer*, Princeton, Princeton University Press, 1948.

RUBINSTEIN, Ruth, *Renaissance Artists & Antique Sculpture*, London, H. Miller, 1987.

VASARI, Giorgio, *Le vite de' più eccellenti architetti, pittori, et scultori italiani, da Cimabue insino a' tempi nostri*, Torino, G. Einaudi, 2000.

WOLFFLIN, Heinrich, *Die klassische Kunst: eine Einführung in die italienische Renaissance*, München, Bruckmann, 1899.

ZERNER, Henri, *L'Art de la Renaissance en France : l'invention du classicisme*, Paris, Flammarion, 2002.

Index